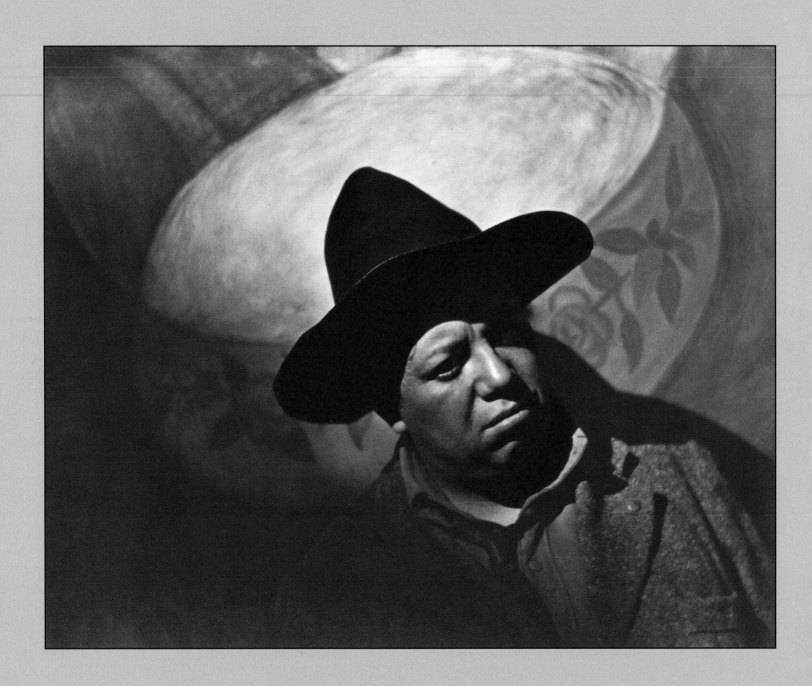

DIEGO RIVERA

PETE HAMILL

HARRY N. ABRAMS, INC.
Publishers

#41185104
DLC

1-25-00

This book is for Betty and Homero Aridjis

HALF TITLE:
"Landscape with Cacti" illustration for *Mexico* by Alfred Goldschmidt, 1925
FRONTISPIECE:
Diego Rivera in front of one of his murals
in the National Preparatory School, Mexico City, 1924.
Photograph by Edward Weston.
Center for Creative Photography, Tucson, Arizona
© 1981 Center for Creative Photography

EDITOR: ERIC HIMMEL
DESIGNER: JUDITH MICHAEL
PICTURE RESEARCHER: BARBARA LYONS

Library of Congress Cataloging-in-Publication Data

Hamill, Pete, 1935–
Diego Rivera / Pete Hamill.
p. cm.
Includes index.
ISBN 0–8109–3234–2
1. Rivera, Diego, 1886–1957. 2. Painters—Mexico—Biography.
I. Rivera, Diego, 1886–1957. II. Title.
ND259. R5H28 1999
759.972—dc21 99–28100
[B]

Printed and bound in Japan

HARRY N. ABRAMS, INC.
100 FIFTH AVENUE
NEW YORK, N.Y. 10011
www.abramsbooks.com

Contents

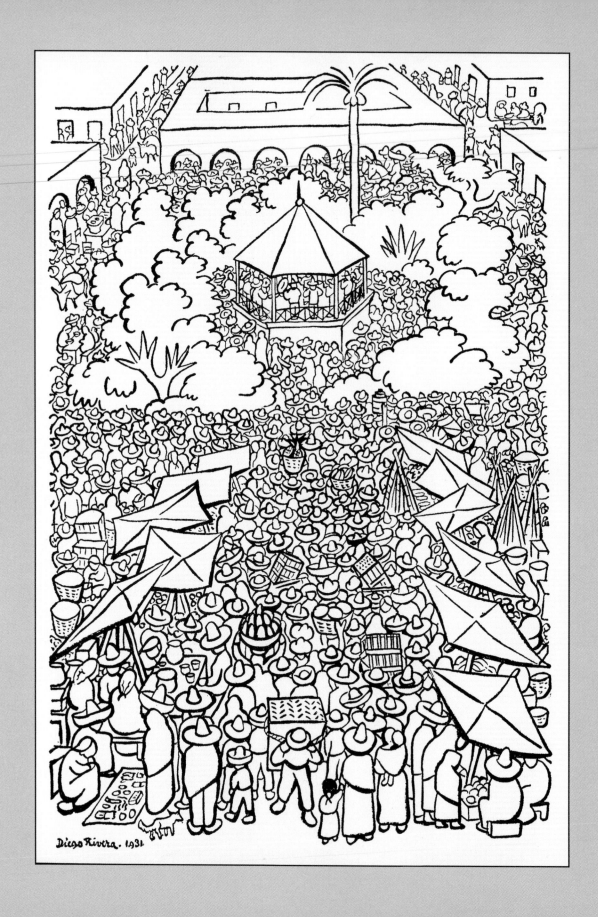

Introduction

THE MASKS
OF
DIEGO RIVERA

I n the fall of 1956, I traveled to Mexico to become a painter. I was twenty-one years old. With a friend, I went by bus all the way from New York to Mexico City, crossing the border at Laredo and plunging into a country that would change my life. It was a country of extraordinary beauty, scrubbed skies, fierce mountains, and steep canyons, endless vistas sprinkled with snow-capped volcanoes. The people were handsome, kind, and carried themselves with dignity and grace.

At the time, there were about three and a half million inhabitants in Mexico City. The air was crisp and clean. The nights were safe. I was enrolled under the GI Bill to study art at Mexico City College, whose most recent students had included Jack Kerouac and William S. Burroughs. The students were a wonderful mixture: young women from the Midwest on a junior year in Mexico; middle-class Mexicans learning English; college boys playing at learning Spanish; and older, graver men who had survived the Battle of the Bulge. The art school was small and solid; my instructors included a fine Canadian painter named Arnold Belkin and a brilliant young artist named José Luis Cuevas.

I was in a daily state of exhilaration and in my free time began seeking out the work of the great Mexican painters. Of these, José Clemente Orozco had the most powerful effect on me. When I saw his work, I was bowled over and immediately lost my nerve. In the presence of his work, it seemed an act of self-delusion to try to be a painter. Before the year was over, I had shifted my focus to writing.

OPPOSITE:
Illustration for *Mexico: A Study of Two Americas* by Stuart Chase, 1931

That year, I looked at the other Mexican painters too. David Alfaro Siqueiros was like some great bellowing opera singer, amazing in his way, but also preposterous. Rufino Tamayo touched something deeper in me, with his mysterious forms, his glowing color; he had found his way into magic, and my own imaginings seemed puny in comparison.

Diego Rivera was the least interesting. His work in the National Palace in the Zócalo seemed clenched and stiff. His reconstruction of the destroyed Rockefeller Center mural in the Palacio de las Bellas Artes seemed to my arrogant eyes a mere political cartoon. In their different ways, Orozco and Tamayo remained fresh. Diego Rivera seemed hopelessly dated, someone out of the 1930s. When he died in November 1957, Mexico was stirred, the funeral received heavy coverage, and some people wept. But it was nothing like the outpouring of grief in April that year when the film star Pedro Infante died in an airplane crash in the Yucatán. It was as if the essential Diego Rivera had died years before the actual end.

Over the following decades, I continued going to Mexico, lived there for extended periods, made many friends, was nourished by the art and literature of the country. I was in Mexico City in 1986 when a huge Rivera exhibition opened at the Bellas Artes to celebrate the one hundredth anniversary of the painter's birth. I went for a look. And then returned again and again. For the first time, I could see what a great painter he had been. In room after room, there were examples of his skill, his invention, his originality. He had done something that few artists have ever done: he'd given a nation an identity. Rivera put his stamp on Mexico the way Bernini placed his on Rome. It is impossible to think of Mexico today without also seeing the images of Diego Rivera.

In his best mural paintings, he merged past, present, and future into dense, crowded visions of an essential Mexico. He drew on Mexican history, folk art, the discoveries of archaeology and other sciences. He mixed them in his own powerful imagination, refined by long years of apprenticeship in Europe, and made something that was not there before: a unifying, celebratory image of Mexico. In his art, he unified a people long fractured by history, language, racism, religious and political schism. He said in his art: you are all Mexico.

This might now seem to be a platitude: it was not a platitude when Rivera was painting his first great public works in the 1920s. His ideas and desires were made powerful by his art, and I've come to think that Rivera was one of the great artists of the century. He brought to his walls immense gifts as a draftsman and colorist; he added a genius for spatial organization, which in his finest works led to paintings in which every part is welded to the whole. He also suffused those works with a passion for the intimate. His beloved peasants, for example, are almost always both specific and universal. So are his conquistadores and his urban workers, his corrupt politicians and his heroic revolutionaries. He looked at individuals and made archetypes.

We stand back and see the vast mosaic. We come close and see an Indian

woman wearing high heels to a fiesta. Those shoes are symbols of what the city is doing to the new arrivals from the Mexican countryside. We also know her feet hurt. In his public works, Diego's great contemporary, José Clemente Orozco, aspires to the universal and loses Mexico. His other artistic rival, David Alfaro Siqueiros, lusts for a Marxist universalism, but there is no room in his vision for women whose feet hurt. The daughter of an industrialist and the son of a farmer could look at the work of Diego Rivera and recognize Mexico. He is like some great writers, from Charles Dickens to William Faulkner to Gabriel García Márquez: the insistence on the value of the local leads to the universal.

The mural paintings are only part of his enormous production. He was a superb portrait painter, using design and detail to reveal human character. His own self-portraits are themselves an extended examination of his own mortality, among the most ruthless in the history of art. He was a very good Cubist painter of the second generation. He was a great painter of machinery, finding beauty in the immense twentieth-century objects that caused revulsion among so many others. As a painter, he reacted to his own times, and also created a vision of the future.

As a human being, he was capable of great folly. He was a liar, a mythomaniac, an artificer. He could be devious and selfish. He was not always brave. His exuberant creativity was shared between his art and his public self. No artist wore so many masks of his own invention. There was the mask of Diego the Marxist Revolutionary. There was Diego the Womanizer. There was Diego the Archaeologist. And there were more: Diego the Biologist, Diego the Sophisticate, Diego the Union Leader, Diego the Bohemian, Diego the Propagandist, Diego the Art Critic. Of Diego Rivera it could be truly said that if you peeled away the mask you would find the mask underneath.

The political passions that drove so much of his public art are now dead. But to my eye, the best of his art seems oddly fresher today than when those ideas were still relevant to the way people lived. It's as if the art has been freed from the prison of its context. In the years since I first truly saw the work of Diego Rivera, I've spent hundreds of hours looking at his work, in galleries, in museums, in dimly-lit government buildings. I've gone back to the biographies in English and Spanish, trying to separate the facts from the masks, the achievements from the failures. I wanted to know more about the artist and the man and the forces that shaped both. This book is the result of that search.

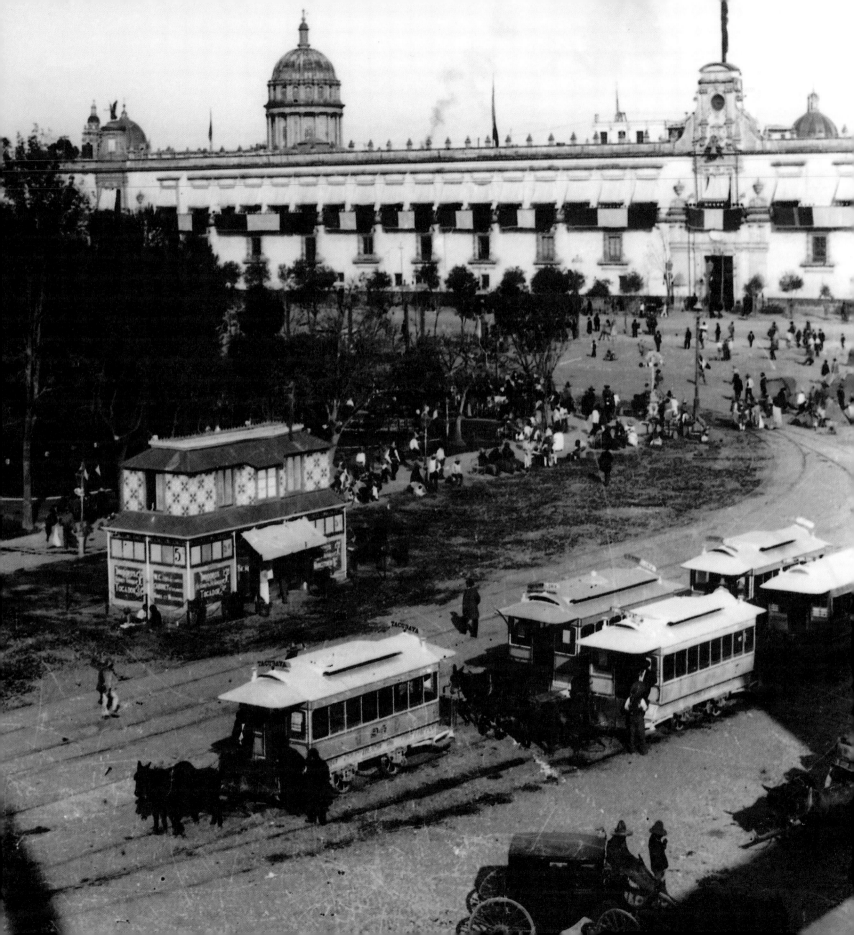

IN THE TOWN OF FROGS

He was born on December 8, 1886, in the beautiful old silver town of Guanajuato, capital of the Mexican state of the same name. The town clings to the abrupt slopes of the Sierra Madre and was established in 1559; the name derived from the Tarascan word that meant "hill of frogs." With its narrow cobblestoned streets, time-weathered walls, and spired churches, the town evokes the atmosphere of El Greco or Zurbarán; when seen from a distance, its tile rooftops and blank facades gather into the patterns of Cubism.

Some sources give his name at birth as José Diego Rivera. Later, he would insist that his full name at birth was Diego María de la Concepción Juan Nepomuceno Estanislao de la Rivera y Barriento Acosta y Rodríguez (the "José" now erased), but this might have been one of his many improvements upon fact or a sly dig at the baroque pretensions of the Mexican middle class. We do know that he was a twin. There is a photograph of little Diego with his twin brother, José Carlos Rivera, the two of them dressed in the frilly clothes of pampered middle-class children, seated in a thronelike chair. The birth of the twins brought great joy to the Rivera home. His mother, twenty-two-year-old María del Pilar Barrientos, had lost three children at birth. His father, a respected schoolteacher named Diego Rivera, tried valiantly to comfort her for those losses. "After each child was born dead," Rivera remembered later, "my father had gone out and bought my mother a doll to console her. Now he did not buy a doll but cried with delight."[1]

They lived in a drafty three-story stone house in the street called Pocitos. Like each of its neighbors, the house was a reminder of the vanished centuries of Guanajuato's silver boom, when fortunes were extracted from the veins of the surrounding mountains. In the early eighteenth century, the mines produced about one-third of the world's silver, and a number of Guanajuato families shared in the boom, including the Riveras. But by 1886, the silver mines were exhausted and the town was slumbering in the tenth year of what was to become known as the Porfiriato: the long reign of dictator Porfirio Díaz that would not end until the Mexican Revolution of 1910.

Tall, bearded Diego Rivera Senior was one of the young moderns of

OPPOSITE:
Streetcar station in the Zócalo, with the National Palace in the background, Mexico City, 1890. Archivo Casasola, INAH, Pachuca, Mexico

Guanajuato, a liberal member of the town's city council, a part-time journalist for a weekly called *El Demócrata*. His liberalism was unusual for conservative Guanajuato, lost in the colonial past, which strongly supported the "progress and order" philosophy of Don Porfirio. But Diego Senior's political passions had been stirred by what he saw of rural poverty on his long tours as an inspector of a school system that was so inadequate it left 85 percent of all Mexicans illiterate. His own family was in its shabby genteel twilight, but on his journeys he could see in devastating detail what he certainly knew in general: he was still better off than the vast majority of the poor. He was, after all, a *criollo,* a Mexican of "pure" European descent, and in that era of hard racial distinctions, this accident brought certain privileges. He was literate, the owner of a good personal library, and did not have to work with his back and his hands; in 1876, he even wrote and published a Spanish grammar book. His service as a young man with one of the Mexican armies that drove out the French granted him a certain immunity from harassment over his liberal political beliefs. His wife, María, was fifteen years younger than Diego, a member of the growing Mexican majority of *mestizos,* part European, part Indian. Her family considered itself part of the "respectable" bourgeoisie and she was one of the small number of Mexican women who were educated (by home tutors). But Diego Senior must have encountered some social censure when he married her. He was secular, anticlerical, a Freemason, a believer in the reform constitution of 1857. His young wife was conventionally religious. She regularly attended mass, usually in the company of two unmarried sisters.

Eighteen months after birth, Diego's twin brother died. For María, even religion was no consolation. "My mother developed a terrible neurosis, installed herself beside his tomb, and refused to leave," Diego said, more than a half century later. "My father, then a municipal councillor, was obliged to rent a room in the home of the caretaker of the cemetery in order to be with her at night. The doctor warned my father that unless my mother's mind was distracted by some kind of work, she would become a lunatic."

With the encouragement of Diego Senior and the concerned families, she went to study obstetrics at the state's school of medicine. Her melancholy passed. She finished the course in half the usual time, becoming one of the first female obstetricians ever to graduate, and was soon working as a midwife.

Life did not get better in Guanajuato. Under pressure to earn more money to support the family and the upkeep of the house on Calle Pocitos, Diego Senior borrowed money to try his luck in abandoned silver mines. But the veins were indeed played out and the hope of one final score vanished; Diego Senior would be in debt for the rest of his life. To make matters worse, in 1891 María gave birth to another child, a girl the Riveras named María del Pilar. At the same time, while Díaz tightened his grip on the country, Diego Senior was beginning to pay a price for the open expression of his political beliefs. There was a growing ostracism, a closing of doors. He understood one irony

of writing about the plight of poor Mexicans: they could not read. He and other liberals of the era were largely directing their arguments at the deaf.

There were, however, consolations. He and his wife had begun to notice a certain precocity in little Diego. The boy talked a streak and enjoyed tagging along with his father on the rounds of cafés and barbershops and the shacks of railroad workers. His curiosity seemed limitless. He learned to read at four. He spent hours taking apart toys, purchased from a shop called El Canastillo de Flores. He could also draw.

"As far back as I can remember," he later wrote, "I was drawing. Almost as soon as my fat baby fingers could grasp a pencil, I was marking up walls, door, and furniture. To avoid mutilation of his entire house, my father set aside a special room where I was allowed to write on anything I wished. This first 'studio' of mine had black canvas draped on all the walls and on the floor. Here I made my earliest 'murals.'"

Some childhood drawings have survived. There is a bouncy version of a railroad locomotive and a caboose (the boy loved watching the trains arrive at the town depot). There is a well-drawn head of a goat, and others of toys. "From three to six, I drew machines and battles," he told journalist Alfredo Cardona Peña, many years later. "A great part of the time . . . the drawing was the expression of a real object that I had invented. I drew the battles, imagined them, on the basis of the stories my father told me about his campaigns against the French intervention and the Empire. I refused for a long time to draw mountains, owing to the fact that that although Guanajuato was surrounded by them, I didn't know what was inside them."[2] After his father took him on a trip into one of the mines that were cut into their slopes, the boy started drawing mountains. But none of the surviving drawings give any true indication of what was to come. They are the drawings of a relatively happy child and seem to give the lie to Diego's later statement that "My childhood was that of a little boy without a childhood."

Diego's life was certainly affected by the social pressure in Guanajuato and the heavy burden of family debt, which eventually drove María Rivera to an act of desperation. In 1892, while her husband was off on one of his tours of the countryside, she sold off most of the furniture in the house on Calle Pocitos, packed up her five-year-old son and baby daughter, and left for Mexico City. Diego Senior returned to an empty house. He soon followed his wife to the capital.

The Capital

The Mexico City of the 1890s was the country's metropolis, the showcase for the Porfiriato, but it was a small city compared to New York or London. There were then only about 400,000 inhabitants, including about 50,000 foreigners, and the memory of that more intimate city would infuse the nostalgia of gen-

erations to come. At 7,500 feet above sea level, with a springlike climate and air that was always clear, it was a sparkling town. Unlike Guanajuato, with its narrow cobblestoned streets and alleys, the capital was known for its broad boulevards: the Paseo de la Reforma, for example, was well on its way to equaling the Champs-Elysées as one of the great thoroughfares of the world. In the mornings, everybody could see the twin volcanoes, Iztaccíhuatl and Popocatépetl, rising another ten thousand feet above the city, snow forever white upon their peaks.

And though the Riveras were forced to move into what Diego later called "a poor house in a poor neighborhood," the city held many wonders. There were, to begin with, electric lights on the major streets and avenues and in the great public buildings of the Zócalo, which was the largest public square in the hemisphere. Gone were the melancholy yellow gaslights of Guanajuato; here was the glittering future. There were newspapers for sale everywhere, dozens of them, their headlines shouting about heinous crimes or the affairs of distant nations, the news brought to Mexico by the miracle of the telegraph. There were immense terminals for the railroads, connecting through the will of Porfirio Díaz with every part of the Republic on eleven thousand miles of new tracks. Electric streetcars were beginning to move along the avenues, frightening the horses and providing great fun for the newspaper cartoonists. There were buildings more immense than any young Diego would have seen, here in the place they called the City of Palaces.

The Riveras were not rich enough, of course, to take full part in Mexico's Belle Époque. They could not easily pay the admission prices into the city's eighteen theaters with their fare of French farces, Spanish classics, and domestic middle-class dramas. Still, they were better off than many others. In spite of the much-publicized accomplishments of the Porfiriato, the average life span in Mexico was twenty-four. One reason for that appalling average was that half of all infants died in the first year after birth.[3] Plumbing was primitive; disease often seemed as widespread as illiteracy. Among the poor of Mexico City, most of whom lived without the amenities of sewers, running water, or those glittering electric lights, life was hazardous. Smallpox, diphtheria, and typhus were rampant; cholera was a regular visitor. The Riveras were not immune to the hazards. María Rivera was soon pregnant again, and sick; she gave birth to a boy named Alfonso who died within a week. And in the months after their arrival in the capital, young Diego was stricken with scarlet fever, typhoid, and diphtheria.

The boy's illnesses, combined with the relative poverty of the family, kept him home from school, reading and drawing, often cared for by his great-aunt Vicenta, who introduced him to some of the wonders of Mexican folk art. But then things began to improve. After working for a while as a cashier in a restaurant, Diego Senior found a job as a clerk in the Department of Public Health, his mother began to get work as a midwife, and the Riveras moved out of the squalor of the center of the old city into a newer neighbor-

hood, near the present Monument to the Revolution. In 1894, when young Diego was eight, he was enrolled at last in school. His mother made the choice: a Catholic institution called the Colegio del Padre Antonio. He lasted only three months. The following year he was transferred to the Colegio Católico Carpantier. Here he did better. According to Diego's biographer Bertram D. Wolfe:

"A report card for August 1895 shows him a bright pupil in the Colego Católico Carpantier, 'perfect effort and proficiency,' several latenesses under 'attendance,' condemnation with faint praise under the heading of 'cleanliness.' The habits of coming late, bathing not too frequently or zealously, and dressing carelessly were to remain with him all his life."[4]

But the spoiled Diego was unhappy at this school too. Once again, he dropped out. It was infinitely more fun to wander among the *ahuahuete* trees and iron benches of the Alameda Park, gazing at people, or to go with his father on Sunday mornings to the vastness of Chapultepec Park, than to labor with iron rules of grammar. He moved on to the Liceo Católico Hispano-Mexicano, where he responded to the teaching of an "intelligent priest" named Father Servine.

"Here I was given good food as well as free instruction, books, various working tools, and other things," he would say later. "I was put in the third grade, but having been prepared well by my father, I was soon skipped to the sixth grade."

The *liceos* of Diego's childhood took as their models the lyceums of France. In those waning years of the nineteenth century, culture in Mexico City was a peculiar hybrid, and one filled with ironies; the lyceum system was only one of them. Porfirio Díaz had made his early reputation as a fiercely intelligent general in the service of the great democrat, Benito Juárez. He was a hero in the war that in 1867 finally drove the French out of Mexico and their conservative sponsors out of power. Twenty years later, Díaz had destroyed every pretense to democracy, and the ruling class, still suffering from that inferiority complex peculiar to people shaped by a colonial heritage, was increasingly enslaved to the fashion of all things French. Clothes, furniture, books, music, and art were all imported. So were ideas. The influence of French architecture could be seen in the mansions of the newly rich on the Paseo de la Reforma. The most fashionable restaurants were French. Every rich family employed a French governess; every striving middle-class family yearned for one. The children of the rich were sent to Paris to complete their educations. Those who stayed home could complete another sort of education by visiting those whorehouses that were modeled on French bordellos. One Mexican composer wrote an opera about the life of Nezahualcóyotl, the Aztec poet-king, but the title and libretto were in French. Even among the lower classes—made up of those who had just arrived from the provinces after losing their bits of land to the expanding power of the big landowners—there was a French influence. The Mexico City police force

was organized on the model of the French *gendarmerie,* down to the blue uniforms and the colonial kepis. It would have been comical if the guns and secret police of Porfirio Díaz had not made it so serious.

The regime of Don Porfirio was laced with ironies that could not have escaped Diego's politically astute father. Porfirio Díaz was himself a *mestizo,* but he surrounded himself with white advisers and white servants and encouraged white immigration from the United States and Europe. The ideology of the Porfiriato was derived from Europe: a hybrid of the positivism of Auguste Comte and the fashionable theories of social Darwinism. The theory of Comtean positivism was introduced to Mexico by another native of Guanajuato, a physician and educator named Gabindo Barreda. He had been a student of Comte in Paris and helped impose the principles of positivism on the Mexican nation's educational system as "a philosophy and educational system, and as a political weapon."[5] In practice, this meant that an elite made up of intellectuals, businessmen, and technocrats (they called themselves *científicos*) would use the latest scientific knowledge to cure social maladies. At the same time, the plight of the poor would be resolved by the principle of survival of the fittest. The economy, as guided by the brilliant treasury minister, José Yves Limantour (son of a French immigrant), was an early version of "trickle down" economics. The *científicos* believed that a postcolonial nation, particularly one as wounded by civil strife as Mexico had been for a half century after independence in 1821, first had to create wealth before it could ever think of sharing it with the poor. As a result, the weak would die in squalor; the strong would hire French governesses.

The Mexico City of Diego's adolescence was the product of these theories—and the long history that had preceded them. The heritage of the Conquest was a complex mixture of arrogance, cruelty, passivity; these did not vanish with independence. Conflict remained general. Conservatives conspired to maintain the old order, with the Church and the army as their allies. Liberals waved the banners of anticlericalism, and in the wars of reform had effectively broken the secular power of the Church. But Porfirio Díaz, who had fought for the liberal cause, was not the first leader to be transformed by power into a conservative. He relied on the guns of the army and his special national force called the *rurales* (often made up of semi-reformed bandits granted amnesty and respectability). He reached an accommodation with the Church, cheerfully ignoring the anticlerical strictures of the constitution he had once fought to restore. He opened the country to massive American, British, and Spanish investment. Driving hard to modernize Mexico, Díaz won the approval of the world when he balanced the budget in 1894, for the first time in Mexican history. He would end up witha trade surplus. Everything else could wait.

So there was often misery in the countryside, accompanied by seizures of "unproductive" land and the reduction to peonage of many *campesinos*— those who lived in the *campo,* or countryside. Even in Mexico City, the apex

of the Porfirian pyramid, there were brutal divisions between the classes. The police of Don Porfirio penned the poor into wretched ghettos, where murder was a casual affair, health precarious, education nonexistent. On one street, Diego might see men in bowler hats and women wearing bustles and feathered boas; on another, he could witness the police battering a man into unconsciousness for the crime of walking barefoot into a "good" neighborhood. Memories of this era would accompany him for the rest of his life and inform some of the best and worst of his art.

The Youngest Art Student

When he was ten, Diego Rivera found his way to the life of art. He loved drawing more than anything else and demanded that his parents get him into art school. The father was unsure; Diego's sketches of battles and troop formations made him think the boy should be groomed for the army; his drawings of trains suggested a career as an engineer. But his mother liked the notion of Diego as an artist. Somehow, aided by the boy's size (he was taller and bulkier than other Mexican children of his age), she got him admitted to evening classes in the San Carlos Academy of Fine Arts. He would continue his formal schooling by day; in the evening he was beginning his long apprenticeship.

The San Carlos Academy had a long history in Mexico. It was chartered by the Spanish crown in 1785 and had served as training ground for generations of Mexican painters, engravers, lithographers, and architects. When Diego

Rivera was admitted to the day school in 1898, the curriculum was rigidly traditional, emphasizing technical skill, high polish, and rigorous analysis of the visible world. That is, he was shaped by an artistic curriculum filtered through positivism. On some important levels, this approach certainly had an appeal to young Diego: the boy who took apart his toys, drew locomotives, and could not draw mountains until he was inside one—that was a boy suited to the final years of the Mexican nineteenth century.

For most of its history, San Carlos was a gloomy prisoner of the European tradition, a condition made worse by the familiar time lag between mother country and colony. The school's directors were usually imported Spaniards, beneficiaries of a policy that was even more rigidly enforced during the Porfiriato. Right up to Diego's time, most attempts at creating a *Mexican* art were discouraged. Students at San Carlos spent months, sometimes years, copying classical busts or engravings of European paintings. Meanwhile the most vigorous art of the era was being made by less privileged Mexican artists: those who created cartoons, political engravings, and every variety of folk art. Even vernacular Mexican architecture had greater vitality than the pompous marble rhetoric of official buildings or the imported French homes of the rich that were often equipped with mansard roofs for snow that never fell.

This aesthetic inferiority complex was easy to observe the year that young Diego started as a day student. The San Carlos Academy's major show in 1898 was of Spanish paintings, thus affirming the taste and assumptions of the educated classes while simultaneously offering models to the Mexican art students. The acres of rigid Spanish academic painting brought scorn from a periodical called *El Hijo del Ahuizote:* "We hear talk of what a difference there is between the Mexican works and the Spanish ones. Only too common among us is the impulse to praise what is foreign and to deprecate what is national, and this regardless of quality."[6]

Cartoons in the popular press mocked the 1898 show, but we have no records of what twelve-year-old Diego Rivera thought about the dispute. He was industriously doing his schoolwork, a boy among young men. In his later researches in the archives of San Carlos, Jean Charlot did find "a childish copy of a rococo plaster ornament in low relief" signed by Diego, along with other student works. These were done in the boy's first two years at the academy, and the records indicate that his work pleased his instructors.

"From the same hand, and slightly later in date, a Venus de Milo and a bearded bust of Homer were copied from the round," Charlot wrote. "With hindsight we can discover in the faceting of Homer's beard a seed of the preoccupation with geometric forms that characterizes Rivera's Cubist period. And surrealism could be said to hover over the Venus drawing, inasmuch as she is represented as standing on her head. This unconventional posture, however, was but a device used by his academic teachers to instill in the boy an appreciation of proportions *per se.*"[7]

OPPOSITE:
Head of a Woman. 1898.
Pencil on greenish blue paper,
14¼ x 11⅛″ (36.2 x 28.3 cm).
Escuela Nacional de Artes
Plásticas, UNAM, Mexico City

The rigidity of the instruction was not all wasted on Diego. The dean of the school was a somber bearded painter and etcher named Santiago Rebull. He had arrived at the school as a nineteen-year-old in 1848, and was still there fifty years later. Along with many of his contemporaries, he believed that Jean-Auguste-Dominque Ingres was the greatest of all the century's artists and insisted that his students emulate the pure linear draftsmanship of the master.

In a way, Ingres fit perfectly into the prevailing spirit of positivism: his greatest works were a triumph of reason over passion, dominating most of the nineteenth century with their rigor and exactness. Decade after decade, whether living in Roman exile or in full sway in Paris, Ingres had held the line for classical lucidity against the forces of romanticism led by his great rival (and bitter enemy) Eugène Delacroix. When Ingres died at eighty-seven, in the fateful Mexican year of 1867, his influence had spread far beyond Europe.

The Mexican-born Rebull was said to have studied in Paris with Ingres while a young man. When Diego arrived in the worn stone corridors of the academy, Rebull was in his seventies and still a follower of the austere artistic cult called the Nazarenes. This monkish sect, which was extremely influential in Europe from 1818 to the 1840s, made a religion of art. The practice of Ingres and the Nazarenes, with its insistence on enameled surfaces free of any evidence of the brush and driven by fidelity to the High Renaissance, influenced the method of instruction at San Carlos as it did most art academies in the United States and Europe. For the first two years, Rebull and the other senior instructors had their students draw from reproductions (with supplemental examples added from the "modern" craft of photography). The copying of reproductions was followed by two years of drawing from plaster casts before students could move to the live model. Diego and the other would-be artists were being trained to make their hands obey their mental commands, while simultaneously mastering tonal values and the technique of chiaroscuro. Ingres, after all, said often that color was always subservient to drawing. Years later, when Diego Rivera had been recognized as one of the finest draftsmen of the twentieth century, he remembered Santiago Rebull with some fondness:

"One day, when a class of about fifty students was painting a model, he singled me out. He found fault with my drawing, but he said, 'Just the same, what you're doing interests me. First thing tomorrow morning, come to my studio.' The other students flocked around to see what had interested old Rebull enough to extract an invitation to his studio, to which he had

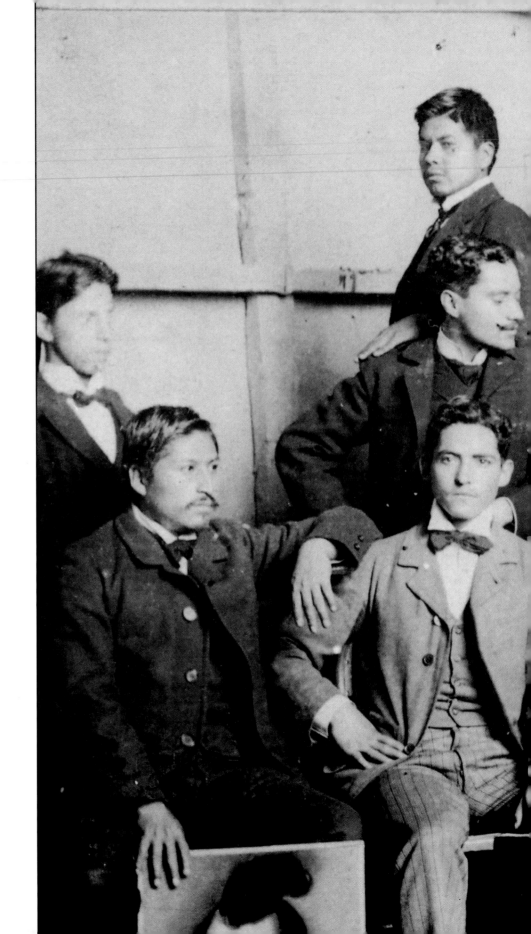

Diego Rivera (back row, center)
with his teacher Antonio Fabrés-Costa
and fellow students at the San Carlos
Academy of Fine Arts, 1902.
Fabrés-Costa replaced Santiago
Rebull in 1902 after the latter died.
Museo Diego Rivera, INBA, Guanajuato

admitted no student for twenty years. They could see nothing and ascribed his enthusiasm to a senile whim.

"But the next day the old man told me what he had discovered in my work was an interest in life and movement. Such an interest, he said, is the work of a genuine artist. 'These objects we call paintings,' he went on, 'are attempts to transcribe to a plane surface essential movements of life. A picture should contain the possibility of perpetual motion.' Rebull made me more aware than I had yet been of the laws of proportion and harmony, within which movement proceeds, and which are to be discerned in the masterpieces of all ages."

Rebull also instructed Rivera in composition, emphasizing the use of the Golden Section, a theory of proportion that dates back to the first century B.C.[8] The Golden Section was probably added to the program at San Carlos by the Nazarenes on the faculty. But the elevation of the geometric pseudo-formula was another example of the way the philosophy of positivism was permeating most aspects of Mexican education, even that of artists. The effect on the boy was clear: he was learning that there were rules and scientific principles behind everything. Throughout his life, both in his Cubist phase and in his commitment to Marxism, Rivera continued to insist on the presence of rules.

Two other teachers were important to the emerging artist. One was Félix Parra. He was also a Nazarene. His own paintings were conventionally dark and forbidding, but he had a great love for the art of pre-Conquest Mexico and communicated it to his students, including young Diego Rivera. There is no evidence in his surviving student work that Diego translated that enthusiasm into drawings or paintings (just as there is absolutely no evidence that he apprenticed himself to the great Mexican engraver José Guadalupe Posada, whose storefront studio was a few blocks from the art school). The other teacher was José María Velasco, who was probably the finest painter of the Mexican nineteenth century.

Velasco was not a dogmatic man, but his presence could be felt throughout the institution; by the turn of the century he was laden with honors. It is not clear when young Diego Rivera first studied with him. It is certain that he studied perspective with Velasco in 1902 and entered his landscape painting class the following year when the painter was sixty-three. Velasco was also a graduate of the San Carlos Academy, receiving his final student prize in 1868 from the hands of Benito Juárez himself. He was a fine portrait painter, sensitive to character as revealed by posture, hands, and the set of the human face; his own self-portraits are among the finest made in this hemisphere. But he was famous for his luminous landscapes, particularly of the Valley of Mexico and its two spectacular snow-peaked volcanoes, Popocatépetl and Iztaccíhuatl. As a student, Velasco had studied geology, zoology, physics, and botany, in the spirit of scientific analysis and the thirst for knowledge that characterized the time. That knowledge informs his extraordinary landscapes,

where the corn is corn, the nopal is cactus, and the dry rivers and weathered rocks are emblems of Mexico, while the painting is above all a painting, the work of a man. He is, like Vermeer, a painter of light. His mastery of light can be seen in the subtle modeling of clouds and the rendering of sky and above all the bleached delicate painting of his horizons. Velasco's landscapes suggest the immense distances and emptiness of the great Mexican plateau, his planes perfectly and subtly placed to force the eye to the pale light-soaked immensity of the sky. He felt no need to add a quality of tropical melodrama to his vistas; they are as dry as the high mesa with its clarifying light. Even the shadows have air.

When young Diego came to the master's class, Velasco was in the final stages of his career as painter and teacher. His abilities were not sufficient to guarantee his employment; he was not a master of institutional politics. His class in perspective had been taken away from him in January 1903, with a corresponding reduction in salary. The new director of the school, an architect named Antonio Rivas Mercado, wanted to emphasize architecture at the expense of painting (he was the designer of the Angel of Independence column on the Paseo de la Reforma that has become the symbol of Mexico City in the same way that the Eiffel Tower now stands for Paris). In an intramural struggle with the fine-arts faculty, Rivas Mercado took the side of modernity, the spirit of the new century. In practice, too many changes were accomplished in a heavy-handed way. In a country that placed great emphasis on courtesy, Rivas Mercado committed many sins against manners. He apparently viewed Velasco as just another member of the parochial Mexican old guard instead of the fine artist and serious educator that he was, and brutally insisted on his removal. The sensitive Velasco was deeply wounded by the callousness of his treatment, but it does not seem to have affected his teaching.[9]

For Rivera, the politics didn't matter. After so much indoor work and grinding adherence to the classical ideal, the youth clearly welcomed the chance to gaze at the Mexican landscape in the company of a master. Some of the lessons he absorbed lasted a lifetime. Jean Charlot later pointed out that Velasco's solid teachings saved Rivera from the more conventional versions of Impressionism then being taught in art schools in Europe and the United States.

"Instead," Charlot wrote, "his (Velasco's) severely logical approach to optical problems prepared the adolescent for the further rationalizations of Cubism."[10]

At one point, Velasco corrected one of Rivera's landscapes and gave him the following advice:

"Boy, you can't go on painting like that. In the foreground, you put, side by side, yellow spots for sunlight and blue spots for shadow; but yellow comes forward and blue recedes, so you destroy the very plane that you pretend to describe."

Such practical advice, along with the weaving of theory into practice and

the insistence on the *seriousness* of the artistic enterprise, moved Rivera, years later, to praise the old master:

"He had no precedent in the entire history of art nor has he had a successor yet. Velasco came to be and remained unique in the life of art. His genius possessed such greatness that he developed an enormous simplicity taken from the appearance of the physical world, when in reality his paintings were pure creation. . . . He created a world parallel to the physical world, so near to him as air or the surface of water in a lake; yet they are a different world. That parallelism makes mediocre men think, when they see one of Velasco's paintings, that they are looking at a photograph. . . . In reality, Velasco created a new visual world. . . . Velasco's art work is greater than a mural painting and a pyramid, it is a poem of color with mountains as its stanzas."

Through all his years at San Carlos, Rivera found refuge from the austerity of the school in the nearby markets and along the canals (now vanished) that had survived since the days when Mexico City was still Tenochtitlán. The profusion of fruits and vegetables, the stalls abundant with flowers, the brightly colored peasant serapes and rebozos, gorgeously embroidered skirts and blouses, were a feast to the eye. So were the murals painted on the walls of *pulquerias,* the bars where the fermented cactus drink called *pulque* was served, windowless (by law), womanless, and forbidden to children. They were urban Mexico, but there are no records showing that Rivera ever painted them.

Perhaps he didn't see what was truly valuable because he was simply too young. Charlot has written about a fellow student, Ignacio A. Rosas, who remembered how "Rivera came to school in short pants and shocking-pink socks, his pockets stuffed with fearful boyish things—bent pins, odd bits of string, and earthworms that wriggled freely minus the luxury of a container. Between classes, and presumably more often, the fat boy would sneak out through back streets with low-brow names—de la Alhondiga, de la Lena, de Machincuepa—and, sitting on the bank of the canal, feet dangling close to the stinking waters, fish."[11]

So, as the century turned, young Diego Rivera shifted back and forth, from boy to precocious art student to boy. For most of his time in San Carlos, he was so much younger than the other students and looked so different, with his bulging froglike eyes and short pants and large fleshy body, that he must have begun to design the first of the many masks that would keep him safe. In his late teens, he kept company with other young men from San Carlos, full of poetry and macho dreams, living a version of the bohemian style on the fringes of Porfirian certainties. But there was no sign of revolt or rebellion in his art; he seemed destined to be a painter of conventional gifts and no ideas at all. He learned much at San Carlos, and not the least of the lessons was the habit of work. He would become in later life one of the most industrious of artists, famed for his twelve-hour days. Painting was his card of identity. He would not be the first (or last) artist to wear his talent like armor.

OPPOSITE:
Landscape. 1896–97.
Oil on canvas, 27½ x 21⅝"
(70 x 55 cm). Collection
Guadalupe Rivera de Iturbe

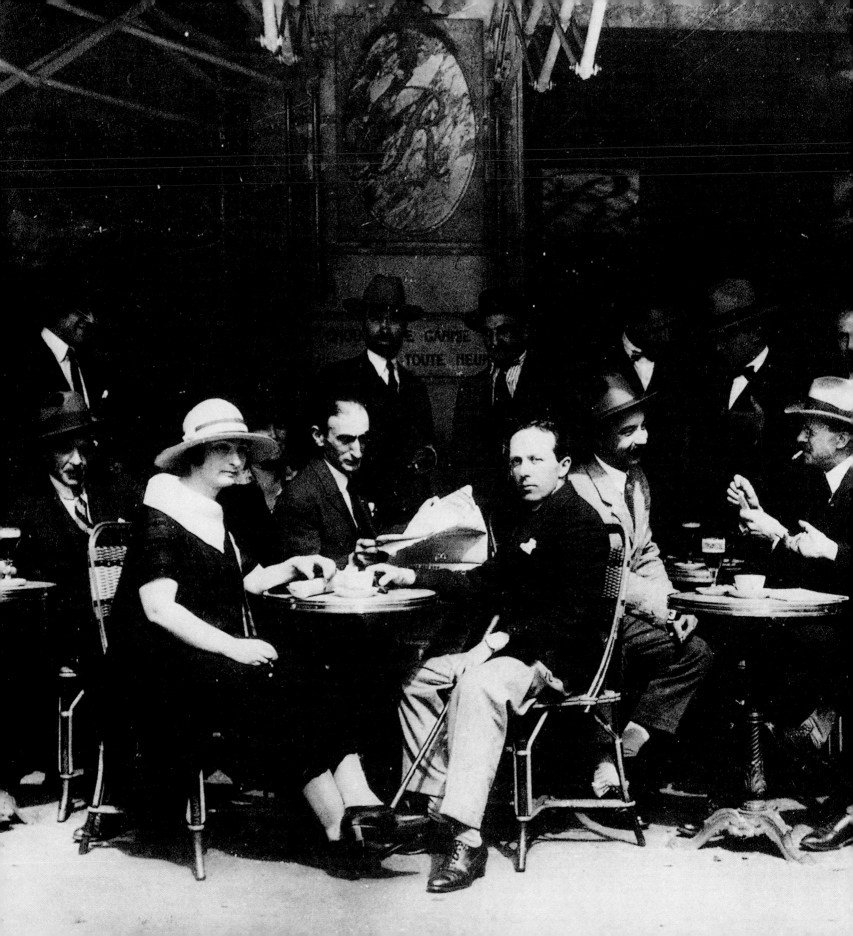

Chapter Two
EUROPE

In the fall of 1905, as Diego Rivera entered his final year at the San Carlos Academy, his great rival was a gifted young painter and exact contemporary from Guadalajara named Roberto Montenegro, who was in many ways his polar opposite. In a formal, conventional way, Montenegro was better educated than Diego. Montenegro was lean while Rivera was plump. Montenegro was often diffident and aloof in the elegant style of the middle classes of the northern state of Jalisco, while Rivera was increasingly given to elaborate tales and a bawdy big city style. Montenegro dressed with great élan while Rivera often looked like an unmade, paint-spattered bed. Montenegro had been privately tutored by his first cousin, the Mexican *modernista* poet and novelist Amado Nervo, and was sophisticated about literature and music; Rivera was eclectic and uncertain in his own tastes and knowledge. It was an almost Balzacian contrast, with a good dose of irony: the provincial was more sophisticated and knowing than the young man from the capital.

The rivalry, however, was about something more substantial than personal style. It was about art. Montenegro was a gifted draftsman, solidly trained, with a taste for the symbolist style then current in France. And though Montenegro was a late arrival at San Carlos, coming from the provinces for this final year in the capital, he soon joined Diego and other students in El Grupo Bohemio. This was a loose group of talented students, mentored by an older faculty member, Gerardo Murillo, who later called himself Dr. Atl (he based the pseudonym on the Nahuatl word for water). Dr. Atl was from Guadalajara; he was eleven years older than Rivera and Montenegro and was just beginning to play an important role in the history of modern Mexican art. He urged all his young acolytes to drink from the currents of

Expatriate painters gather on the terrace of the Café Rotonde, Paris, c. 1925. From about 1911, the Rotonde was a popular hang-out for artists of all nations.

modern art, to abandon the cramped parochialism of Mexico and find a way to go to Europe. An eye infection had forced him to cut short his own European sojourn in 1903 (most of it spent in Rome), but he had seen enough to preach the virtues and astonishments of Post-Impressionism: Paul Gauguin, Paul Cézanne, Giovanni Segantini, and others. At this time his own paintings were of minor interest, much tamer and more conventional than the work he was praising to the young. His influence was primarily inspirational; he was a better coach than a player.

"Atl had a great feeling for color," Rivera later wrote, "and a passionate love for landscape, which he communicated with a missionary zeal."

Politically, Atl was an anarchist, a vehement believer in individualism, and Rivera later insisted that he shared that creed with the older man. But by most accounts the student group was more traditionally bohemian than political, given to beery discussions of art, poetry, music, and women rather than the ills of society; there is no evidence, for example, that they were stirred by the failed revolution that took place in 1905 in distant Russia. And though Diego Rivera would later claim to have been a revolutionary since childhood, he planned no revolutions as a member of El Grupo Bohemio. He and his friends certainly did not become agents of subversion against the regime of Porfirio Díaz.[1] They signed no manifestos. They formed no guerrilla bands. They seemed to accept the permanence of the eternal Porfiriato. Even their art displayed no revolutionary tendencies. It was as conventional as a sunset.

In the spring of 1906, the rivalry between Montenegro and Rivera reached a turning point. Both were in contention for the top prize available to young graduates of the academy: a fellowship to Europe. Under the rhetorical sway of Dr. Atl, and convinced that their artistic educations would be incomplete without a sojourn among the masters, they each wanted desperately to win. Although Rivera was regarded highly by the faculty, the prize went to Montenegro.[2] This was not the end of the rivalry. It would continue, up close or at a distance, for more than a decade.

By most accounts, young Diego survived this defeat with grace. If he felt humiliated, he did not express it to anyone. He turned to his father. The older Rivera was no longer the passionate advocate of change that he had been in his days as a schoolteacher in Guanajuato. Wiser and wearier, he had made his accommodation with the Porfirian system, and he was capable of pushing an occasional lever to help his family in spite of his private, abstract opposition to the regime. In his years of government service, he had made many friends, among them the governor of the state of Veracruz, a cultivated man named Teodoro A. Dehesa. In 1902, Dehesa had granted young Diego a small scholarship to help him through San Carlos. Now, after the loss of the prize in 1906, both Riveras traveled to Veracruz for an audience with Dehesa. They brought samples of Diego's drawings and paintings, which were accomplished within the conventions of the day and certainly not radical. The dis-

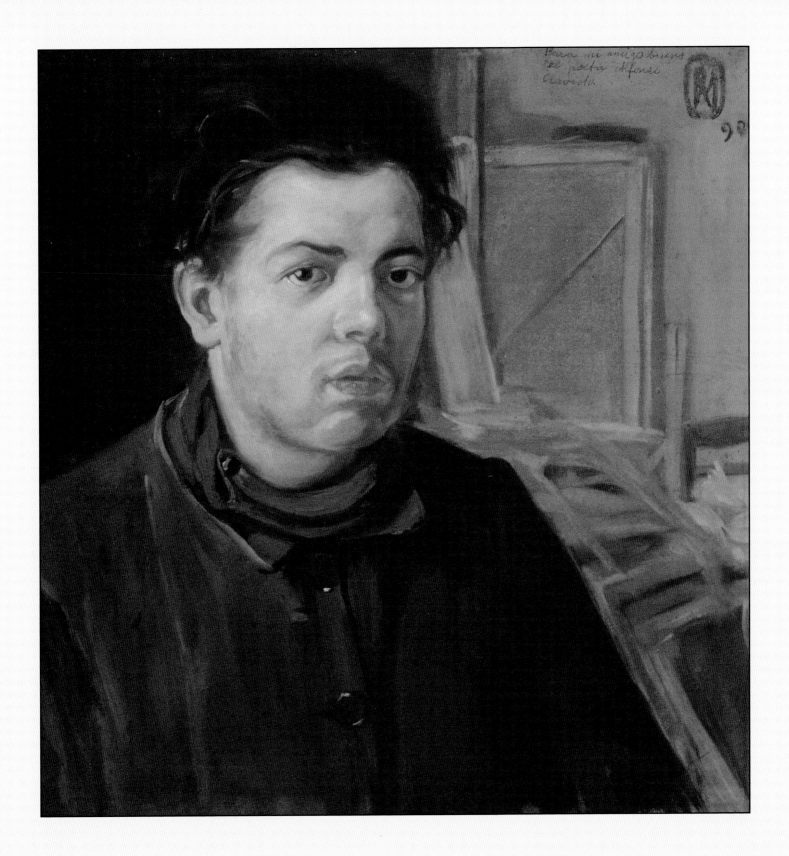

cussions with the governor must have been happy ones. Before leaving Veracruz, Diego had what he wanted: the guarantee of a modest traveling scholarship of three hundred pesos a month. On that he could live and paint in Europe for several years.

First he had to raise the steamship fare. Once more friendship proved useful. Dr. Atl included about a dozen of Diego's oils, pastels, and crayon drawings in a show of student work. Most of the paintings that have survived, including *Citlaltépetl (The Peak of Mt. Orizaba)*, are landscapes, the craft solid, the technique highly finished, but giving off an aura that is slightly musty; they resemble a young man's stories, written out of reading, not living. This didn't matter at the time; they brought Diego the money he needed. Dr. Atl was delighted. It was his custom to take a cut from the sales of student paintings that he exhibited, in order to support himself and his own work. In the case of Diego, he gave the younger man all the money and added some of his own. He also provided Diego with letters to friends in Madrid.

At last, Diego was going to Europe. He did not follow the route of his rival, Montenegro, who went to Paris, where he would quickly encounter the expatriate Spaniards, Pablo Picasso and Juan Gris. In retrospect, Rivera was clearly the more conventional of the two. He chose to go to Spain, at a remove from the currents of modernism. He was twenty years old. He stood a hair over six feet and weighed more than three hundred pounds.

Spain

Diego Rivera reached Spain on January 6, 1907, on the ship *Alfonso XIII*. Years later, the moment of arrival still filled him with excitement:

"I remember, as if I saw it from another point in space, outside myself, a dimwit of twenty, so vain, so full of the blackheads of youth and dreams of being master of the universe, just like all the other fools of the age. The age of twenty is simply ridiculous, even when you're talking of Genghis Khan or Napoleon. . . . Diego Rivera, standing erect on the foreship of the *Alfonso XIII*, looking at the ship and how she cleaves the water, her wash foaming behind her, bawling out passages from *Zarathustra* in the face of the profound and melancholy silence of the ocean, is the most pathetic and kitschy thing I know. That was me."[3]

He arrived in fog at Santander, then took a train to Madrid. He carried with him a letter from Dr. Atl to a fashionable Spanish painter named Eduardo Chicharro y Aguera. At the time, Chicharro was counted one of the more talented younger painters in Spain, working in the sun-drowned Spanish Impressionist manner of Joaquín Sorolla and Ignacio Zuloaga, while adding to his paintings bits and pieces of symbolist orthodoxy and Spanish regionalism. Rivera would study under him for several years.

In those first months, he was very much the colonial arriving in the

mother country: unsure, green, hesitant to force himself upon others. In Madrid, he lived in the Hotel Rusia on Calle Carretas, which was close to the Café de Pombo, the gathering place for many of the painters, writers, and intellectuals of the Spanish capital. Slowly, sponsored by Chicharro, he became a regular. He watched. He listened.

He also frequented the Prado, studying and absorbing Old Masters, especially Diego Velázquez, Francisco Goya, El Greco, Pieter Brueghel, Lucas Cranach, and Hieronymous Bosch. All would shape aspects of his own vision. Later Rivera claimed to have become such a masterful copyist that three of his "Goyas" and one "El Greco" ended up in collections in Paris and the United States. This was almost surely an invention, but even the tall tale is a kind of homage to their genius. Rivera was saying: I could do that.

Rivera came to speak about those first years in Spain with a certain regret: "The inner qualities of my early works in Mexico were gradually strangled by the vulgar Spanish ability to paint. Certainly the flattest and most banal of my paintings are those I did in Spain in 1907 and 1908."

This is a shrewd self-assessment, although characteristically, Rivera did not go deeper into his own youthful personality to explain why. Some of the surviving paintings display his skill: *The Forge, The Fishing Boat,* and the handsome *Old Stone and New Flowers.* Unfortunately, thousands of similar paintings were being made from New York to Moscow at the time. In Paris in 1907, the twenty-six-year-old Pablo Picasso was painting *Les Demoiselles d'Avignon,* the first great explosion of an artistic revolution. But Diego Rivera, only five years younger than the great Spaniard, remained just another academic painter with an eye for the conventionally picturesque. He was obliged by the terms of his scholarship to send paintings to Governor Dehesa in Veracruz, as a kind of proof that he was working. In a way, Rivera was making at least some of his paintings for an audience of one. He would not be the first poor boy to play it safe in order to eat.

This is not to say that young Diego was wasting his time. At the Café de Pombo, he was supplementing the education he was receiving in the galleries of the Prado. He forged some important friendships with older intellectuals and artists. One was Ramón Gómez de la Serna, an influential critic and later a Dada poet; he was to serve as Diego's guide through the bohemia of Madrid. Perhaps more important, Rivera also became friendly with Ramón del Valle-Inclán, one of the finest Spanish novelists of the era, and a man who loved Mexico, where he had traveled in 1892 and 1893.[4] When young, Valle-Inclán had lost his left arm as the result of a disastrous café brawl. He was famous among his acquaintances for the fantastic versions he created of this event: Rivera evidently admired this gift for fabulous lies and he made it part of his own mature character. In addition to the two Ramóns, Diego came to admire the person and work of a painter of considerable originality named María Blanchard, who was also a student of Chicharro. All were full of the theories and gossip of the avant-garde, including tales of those Spaniards who

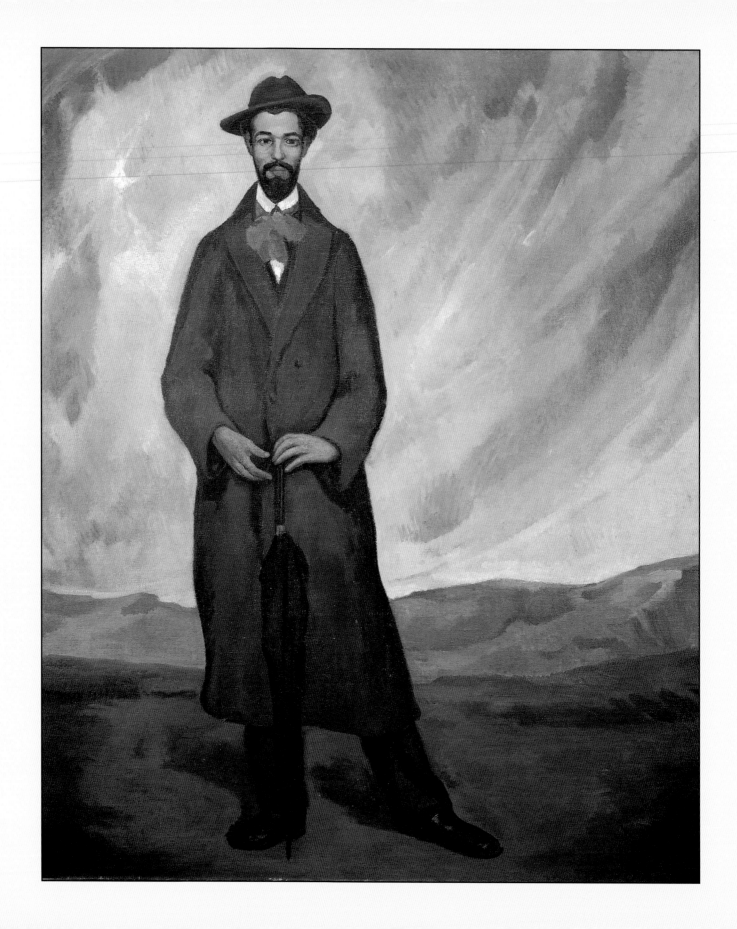

had already chosen to live and work in Paris: Picasso, Juan Gris, the sculptor Julio González. As young Diego Rivera labored on in Spain, unhappy with his work, Paris was beckoning from beyond the Pyrenees.

Paris and Angeline

The person who finally convinced him to abandon Madrid and head north was Valle-Inclán. In the spring of 1909, supposedly financed by winnings from a night in a Spanish casino, Rivera and Valle-Inclán took the train to Paris and checked into the Hotel Suez on the Boulevard St-Michel in the Latin Quarter. The hotel catered to art students from Spain and the Americas, and Rivera was delighted to be assigned a small room in which the painter Julio Ruelas, "precursor of surrealism," had recently died. After the austere gray of Madrid, Paris was to Rivera, as it has been for thousands of other young artists, a delight. He prowled the Louvre. He painted in the open air beside the Seine. He sat in the cafés and listened and argued and sketched.

He later claimed that his social conscience drew him to the work of Honoré Daumier and Gustave Courbet; there is no sign of either in his drawings or paintings of the time. "Though aware of their examples," he wrote later, "I was slow and timid in translating my inner feelings on canvas. I worked at my canvases in an indifferent, even listless way, lacking the confidence to express myself directly." One painting of that year, *Notre Dame de Paris,* shows that he was looking at Claude Monet: the dark earth colors of the foreground, with its remorseless modern machinery, are placed against the misty atmospheric blues of the cathedral, the whole executed in thick Impressionist impasto. Part of the canvas suggests the painter to come: the clouds are painted in many small layered strokes, a technique that Diego would later use to the point of mannerism.

In the summer, he began traveling beyond Paris. He visited the old medieval town of Bruges, on the coast of Belgium, with another Mexican art student, a young man named Enrique Friedmann; they might have been amused by the name of the town in Spanish, Brujas, which means "witches." Diego was to make some solid paintings along its canals and streets: *House on the Bridge,* with its bold scribble of light on opaque oily canal water and its looming houses where no humans can be seen; the fine layered washes of *Reflections,* with its emphasis on the distorting qualities of water; the dark and mysterious monochrome of *Béguinage à Bruges,*[5] suggesting primitive secrets in houses without lights. In these pictures (some completed on his return to Paris), there was still no attempt to explode painting, no sign of the influence of Cézanne, whom he later would misleadingly claim to have already discovered, and there were no Rivera versions of the aesthetic experiments then common on the slopes of Montparnasse.

It is possible that Rivera examined paintings by such Flemish masters as

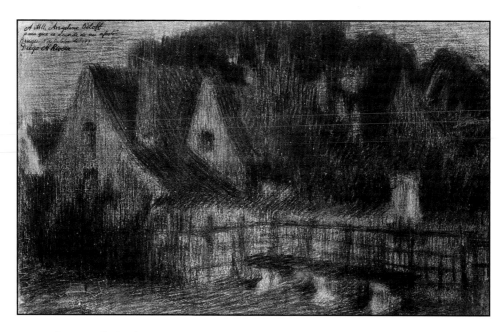

Jan van Eyck, Hans Memling, Rogier van der Weyden, and the famous *Last Judgment* of Hieronymous Bosch in the museum in Bruges. Certainly his Mexican heart would have been stirred by the mask paintings being made by James Ensor in nearby Ostend. Alas, there is no record of what he saw of other painters, past or present. Essentially, from the evidence of the surviving paintings, he was still doing more refined versions of what he had been doing in Spain. In 1909, his third year in Europe, Rivera was content to use his tools to express mood and place.

"I have often tried to find an explanation for the incongruity between my understanding of life and my way of responding to it in this period of my painting," he later wrote. "Probably the natural timidity of youth was a factor. But more potent, though I was little aware of it then, was my Mexican-American inferiority complex, my awe before historic Europe and its culture."

An important event in his long apprenticeship took place in Bruges. In a small inn, he ran into María Blanchard. She was traveling with a Russian émi-gré artist known as Angeline Beloff, who was destined to play a large role in the life of Diego Rivera.

Fair-skinned, blonde, with delicate features and hands and startling blue eyes, Beloff was born in 1879 in St. Petersburg. Her father, Michael Beloff, had been a liberal lawyer who, like Diego's father, ended up working in the government bureaucracy to support his family. Her mother, Catherine, was of Finnish-Swedish descent, personally reserved, devoted to her children. The parents wanted Angeline to be a doctor, and she began training at the university in St. Petersburg but soon insisted on switching to art school. As a scholarship student at the Academy of Fine Arts, she went through the Russian version of the same rigid academic training that Diego had endured at San Carlos, a world away. She made drawings from plaster casts. She

absorbed dry theories. And she made vague plans to support herself by teaching art.

Then, in 1908, everything changed. Her parents died within months of each other, leaving Angeline and four brothers with little money. Angeline was granted her share of a small pension by the Russian government and decided to use it to go to Paris. Aspiring Russian and Mexican artists had that, at least, in common: all artistic roads led to Paris. Arriving in frigid weather in February 1909, Beloff checked into a small *pensione,* stammering in school-girl French and longing for the well-heated homes of St. Petersburg. She enrolled briefly in the classes then run by Henri Matisse in a studio on the Boulevard des Invalides, but was baffled, perhaps scared, by the bold experiments with color she encountered in the master's atelier. She retreated to the Academia Vitti on the Boulevard Montparnasse and the more conventional classes taught by a small bearded Spaniard named Anglade Camarasa.

"His colors were very fine," she wrote in her memoirs, "but he emptied entire tubes of each color on his paintings, and as a result his canvases weighed as if they were made of lead. His clients were almost all rich Argentines and we said that he must have sold his works by the pound."[6]

In Camarasa's class, she met Blanchard and admired her talent and her will. Blanchard's spine had been damaged in a dreadful accident when she was a small girl, leaving her with a humpback.[7] "Her face was admirable," Beloff remembered, "and her beautiful eyes showed a great intelligence." They became close, swearing a "pact of friendship" in one of the towers of Notre Dame. In June, when classes ended, Beloff wanted to travel to Brittany; Blanchard insisted on Bruges. Arriving in gray, rainy weather, they went in search of lodging. The hotels were too expensive. They found a small café facing a fish market, with a sign offering rooms to rent. They went in. There was a large room with a bar on one side and a dining area on the other.

"At one of the tables two young men were eating," Beloff remembered. "When they saw us, one of the young men stood up, and came directly to María, his arms wide open. She embraced him in the Mexican style, which I got to know much better later, when I came to Mexico. That young man was Diego Rivera."

And so it began. Diego was sharing a room on the second floor with Enrique Friedmann. María and Angeline took an empty room on the third floor, after the shy Angeline arranged for an extra bed. The artists were not immediately comfortable together; Angeline spoke no Spanish and couldn't keep up with the others. Diego spoke very little French and absolutely no Russian. One night, Diego came to their room and talked with María for hours in Spanish. Angeline was exhausted, and bored, since she couldn't follow anything that was being said.

"When Diego left," she remembered later, "I said to María that if he returned the next night she should tell him I was sleeping and he couldn't come in. But María objected, saying that since Diego was Mexican, he would

OPPOSITE:
Béguinage à Bruges. 1909.
Charcoal, 11 x 18⅛"
(27.9 x 46 cm).
Museo Diego Rivera, INBA,
Guanajuato

consider this a great slight. And so he kept repeating his visits and my boredom was greater each time because I was forced to listen to them without understanding a word."

Another student arrived from Paris, a Pole named Vladislava, and soon the group of five painting friends were moving around the old city. Diego and Angeline together worked on a view of the house on the canal; Rivera painted it, and Angeline made drawings that she later developed into an aquatint.

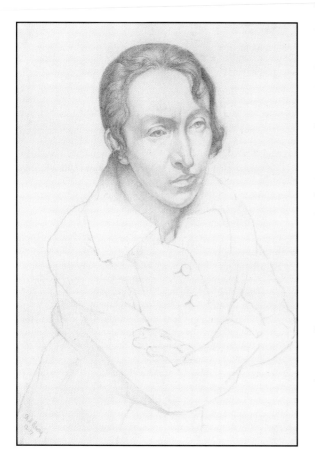

The night Diego decided to paint the Béguinage, Angeline declined to join him; the nights were too cold. Diego went painting with María Blanchard. This went on for a number of nights, and then María returned one night very late and clearly upset.

"It seemed that Diego had made a declaration of love," Angeline remembered, "directed at me, because he did not know how to tell me in French."

Beloff didn't take this seriously; Blanchard apparently did. They had a quarrel over another matter—the group went off to Gent without María, who kept delaying the short trip while she finished a painting. When they returned, María refused to speak to Angeline for days. This rupture could have been about Gent; it could also have been about Diego. In spite of this, the five all went off together for a month in London, taking a small freighter from Dunkirk and landing in the spooky precincts of Whitechapel. They soon found a small bed-and-breakfast near the British Museum and began exploring the city. London was then at the height of its imperial power, but the slums that had driven Karl Marx to such towering fury still existed. Diego had never seen a city of this size before, nor this kind of grinding urban poverty; he was appalled, but again, with the exception of a drawing of brawling waterfront strikers, he did not convert what he saw and felt into art.

In his journeys to the museums, often in the company of Beloff, he was impressed with the Turners and Blakes; he said later he had also seen for the first time the engravings of William Hogarth. And much later, he insisted that the sight of Pre-Columbian art in the British Museum had stirred deep nostalgia for Mexico. But in London, he had other things on his mind. One day, in a pub, speaking his bad French, he told Angeline that he loved her. She was flattered but cautious, unsure of her own feelings. In 1909, Diego was not yet the fat man who delighted so many caricaturists; photographs from that era show a large man, dressed in suit and tie, exuding confidence and power. Even in his mangled French, his intelligence was clear to Angeline, and his knowledge of art and its techniques was exhilarating. She would remember sitting with him in the sculpture section of the British Museum, facing a stone

head she thought was called "The Dream," and talking about their lives. They were growing closer.

At the end of their month in London, the group returned to Bruges. Feeling confused by the pressure of Diego's courtship, Angeline left the group and traveled alone to Paris "to reflect in peace."

"When Diego arrived in Paris," she recalled, "I would tell him that I accepted that we were *novios* [engaged] and that I believed I could love him."

She was almost seven years older than the big Mexican. She spoke almost no Spanish. Culturally, they were as different as they were physically, except for their shared passion for art. They became lovers. María Blanchard was painting alongside Diego in his small studio near the Rue de Rennes. Angeline was studying engraving with an English instructor and working in her own place on the Rue Campagne Première. The trio often dined together in cheap restaurants or in Diego's studio. When Diego came down with a liver infection, Angeline nursed him, keeping him on a strict diet of fish, vegetables, and mineral water prescribed by a doctor. Her love for him deepened, but she still had doubts. Nor was she convinced of Diego's greatness as a modern painter.

"His colors were clear and well harmonized. Nevertheless, for me the painting was nothing new, since the Russian landscape painters followed the same school and you still could not divine the personality of that young Mexican. For me Matisse was much more astonishing and modern."

As an artist, Angeline Beloff saw her new lover clearly. In 1910 Diego was still following the career path of the traditional academic painter. While Picasso and Braque were creating Cubism, inventing a completely new artistic vocabulary, and the Italian Futurists were issuing their first manifestos, Rivera was studying with still another dull academic painter on the Right Bank. That wasn't all. Playing strictly by the rules of the nineteenth century that had shaped his painting, he even entered the massive group shows called salons, paying a fee to exhibit six paintings in the Salon des Indépendants, which had no jury. Then, before that show closed, he hurriedly took *House on the Bridge* off the wall to exhibit it in the Salon de la Société des Artistes Français, by all accounts the most conservative of the Parisian group shows. He wanted two things from these actions: attention and credentials. Years later he was still embarrassed by this part of his career, claiming that he needed the academic recognition in order to continue receiving the fellowship money from Governor Dehesa. And he was torn over this. The grant money was very useful.

"But I also wanted to be able to face life by myself, to solve my economic problems by my work," he remembered later. "I had begun to feel restive under patronage, fearing that dependence might sap my strength."

He later claimed that he hoped he would be rejected by the salons. But official acceptance had some tangential benefits, beyond his certification to the governor in distant Veracruz. One was psychological: he began to lose his

Mexican inferiority complex. Another was aesthetic: wandering through the acres of paintings, in those years before color reproductions or the full development of the gallery system, he began to look more closely at the modern masters.

"One museum after the other, one book after the other, I swallowed," he remembered later. "So it went till 1910, the year in which I saw many pictures of Cézanne, the first pictures of modern painting which gave me real satisfaction. Then came pictures of Picasso, the only one for whom I felt a kind of organic sympathy. Then all the pictures of Henri Rousseau, the only one of the moderns whose works stirred each and every fiber of my being. The dregs which bad painting had left in the poor American student when he still faced Europe so shyly were washed away."[8]

Well, not exactly. Rivera had one more official show to contemplate, one additional ritual of acceptance. At home. In Mexico. The eighty-year-old dictator Porfirio Díaz had ordered a huge national celebration to mark two events: the hundredth anniversary of the 1810 revolution that began the process of liberating Mexico from Spain; and the thirtieth anniversary of his own glorious reign. The slogan of the Porfiriato was Order, Peace, and Progress, and it would be proclaimed from every rooftop, in the censored press, from the mouths of the nation's political hacks. The celebrations, scheduled to begin in mid-September, would cost twenty million pesos. There would be parades, speeches, fireworks, grand balls, bullfights, a lottery, pageants, and an assembly of international dignitaries. Already, twenty carloads of imported champagne had been unloaded at the port of Veracruz. Orchestras from Europe and the United States would perform, although the new Palacio de las Bellas Artes, with its twenty-two-ton Tiffany glass curtain, could not be finished on time. *Aida* was in rehearsal at the Teatro Abreu. Theater groups were learning their lines. Medals were being cast. The foreign press was being issued credentials. And plans were under way to show the nation's art.

In Paris, Diego Rivera was not yet a figure of stature in the world of art. In Mexico, he was somebody, at least among his friends from the San Carlos, at least to Dr. Atl and the members of the old Grupo Bohemio, and he wanted to be part of it all. Hadn't he heard that even his old rival, Roberto Montenegro, after visiting Spain, France, and Italy, was back in Mexico City? Diego had received a few meager notices of his own work and had dutifully sent them on to Mexico; they had been inflated in the newspapers of *la capital*, which named him as one of the coming stars among the nation's artists.

This possible journey home to Mexico would also delay the necessity of coming to terms with Angeline's needs, now that they were living together: "We spoke of our future, about marriage," she remembered later. "Diego argued that he was afraid, if we would marry, that because of a lack of work we would be obliged to live in the studio, and that if we had a child we would have to hang the diapers inside; if the baby cried or shouted while he worked,

he would be capable—he said—of throwing the baby out the window."

He was exaggerating, of course, raising his fears to absurdly comic levels; but he did a good job of frightening the ingenuous Angeline. He was anxious about his own future. In the short term, serious political trouble in Mexico might bring an end to his fellowship money; even if everything continued smoothly in the nation's politics, a prolonged absence could make him appear to be a distant, shadowy figure in the minds of the state paymasters. In the long term, of course, he would have to earn his own living as an artist, and he couldn't have been entirely happy sending home works that pleased his patron more than they pleased himself. In 1910, he seemed to be gathering strength to move his art in new directions. He needed the security of the grant, and he needed to avoid deeper personal obligations that would saddle him with financial and emotional responsibilities.

Angeline came up with a solution. They would close the studio in Paris and each go home, she to St. Petersburg, where she could talk things over with her brothers, Diego to Mexico, to mount an exhibition and ensure the continuity of his grant. They would wait a year.

"If, after that, he still loved me, he would return to Paris and we would marry."

In July 1910, Angeline Beloff took the train to Russia, while Diego went to paint alone in Brittany, and then to board a ship for Mexico.

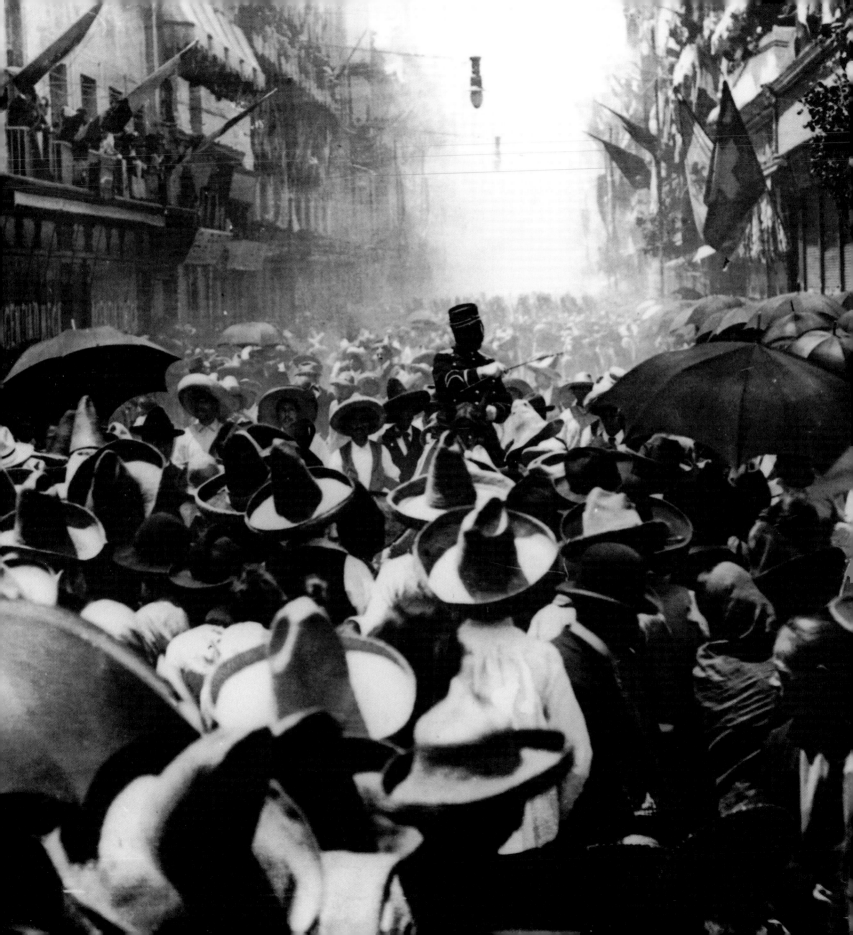

Chapter Three

MEXICO AGAIN

As Rivera sailed to Veracruz that September, tremors of discontent were shaking Mexico. On the surface, all seemed calm and progressive; underneath that surface, among those who lived in the Mexico of illiteracy, disease, and hunger, serious men were talking about taking to the gun.

From the north, a small intense man named Francisco I. Madero, the liberal son of a rich family, had emerged as the best-known spokesman for the opposition to Porfirio Díaz. He was not the only Mexican to demand change, but he had a gift for oratory and great personal courage, and in April he was nominated as the candidate of the Anti-Reelection Party. On May 4, Halley's Comet appeared in the skies over Mexico and was widely interpreted as an omen of coming disaster. In June, while Diego was in Brittany, painting *Head of a Breton Woman* and *Breton Girl* in the manner of the Flemish masters, Madero was jailed on trumped-up charges of inciting rebellion. So were thousands of his followers, many of them, like Diego Rivera, from that educated lower middle class from which so many revolutionists have come. On July 8, eighty-year-old Porfirio Díaz was elected to still another term as president, a post he had held, with one interruption, since 1876. Faced with another wearying example of blatant electoral sham and blunt political oppression, the cynicism of the Mexican young was general.

The monthlong centennial celebrations began on September 15, right on schedule, and Diego Rivera arrived in the port of Veracruz on October 2, coming down the gangplank with rolls of canvases under his arms. His father and younger sister, María, were there to greet him, his arrival smoothed by a relative who worked for the customs office. His mother remained in Mexico City. Two days later, the July elections were confirmed by the Mexican congress, theatrically announced as one of the high points of the centennial

celebrations. That evening Madero did not return to the building in San Luis Potosí where he was under house arrest. Instead, wearing a disguise, assisted by a band of his followers, he began making his way to the United States. The Maderistas had tried the way of open elections. Now they would take up the gun. The Mexican Revolution was about to begin.

None of this seemed to affect Diego Rivera. Years later, Diego would insist that he always had endorsed the principles of revolution and the need to overthrow Don Porfirio, by any means necessary. He claimed to have been aroused since childhood by the cruel inequities of life in Mexico, to have been a friend of the miners, the workers, the *campesinos*. There is absolutely no evidence to support this mythmaking. He was more concerned with the impending exhibition of the work he had brought from Europe: thirty-five oils, two etchings, eight drawings. He saw old friends, including Dr. Atl, who the year before had offered a plan for a very Mexican kind of mural at the Palacio de las Bellas Artes and had been rejected. He saw his former teachers. A group exhibition of Mexican painters was under way, as a collective protest against the official centennial show mounted by the Díaz government, which was made up entirely of Spanish art. Diego visited the counter-exhibition and saw for the first time the work of a fierce San Carlos student named José Clemente Orozco. He briefly met a teenaged student of great talent named David Alfaro Siqueiros. He wrote to Angeline in St. Petersburg. He talked to critics and newspapermen. Sunday supplements and cultural magazines ran stories about him, illustrated with his paintings and photographs of a darkly brooding young Diego Rivera in proper suit and tie.

Surely, from all these contacts, he must have heard reports of scattered fighting in the north, swiftly crushed by the dictator's army. He must have learned about Madero's Plan of San Luis Potosí, with its promises of a more just and democratic Mexico. But he kept working on the exhibition. The rolled paintings had to be remounted and framed. Their placement on the walls of the San Carlos must be perfect. So must the lighting. And the guest lists. Some of the titles of the pictures suggest their banality: *The Beached Ship, The Valley of Ambles, The Tranquil Hour*. Not one painting could have disturbed any of those who believed that Porfirio Díaz would live forever.

"In 1910 the painter was a fledgling academic master," the artist Jean Charlot would write years later, "a docile retriever bringing back from Europe the artistic booty that his aged protector, Don Teodoro Dehesa, rightist governor of Veracruz, had paid him to fetch."[1]

On November 18, fighting broke out in the city of Puebla, sixty miles from Mexico City. A small band of Maderistas held off the Díaz soldiers for a full day before being overwhelmed. Three were killed. On November 19, Madero himself crossed the border from the United States at Eagle Pass, at the head of a group of armed men.

On November 20, the day proclaimed by Madero as the beginning of the Revolution (the word was always capitalized), Diego's show opened in the

galleries of the San Carlos. Because of the troubles erupting around the country, Don Porfirio could not attend, although he was invited. Instead, the event was formally presided over by Carmen Romero Rubio de Díaz, the dictator's wife. At forty-five, she was quite handsome and carried herself with a regal bearing. She had married Don Porfirio twenty-six years earlier, when he was already fifty-four years old; she had taught him table manners and led him to good tailors; she had helped broker a social peace with the Catholic church and was herself deeply religious. Her presence was a powerful reminder of the political and social nature of Diego's first one-man exhibition, an endorsement of the rule that temporal rewards awaited those who cooperated with the regime.

At that point, while men with guns were fighting in the countryside, Diego Rivera remained what he was: the beneficiary of a Porfirian scholarship. And this show of his work was a Porfirian event. The cream of Porfirian society was in attendance, including Governor Dehesa, who had traveled from Veracruz to be there. So were friends and relatives, critics and artists and potential patrons. The wife of the dictator bought six paintings for herself and arranged for the government to buy another seven. The month-long event was an immense success: critically, socially, and financially. Within days, there were outbreaks of fighting all over the country. In the northern state of Chihuahua, a young officer named Pascual Orozco was organizing an army that included a fierce warrior and former bandit named Pancho Villa. To the south, Emiliano Zapata was gathering his guerrilla forces in the state of Morelos, within striking distance of the capital city. Years later, in his public role as revolutionary artist, Diego Rivera would concoct various stories to explain his actions during those fateful months. He claimed that he had been warned by well-connected friends that if he didn't leave Mexico he would be shot as a sympathizer of the Revolution. He claimed that Lenin himself wanted him in Europe to help mediate among various Mexican factions. He claimed that he had gone to Morelos to soldier with Zapata. He claimed that even on the evening of his great opening he and his friends planned to assassinate the dictator, but changed their plans when Porfirio Díaz sent his wife in his place. All were fantasies.

After the successful opening, Rivera first determined that his scholarship would continue (it would, as long as Díaz remained in power) and then began arranging his departure. The exact date isn't clear. One version has him leaving in June, after Orozco and Villa had taken Ciudad Juárez and Zapata had marched into Cuernavaca, forcing Díaz to flee to exile in, of course, Paris. Ramón Favela plausibly argues that Rivera probably left much earlier: in January 1911. The artist-scholar Jean Charlot agrees. At the time of the one-man show, newspaper accounts said that Diego would be returning to Europe on January 3, 1911. In addition, Favela's search of the major Mexico City dailies of the era turned up no mention of Rivera for the entire year of

1911. He reasons that it was unlikely that the voluble Diego could have maintained his silence for almost six months while moving in the company of artists, writers, and newspapermen.

But a letter was published by the magazine *Plural* in 1986 that seems to prove that Rivera did stay longer.[2] It is a love letter from Diego to Angeline and is dated March 1. If authentic, this would place him still in Mexico two months after Favela and Charlot believe he left for Europe. According to the letter, Diego is in the town of Amecameca, in the Valley of Mexico, south of the capital. He is painting landscapes. He includes a sketch, a view of the volcano, Iztaccíhuatl, a subject much loved by his master at San Carlos, José María Velasco. There are some touching passages in the letter, expressing his longing to be together again with "mi mujer" (my woman), his excitement about painting again after the distraction of the exhibitions, some joy about the sales of his work. He mentions the Revolution only in connection with the disruptions to the postal system. Conceivably, the letter was written with the caution of a man who feared it could be intercepted by Díaz police. More likely it was written by a man who had not yet understood that the Revolution was serious, that it would change everything in Mexican life. For Rivera, the Revolution was something that happened to other people.

One thing is certain about Diego Rivera in the winter of 1910–11: for the first time in his life he had earned a considerable sum of money with brush and pencil. He had become a professional by demonstrating a certain mastery of the conventional art that derived from the last quarter of the nineteenth century. But as he wrote to Beloff, about *Bridge on the Canal* and other works: "I now want a thing that is different from that, and from the work in Brittany." He just wasn't sure what that other "thing" was. He still believed he would find it in Europe.

The decision he then made would haunt him for years. Whether he returned to Europe in January or in May, he would be gone for ten long years, missing almost all of the immense national convulsion called the Mexican Revolution. From 1910 to 1920, more than a million Mexicans would die in a country that then contained eleven million. At eighteen, Siqueiros gave up painting and joined the Constitutionalist Army to fight against those who had overthrown and murdered Madero. He would finish as a captain. The one-armed Orozco, unable to fire a rifle, served as a field artist in the army of Venustiano Carranza, walked among the corpses, smelled death.

Diego Rivera went to Paris.

A child soldier in the Constitutionalist Army, Mexico City, c. 1914. Archivo Casasola, INAH, Pachuca, Mexico

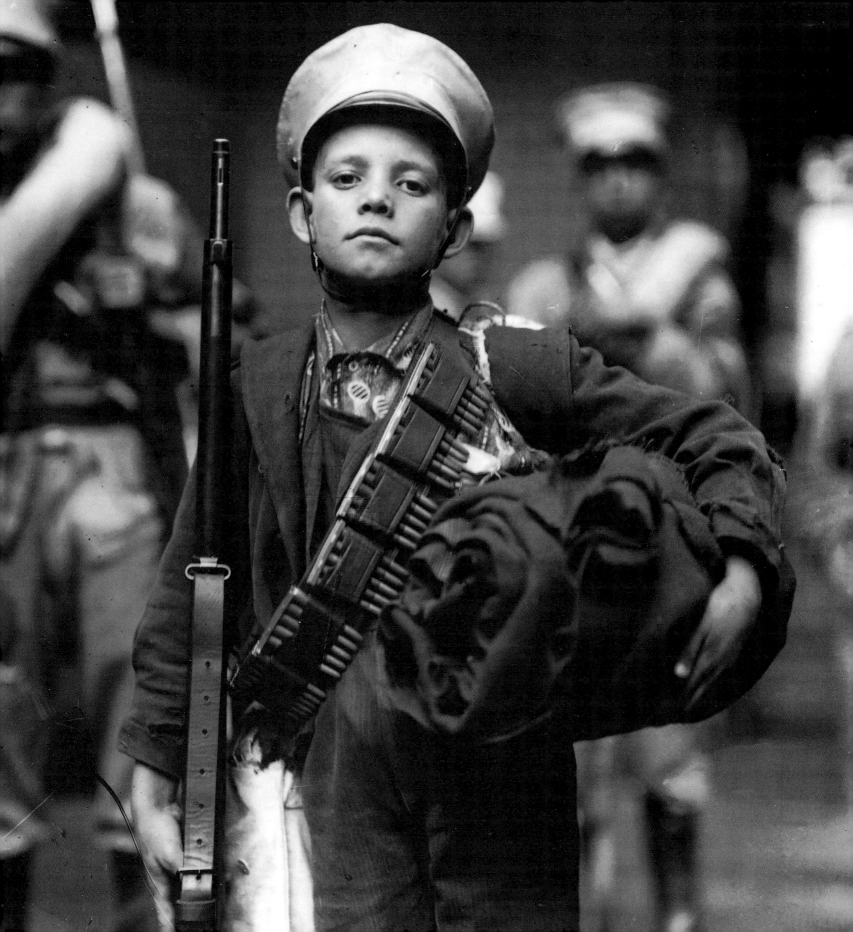

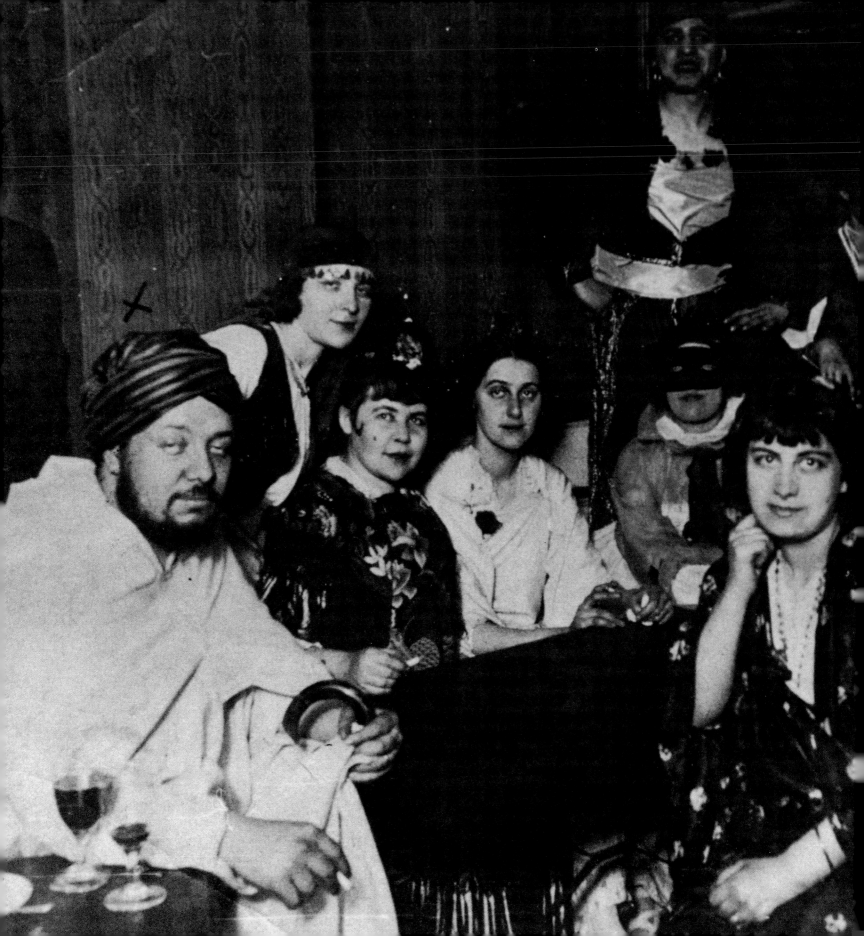

Chapter Four

THE CUBIST ADVENTURE

At some point in April, Angeline Beloff left St. Petersburg for Paris. She trusted Rivera's letters, in which he pledged his undying love, and she went to prepare everything for his imminent arrival. She rented a studio for them at 52, avenue du Maine, near the Montparnasse metro station, and waited. And waited. And waited. A telegram arrived at the end of April or in early May saying that Rivera had arrived in Spain. Beloff expected to see him within days. He didn't show up. She had no way of knowing that Rivera had decided to spend some time with his Madrid friends, visit the Prado, sit at the tables of the Piombo, and take in a large show of international paintings.

"I was dying of anxiety and sadness," Beloff wrote later, "because after the telegram I didn't hear from him again. At last he arrived and explained with complete tranquillity the cause of his delay. What could I say? I was so happy to see him again."

Rivera was equally happy.

"Our reunion was rapturous," he later remembered. "Both of us had agreed to wait until this moment to see whether our love was strong enough to withstand the test of separation. We now decided to live together."

In her memoirs, Beloff said flatly that in the month of June, she and Rivera were married. No records of a formal union have ever been found, but in his own memoirs, Rivera described Angeline as his common-law wife for the next ten years: "During all that time," he remembered, "she gave me everything a good woman can give to a man. In return, she received from me all the heartache and misery that a man can inflict upon a woman."

At the beginning, however, they were apparently happy. The studio was next door to the Académie Russe, founded to accommodate the large numbers of young Russians arriving in Paris for training in art. Angeline could speak her own language with teachers and students and taught some classes in engraving. Diego finished his two large canvases of Iztaccíhuatl, begun in Mexico, and entered them in the 1911 Salon d'Automne. They received no notice from the Parisian critics. Diego was still not quite in the flow of the surging artistic currents of Paris. By delaying his return to Paris, he had missed the controversial spring show at the Salon des Indépendants, where

OPPOSITE:
Diego Rivera (left)
and Angeline Beloff
(in black mask)
at a costume party
in Montmartre,
c. 1916–17

many of the young Cubists exhibited (by choice, Picasso and Braque were not among them), causing a public sensation. But he certainly must have seen the Cubist room at the Salon d'Automne, where his volcano landscapes were hung. This group of young painters included Jacques Villon, his brother Marcel Duchamp, and André Lhote.

In the summer, Rivera and Beloff had traveled together to Normandy and stayed in a place by the sea near Dieppe. She remembered it later in lyrical terms: "full of flowers, trees, and green meadows." Such a lush vision was clearly not what Rivera wanted. After the Salon d'Automne closed, he gathered his volcano landscapes, stored them (they were later lost), and went off with Angeline to Spain. It was as if he needed to be in a place that more closely resembled the hard, dry mesas of central Mexico.

They went first to Barcelona and then climbed into the stony Catalan countryside beyond the city. For two months, they stayed in a town near the mountain called Montserrat, and for the first time Rivera began experimenting with a more modern style, specifically the pointillism of Georges Seurat and Paul Signac. "He bought the book *From Delacroix to Signac*,"[1] Beloff remembered, "and went off to paint large canvases of the mountains, the trees and the vineyards around the town."

Two of these paintings were exhibited in the spring salon of 1912; again, there was little critical notice. The works were clearly derivative. And out-of-date. Seurat, after all, was one of the great painters of the 1880s but he had died at thirty-one in 1891. Signac was Seurat's most faithful disciple, and was still working in 1911–12; he and Matisse spent the summer of 1904 painting together, and his bold paint handling and use of color had a powerful effect on the painters called the Fauves. But by the time Diego Rivera began experimenting with pointillist (or, as Seurat preferred to call it, Divisionist) technique, it was already old hat. In any event, this phase didn't last long. It was as if Rivera, fearful of being thought of as a young fogy, had begun trying on various suits of clothes, in various fashions, to see if any of them fit; they remained other men's suits.

After a few months, the couple returned to Paris. In Montparnasse, Diego began making friends among the many artists who were abandoning Montmartre, with its crumbling buildings and increasingly vicious mafias, for the broader streets and more comfortable studios of this newer district. Even Picasso moved out of the ramshackle Montmartre studios called the Bateau Lavoir and took his paints and easel and collections of scrap and junk to Montparnasse.

More than ever now, the café was central to the lives of young artists in Paris, and Diego began to find his way to the terraces of the Rotonde. He was one of the hardest working of the Left Bank artists, didn't smoke, didn't drink himself into a stupor. But for him, as for many of the foreign-born artists, the cafés were part of a strategy against loneliness. He began to know the

painters and models, the frauds and hustlers. His French was better now, and his personality began to emerge: he was a teller of tall tales, a retailer of myths about his dark side (real or imagined). Sometimes with Angeline, sometimes alone, he told tales of fighting with Zapata, of eating human flesh. But he listened, too, and as he listened, he was being educated as an artist. His understanding of the modernist impulse was deepening. His eyes were opening. His imagination was stirring.

At first, his closest friends were fellow Mexicans: the painters Angel Zárraga and Enrique Friedmann. But soon there were others. Piet Mondrian, the Dutch painter, also lived at 52, avenue du Maine. He and Rivera could not have been great buddies; Mondrian was fourteen years older than the extroverted Mexican, a convert to Theosophism, formal, even restrained in personal style. But in 1912, shocked by his first encounter with Cubism, Mondrian was beginning his own series of brilliant explorations of the new pictorial language. He was painting a series of canvases of trees, in which the image becomes increasingly more abstract; first color vanishes, then the leaves, then the remains of all naturalistic description. Mondrian seemed to be carrying Cubism to its logical conclusion: pure abstraction. This was a journey that even Picasso never took. But young Diego Rivera must have glimpsed the middle stage of the Mondrian process; a Rivera watercolor called *Tree*, painted at the same time that Mondrian was doing his trees, was probably inspired by the Dutch painter.

If Rivera admired Mondrian, however, he also still loved drawing, the lavish use of paint, the look of landscape, and the play of light on faces and houses. And perhaps he found the new language of art intimidating. In the spring of 1912, Rivera, Beloff, and Zárraga again decided to travel together to the familiar terrain of Spain. This time they would stay in Toledo, which Diego had first seen in 1907, and whose stacked houses and abrupt hills reminded him of Guanajuato. The plan was to study the work of the great seventeenth-century master El Greco and the immensely popular Spanish artist Ignacio Zuloaga, the *costumbrista* painter of gypsies, bandits, and bullfighters.[2] In particular, they wanted to understand better El Greco's use of distortion and his elongation of figures.

They returned again and again to El Greco's rapturous masterpiece *The Burial of the Count of Orgaz,* painted in 1586–88, in the Chapel of San Tomé. Walking the countryside, Rivera located the precise spot from which El Greco had painted his well-known view of Toledo (now in New York's Metropolitan Museum of Art), and began to paint his own version. The trio apparently made few local friends; most of the inhabitants were connected to the military college and kept strangers at a distance. But the young artists seemed happy and productive. They lived in a rented house at 7 Calle del Angel, which they would use on various trips from Paris over the next two years,[3] and were not too poor to afford a servant. Beloff remembered her name as

Vicenta, and said she was a proud woman who ran her own household and also taught Beloff how to cook in the Spanish style.

Beloff was not idle. She continued her own work, making drawings of the houses in the town and finely detailed etchings of street scenes. In Toledo, Rivera painted some very good canvases, in particular *The Old Ones, The Samaritans, View of Toledo,* and *The Purification,* in addition to others in the manner of Zuloaga and the *costumbristas.* In these paintings, his draftsmanship, as always, is meticulous; but they are unique, at this stage of his development, for their high-key color schemes, the clarity and dryness of the light. Rivera's palette was getting brighter, perhaps as a result of his brief immersion in pointillism. The stylized houses in some of his Toledo backgrounds resemble the townscapes painted by Picasso in the Spanish village of Horta de Ebro in 1909 and by Braque during his 1908 stay in L'Estaque, in Cézanne country. It's not known whether Rivera saw those paintings by Picasso and Braque, even in black-and-white reproduction, but as they had for other painters, Iberian forms and Mediterranean light were changing his own work. In addition, his paintings were large: *The Old Ones* measures about seven feet by six feet, the *View of Toledo* ten feet by seven and a half feet. In their size, ambition, and desire for the monumental, they anticipate all that was to come.

Pushed by Zárraga, who was at this stage further advanced in his understanding of the newer idioms (and who had recently spent months absorbing the art of Renaissance Italy), Diego was thinking about the picture plane itself: "His strongly Realist and expressionistic studies of Spanish peasants," the scholar Ramón Favela has observed, "backed by panoramic views of the austere, rugged and harsh Spanish landscape eventually gave way to geometricizing and broad faceting of planes, or in short, Cubism by 1913."[4]

Rivera was also experimenting in other ways. According to Beloff, they began mixing their own colors with linseed oil, then tried a mixture of essence of lavender, a lemon resin, and beeswax. In vision and technique, something new in Rivera was longing for expression.

He was, at the very least, freeing himself from the rigidities of his own academic training. This process was accelerated by enormous events back in Mexico. Madero had taken office as president in November 1911; Rivera's fellowship, although awarded by the Díaz regime, was continued by the liberal and tolerant Maderistas. Other Mexican artists and intellectuals also benefited from the change in government. Back in Paris later in 1912, Rivera was delighted by the company of a group of Mexican expatriates that included Dr. Atl, his old rival Montenegro, and a brilliant, dandified artist-intellectual named Adolfo Best Maugard.

But in February 1913, Madero was murdered in a coup d'état commanded by General Victoriano Huerta and endorsed by the American ambassador. This triggered the bloodiest, most prolonged stage of the Mexican

Revolution, essentially a countrywide civil war. For Diego Rivera, now twenty-seven, the violent end of the Madero government had a specific, personal consequence: it brought his government subsidy to a sudden end. For the first time, he would have to support himself and Angeline with sales of his own work. In one way, this was a liberation; he no longer had to paint for a tiny, essentially conservative audience back home. But a practical consideration was now added to his aesthetic choices. He must have known one simple thing: to flourish in the Parisian marketplace, and build his own reputation, he must cast off the dark palette, rigid academicism, and varnished familiarities of the past. That process had begun tentatively in Toledo in 1912. Now it would accelerate.

Cubism

By 1913, Diego Rivera had plunged completely into Cubism. In Toledo, he finished his *Adoration of Mother and Child*, a quite accomplished synthesis of El Greco and Cubism, with some elements that seem inspired by Cézanne, the whole welded together by Rivera's own vision. From the beginning of this stage of his development, he showed little interest in adapting the limited or monochromatic palettes used in early Cubism by Braque and Picasso. Instead, in his landscapes he was making his own elaborations of discoveries made by Mondrian, while in other pictures, we can sense the presence of Robert Delaunay and his theories of simultaneity.[5]

These can be seen and felt most clearly in Rivera's fine portrait of Best Maugard, which Diego considered his most important painting to that date (although it attracted no critical interest at the spring show of the Société des Artistes Indépendants, where it was shown along with two Toledo landscapes). A stylized, elongated Best Maugard is shown pulling on an expensive glove, a cane in the crook of his arm. His high collar, long coat, Edwardian trousers, and polished shoes are in elegant contrast to the background images of railroad trains, billowing industrial smoke, a Ferris wheel, all of which are overwhelming a neat stylized building from an older Paris. The picture evokes Delaunay's paintings of the same year of the Eiffel Tower and yet is insistently original. The tilted, unsettling planes of the picture, the warm earth colors of the foreground receding into the blues and grays of the modern age, combine into the painter's own comment: Best Maugard, Rivera seems to be saying, is an anachronism.

Best Maugard was also an influence. Born in Mexico in 1891, he had moved with his parents to Europe at age nine. He returned to Mexico in 1910, that fateful year, and worked with the anthropologist Franz Boas, making more than two thousand drawings for an ethnological study of the Valley of Mexico. The experience opened his mind to the glories of pre-Columbian art.

OPPOSITE:
Portrait of Adolfo Best Maugard. 1913.
Oil on canvas, 7′5¼″ x 5′3⅝″
(226.8 x 161.6 cm).
Museo Nacional de Arte, INBA,
Mexico City

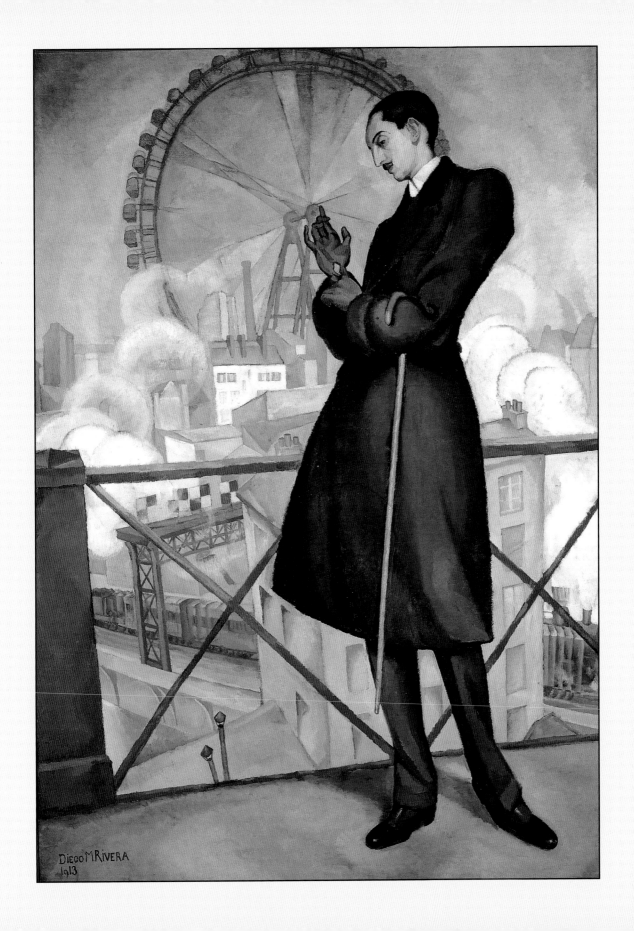

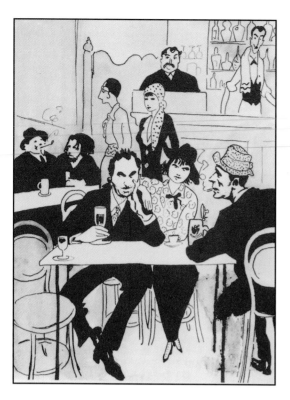

A drawing of the interior of the Café Rotonde by the Swedish artist Arvid Fougstedt shows Victor Libion in the rear at the *caisse;* Russian writers Max Voloshin and Rivera's friend Ilya Ehrenburg sit conspiratorially in the far left corner. The woman with the spit curl is Pâquerette, a model who was then having a love affair with Picasso.

Back in Europe in 1912, he met Rivera, traveled with him to Toledo, helped lead the endless discussions about modernism. He was familiar with the work of such Russian modernists as Wassily Kandinsky and was impressed by the show of Russian folk art that was part of the 1913 Salon d'Automne. His enthusiasm for folk art washed over Rivera too. Best Maugard talked about the need to make art part of the education of Mexican children as the first step in the process of creating a truly nationalist artistic expression. In 1914, he began work on a drawing textbook that combined pre-Hispanic design forms and colonial and folk expressions that were unique to Mexico. After all, if the Post-Impressionists could be inspired by Japanese and Oceanic art, and Picasso by African sculpture, why couldn't Mexican artists draw upon their own rich traditions instead of the traditions of Europe? His enthusiasms were certainly communicated to his friend Rivera, as he struggled to change the direction of his own art.[6]

The change in Rivera's approach coincided with a change in address. In the fall of 1912, Angeline and Diego had moved into a studio at 26, rue du Départ that would be their home for seven years. By an odd coincidence, Mondrian had also moved to this building, as did his Dutch compatriot Lodewijk Schelfhout. Their ideas about the use of space on a canvas clearly began to have an effect on the younger Rivera. "My closest friend, besides Picasso," he said years later, "became Piet Mondrian, the most sensitive, rigorous and ferocious purifier."[7] This is probably half accurate. Rivera didn't meet Picasso until 1914, but in the crucial year of 1913, Mondrian was right there in the building.

At the same time, Rivera was absorbing many other influences in the cafés and ateliers of Montparnasse. He had enrolled in the University of the Rotonde, the café on the corner of the Boulevard du Montparnasse and the Boulevard Raspail. Run by a man named Victor Libion, who expanded it in 1911, the café initially attracted a number of Spanish and South American artists who loved the sun on the *terrasse* and dubbed it *"Raspail plage"* ("Raspail beach"). Rivera often went there with Zárraga, Best Maugard, and a colorful Chilean painter named Manuel Ortiz de Zarate. Descended from one of the men who served Pizarro after the conquest of Peru, Ortiz de Zarate was born in Rome in 1886, while his father was there studying music and opera. Six years later, after the boy's mother died, his father brought the children back to Lima, where he soon remarried. This did not make Ortiz de Zarate happy. He ran away at fifteen, crossed the Andes into Argentina, and made his way back to Italy. He had taught himself to paint by copying Old Master paintings. When he finally enrolled in art school in Venice, one of his classmates was Amedeo Modigliani and they remained friends. In those years

in Paris, Manuel Ortiz de Zarate seemed to know everybody on the Left Bank.

The quartet of Spanish-speaking friends often wandered to other cafés, but the Rotonde was home. By all accounts, Libion was a tolerant, generous man who allowed the artists to nurse their coffees for hours and even extended them credit. He shrugged off his generosity. "It's only good business," he said. "Artists and intellectuals don't have much money, but when they do, they spend it."[8]

On the terraces of the Rotonde and other cafés, Rivera met and talked with such fine painters as André Derain and André Lhote; the Japanese artists Tsuguharu Foujita and Riichiro Kawashima; the Spaniard Juan Gris, who was making his own transition from illustration to Cubism; and the Italian Futurists Gino Severini and Carlo Carrà (whose work would later impress Diego). The poet, critic, and artistic cheerleader Guillaume Apollinaire moved from table to table, at first as an ambassador from Montmartre to Montparnasse, then, as the scene shifted, as a resident. Rivera made many friends.

Modigliani and Picasso

Thanks to Ortiz de Zarate, one of Diego's new friends was Amedeo Modigliani. Descended from Sephardic Jews from Leghorn on the Italian coast, he was handsome, a great draftsman, fine sculptor, and brilliant painter, addicted to alcohol, hashish, and cocaine—the romantic epitome of the self-destructive bohemian, burning his candles at both ends, paying a price for genius. Beloff remembers that she and Diego often took Modigliani to an Italian restaurant on the Rue Campagne Première, where the food was cheap, clean, and abundant. The Italian proprietress took pity on her countryman Modigliani and forced upon him deep bowls of minestrone. Occasionally, Modigliani found himself homeless and drifted to the studio shared by Diego and old friend María Blanchard. Among the Italian's subjects was Diego Rivera. He made three portraits of his huge Mexican friend, capturing in swirling circular line the roguish essence of Diego's character, the jittery eyes peering from the fleshy mask hinting that perhaps Rivera was not entirely to be trusted.

"Modigliani only came to our studio," Beloff remembered. "He spoke little, drew almost always, drew sketches of Diego; frequently he came drugged-up, but even in that state he didn't stop being a fine and enchanting person. He went through terrible miseries."

Eventually, Modigliani moved into a studio at 8, rue de la Grand Chaumière, upstairs from Ortiz de Zarate.[9] Although Modigliani had little interest in Cubism, he clearly enjoyed the company of the Latins and brought them along when he made the rounds. They were sometimes with him when he made drawings to pay for his drinks. Years later, the sensuous coloring of some of Rivera's own easel paintings, along with their elongations and distortions, would evoke Modigliani.

One morning in the early part of 1914, Diego was in his studio, working on a double portrait of Foujita and Kawashima, when Ortiz de Zarate arrived. He was clearly excited.

"Picasso sent me to tell you that if you don't go to see him," he said, "he's coming to see you."

Foujita and Kawashima were then under the influence of Isadora Duncan, dressed in togas, their hair cut in bangs and adorned with ribbons. Diego didn't care. All went off together to Picasso's studio in the Rue Schœlcher, with Ortiz de Zarate leading the way.

"I went to Picasso's studio intensely keyed up," Rivera remembered years later. "My feelings were like those of a good Christian who expects to meet Our Lord, Jesus Christ."

According to Rivera, the visit was marvelous: "Picasso's studio was full of his exciting canvases; grouped together they had an impact more powerful than when shown by dealers as individual masterpieces. They were like living parts of an organic world Picasso had himself created."

Later, Foujita remembered being more impressed by the paintings of Henri Rousseau that Picasso owned than by those of Picasso himself (and hints of the Douanier Rousseau, who had invented tales of his adventures in Mexico, would appear in many of Diego's mature paintings). But Rivera was as over-whelmed by the man as he was by the paintings.

"Will and energy blazed from his round black eyes," he remembered. "His black, glossy hair was cut short like the hair of a circus strong man. A lumi-nous atmosphere seemed to surround him. My friends and I were absorbed for hours, looking at his paintings. Our interest so pleased him that he let us see his most intimate sketchbooks." Finally Ortiz de Zarate and the two toga-clad Japanese said their good-byes. "But when I made a motion to go, Picasso asked me to stay and have lunch with him, after which he went back with me to my studio."

Picasso asked Rivera to show him "everything I had done from beginning to end." He presented to the Spaniard his *Sailor Eating and Drinking*, a second portrait of Best Maugard, several Cubist still lifes, and other work. Picasso approved. They then went off to dinner and stayed up late talking.

"Our theme was Cubism—what it was trying to accomplish, what it had already done, and what future it had as a 'new' art form."

They became friends. According to Diego, Picasso brought his friends to Rivera's studio, including Apollinaire, the Symbolist painter and poet Max Jacob, and Juan Gris.[9]

"Picasso's enthusiasm for my work caused a sensation in Montparnasse," Rivera remembered. "My contemporaries who felt kindly toward me were gratified and those who did not were surprised and outraged. Being accept-ed by the master of Cubism himself was, of course, a source of tremendous personal satisfaction to me. Not only did I consider Picasso a great artist, but

OPPOSITE:
Portrait de Messieurs Kawashima et Foujita. 1914. Oil and collage on canvas, 31 x 29" (78.5 x 74 cm)

I respected his critical judgment, which was severe and keen."

All Cubism, of course, flows from the initial inventions of Picasso and Braque. But Rivera's own work was not a simple knockoff. He was drawn to the more systematic, academic second stage of Cubism, plunging enthusiastically into the theoretical debates, which attempted to define rules or laws or reduce aesthetic principles to paragraphs in manifestos. He briefly allied himself with the group called the Section d'Or. Given its name by Jacques Villon, it included the other Duchamp brothers, Robert Delaunay, Albert Gleizes, Jean Metzinger, and a rough, serious young man named Fernand Léger. This was a natural alliance for Rivera; they were believers in a "modern" version of the Golden Section so beloved by the musty professors of San Carlos. Fine distinctions were made between "analytical" Cubism and "synthetic" Cubism. Critics who could not paint began telling painters how and what to paint.

For Rivera, all of this was new, and apparently enthralling. But by 1914, the intuitive Picasso, enemy of most rigid theories, was already straining against the limitations of Cubism. He had invented collage in 1912; he was moving into flatter color; but he was the sort of artist who would hurry to the exit when others began formalizing the concepts into dogma. For Picasso and Braque, Cubism was a means of liberating the artist from the straitjackets of linear perspective and descriptive color that had ruled the arts since the Renaissance. It was never intended to become a new straitjacket.

Breakthrough

Those who came after Braque and Picasso—call them second-generation Cubists—were also trying to push Cubism beyond its apparent limits. Rivera was one of those second-generation Cubists. Over a period of four years, from 1913 to 1917, he would make more than two hundred Cubist paintings, along with an unknown quantity of watercolors and drawings, and at least one collage. This period of his artistic life is usually described as a mere prelude to the career that was to come. But if Rivera was not a leader of the Cubist breakthrough, he was no mere follower. Many of his Cubist paintings are superb: inventive, vigorous, surprising. Almost from the beginning, they were full of color; not for him the somber repression of color that characterized some who made line, form, and faceting the only permissible syntax of Cubism.

In some ways, Rivera's work was an illustration of Picasso's line: "Somebody does it first, and then somebody does it pretty." Once he understood the essentials, Rivera's version of Cubism swiftly became very personal. He brought his own personality and vision to a series of wonderful Cubist portraits of his friends and acquaintances: Angeline Beloff (three different

paintings), Martín Luís Guzmán (the Mexican intellectual who had served with Pancho Villa and would write the warrior's "autobiography"), the sculptor Jacques Lipchitz, the architect Jesús Acevedo, the modernist Spanish writer Ramón Gómez de la Serna. These portraits, and others, demonstrated Rivera's sureness of control of the new idiom. He used specific objects to identify and comment upon the sitters, employing color to express personality. And in the case of his Mexican friends, he used the patterned colors and textures of the traditional Mexican serape.

As he grew more successful, the circle of his friends widened. Through Beloff, and Ortiz de Zarate, who was teaching at the Académie Russe, he began meeting more and more Russians. Some were on the losing side in the 1905 revolution and dreamed of a successful return engagement. Some were more recent political exiles. Many were artists. He visited their tiny studios in the sprawling building called La Ruche (The Hive), went to their parties, argued with them, told great and wonderful lies in their company. Among those who passed through La Ruche were the painters Marc Chagall and Chaim Soutine and the sculptors Alexander Archipenko, Ossip Zadkine, and Jacques Lipchitz. Some of the Russians were subjects for Rivera's Cubist portraits. Some tried to instruct him in Marxism. Some became good friends. Among the friends who sat for a portrait was a scrawny, badly dressed poet named Ilya Ehrenburg, destined to become one of the most famous Russian writers of the Communist era. He also met a vivacious Russian woman named Marevna Vorobov, who arrived in Paris in 1912, after a year in Capri with the Russian colony that surrounded Maxim Gorky. She would later play a major part in Rivera's European life. There is no indication that Rivera ever met Leon Trotsky, who lived in Paris from November 1914 to September 1916, when he was expelled by the French authorities. But the passionate language of revolutionary Marxism was definitely in the air.

"Diego was a man of the emotions," Ehrenburg would write in his memoirs, "and if sometimes he carried to absurdity the principles he cherished, it was only because the engine was powerful and there were no brakes."[11]

Ehrenburg was fascinated by Rivera and eventually would lift parts of the Mexican's character for his first novel, *Julio Jurenito* (1921). He was as impressed by his personal presence as he was by the Mexican's paintings, explaining: "He was one of those people who do not merely enter a room but somehow fill it at once." Soon, often in the company of a happy-go-lucky Russian writer and Theosophist named Max Voloshin (also the subject of a Rivera painting), they were moving around Paris together. As an old man, Ehrenburg remembered:

"We became friends: we were the extreme wing of the Rotonde because we knew that, in addition to ancient, melancholy, and calculating Paris, there existed other worlds and phenomena of other proportions. Diego told me about Mexico. I told him about Russia."

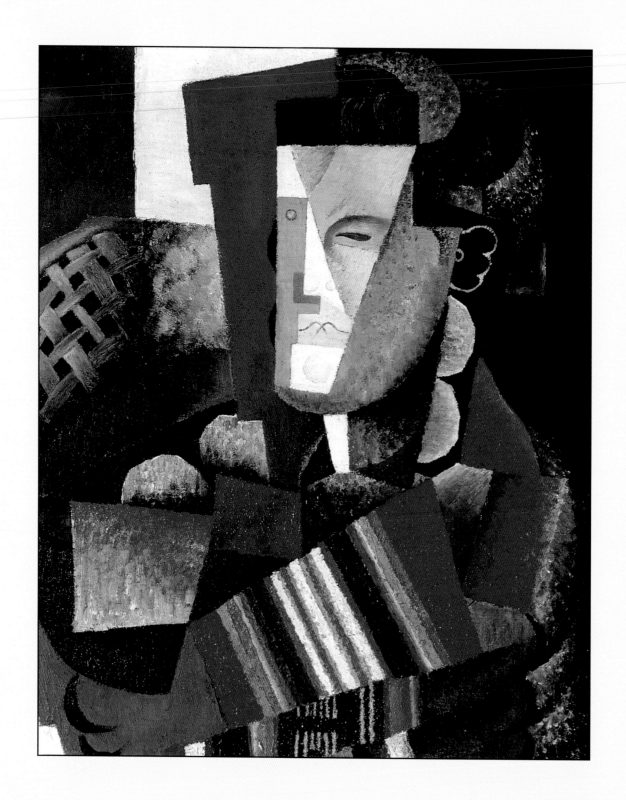

In the company of the Russians, and exiles from Central Europe, Diego Rivera listened. He claimed later to have read Marx and other social philosophers much earlier; this is unlikely, and in any event, he was not given to sustained scholarly examination of ideas. But he was beginning to absorb political and social theories from the Russian painters, writers, and exiles of La Ruche. At the same time, each new arrival from Mexico brought news of the immense struggle at home and his visual imagination was being stirred by Augustín Casasola's extraordinary photographs of the Mexican Revolution that were being reprinted in the French press. There in the photos were Zapata and his brother, Villa and his lieutenants, Obregón and his general staff: seething or swaggering, defiant or triumphant, altogether something new. If the Russian émigré leftists were demanding that any European war be transformed into cleansing revolution, Mexicans were already fighting a revolution. Diego Rivera might have chosen not to take part in that convulsion, but more and more, it was in his mind.

In August 1914, the twentieth century changed forever, and Rivera's life changed with it. That summer, he, Angeline, Jacques Lipchitz, and some English and Russian friends embarked on a walking and sketching tour of Spain, perhaps to find temporary respite from the endless theoretical debates of Montparnasse. On June 28, 1914, they were in Majorca, in the Balearic Islands, painting under the glorious Mediterranean sun, when Archduke Francis Ferdinand was assassinated in Sarajevo. When the war finally broke out six weeks later, some of their friends left to report for military duty. Diego and Angeline, Lipchitz, and a friend stayed on in Palma a while longer, while Diego painted some beautiful, brilliantly colored Cubist landscapes. Then Diego and Angeline sailed for Barcelona to take care of a minor domestic crisis.

With no advance warning, Diego's mother and his younger sister had arrived in Spain. María was afraid that Diego would join the French army to fight in the war. While her husband was away on one of his governmental inspection tours, she sold all the loose furniture, bought one-way tickets, and sailed from Veracruz with her daughter and two Chihuahuas. She had one goal: to save the son she assumed was now very successful. Diego was aghast. So was she.

"She thought Diego was rich and famous," Beloff remembered, "and found us in a serious state of bankruptcy, because when our friends left, we had loaned them some money that they were supposed to send us when they reached their countries. The money had not arrived and we hadn't much money left. After two or three weeks our resources were at the point of exhaustion."

They certainly didn't have the money to pay for two return tickets to

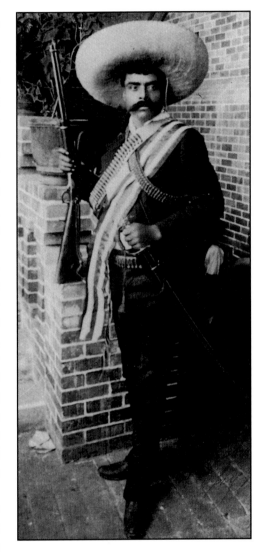

Mexico, or even to feed and house the visiting mother, daughter, and Chihuahuas. The war was disrupting mail service. They had no friends in Barcelona to loan them the money. Finally, an exasperated Diego arranged for enough money from the Mexican consulate to pay for two third-class tickets (his father was also bringing pressure on the consulate from the Mexican end). Mother and daughter sailed away, leaving Diego and Angeline with ten pesetas and the dogs. Now hunger was real, the situation desperate. Rivera talked about getting a job unloading ships at the piers. Then he heard that Russians were being repatriated from Spain and suggested that Angeline should think about going home. She confronted him: is this because you don't love me and want to get rid of me?

"He assured me that no, that was not the reason, but he didn't know what to do," she remembered later. "For him, painting was everything, but he didn't know how to resolve practical questions or difficult situations, at least in those days."

Beloff did. She went to the Russian consulate, to see if they could arrange for her pension check to be sent to Barcelona and immediately talked her way into a job. She would paint the Russian coat of arms over the entrance. On this job, Diego was her assistant, painting a version of Saint George and the dragon on a shield while Angeline painted the eagle that dominated the design. The consul, a fan of miniature painting, was delighted; he paid them one hundred pesetas and offered some additional work. They thanked him, took the money, and boarded the first train to Madrid.

They found an apartment in the same building that housed the writer-diplomat Alfonso Reyes and old friend Guzmán, among other Mexican exiles. Lipchitz soon arrived with a young banker friend and moved in with the Riveras to share the rent. Artists were arriving from Paris to work in the comparative safety of the Spanish capital: Robert Delaunay and his Russian wife, Sonia; Marie Laurencin and her German husband; Foujita and Kawashima. They were soon joined by old friend María Blanchard, whose family lived in the city on the Castilian plain. Nobody knew what would happen in the war. In the first weeks, the Germans had smashed into neutral Belgium and were advancing on Paris. The French government had fled to Bordeaux. By the end of August, seventeen million men from eight nations were engaged in the greatest war in European history.

Rivera and Beloff stayed in Spain for almost a year. Angeline found a morning job tutoring two rich Spanish girls in the Russian language; in the afternoons, she made copies of Tintorettos in the Prado and did her best to sell them. To help them raise additional money, Gómez de la Serna arranged for a joint show of the works of Rivera and María Blanchard, the first exhibition of Cubist painting in the Spanish capital. The work was generally sneered at by the insular Spanish critics and sales were not good. Poor María was so cruelly mocked for her physical afflictions that when she finally left for Paris

after a brief stint of teaching, she never returned to Spain. In the summer of 1915, with the world he knew disintegrating, Rivera returned to Paris. Alone. Beloff remained in Madrid for two long months, staying with Alfonso Reyes and his wife. The war would hurt them all.

Wartime

In the Paris of painters and sculptors, poets and bohemians, everything had changed, starting with the players. Georges Braque had been drafted in August 1914, was assigned to the 224th Infantry Regiment, rose from sergeant to lieutenant, and was shot in the head on May 11, 1915. His brain was not harmed and he was invalided home, but he would not paint for another two years. For his bravery, he was awarded the Croix de Guerre and the Légion d'honneur. Léger served as a stretcher-bearer and a camouflage artist, was gassed, and then was discharged. Guillaume Apollinaire, who was Polish-Italian but had adopted French citizenship, was first assigned to the artillery, volunteered for the infantry, and suffered a terrible head wound on the Champagne front on March 17, 1916. He came home in uniform, his head swathed in bandages (Picasso made a famous sketch of him at this time), toured the cafés and the art galleries, and again threw himself and his pen into the cause of art. But

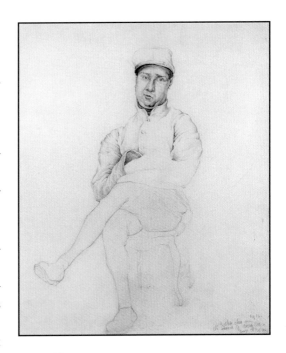

he never fully recovered from the wounds; he would die in the terrible influenza epidemic of 1918. He was thirty-eight.

Rivera once more lived in the studio at 26, rue du Départ, but Paris was not the same. The salons were suspended for the duration. As in every war, prices rose drastically and many goods became scarce. More and more women, their men gone to the war or wounded or dead, took to prostitution. There was no lack of uniformed young men seeking one last fling before dying. Montparnasse was being drained of its bright young talents. To Rivera and others, it sometimes seemed that only foreigners and women remained, and even the foreigners were not immune to the fever of the war, as the case of Apollinaire showed. Among Rivera's friends, Moïse Kisling, the Polish painter of erotic nudes, joined the French Foreign Legion; so did the Russian Ossip Zadkine; both were Jewish and quickly discovered that the French officers in their units were as wormy with anti-Semitism as the rest of the French population. They suffered terrible cruelties for their love of France. The Swiss-Scottish poet Blaise Cendrars joined the Foreign Legion too, went off to fight, and lost an arm. Various other foreigners who loved France volunteered for the army or joined the ambulance corps. Modigliani was turned down for medical reasons. So was Ilya Ehrenburg. Diego Rivera claimed that he too vol-

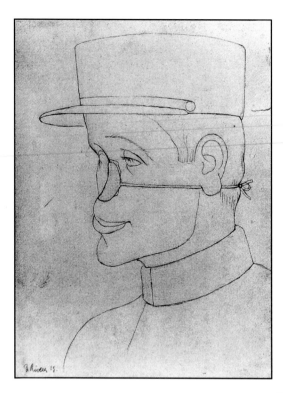

unteered to fight for France and was rejected. He was too fat. Or he had flat feet. Or he knew too many people from the Left.

During his time alone in Paris, Diego finally made a contract with an art dealer, a man named Léonce Rosenberg. At the beginning of the war, the great dealer Daniel-Henri Kahnweiler, who represented Picasso, Braque, and Juan Gris, was trapped in Italy. Still a German citizen, he realized that if he returned to Paris, he would be interned. This was not paranoia; his shop and belongings were seized as enemy property. He was forced to wait out the war in Bern, Switzerland. In this crisis for the Cubists, Rosenberg stepped in to help Kahnweiler's clients, including Picasso and Gris, who was a deserter from the Spanish army and had no passport. Rosenberg recognized the enormous growth in Diego Rivera's talent and offered him the contract.[12]

This two-year contract allowed Rivera to send for Beloff, who explained the arrangement in her memoirs. Diego would submit a minimum of four canvases a month and would be paid according to their size and subject matter. Portraits paid better than landscapes. Landscapes paid better than seascapes. There was something comically absurd about painting by the square inch. But with the art market contracted by the war, the arrangement guaranteed Rivera a certain amount of money every month.

"From the financial point of view," Beloff remembered, "this wasn't the gold of Peru, but we arranged things as well as we could."

There were, however, other complications and problems that could not be solved by money. While Diego was alone in Paris, he had again met Marevna Vorobov. She was six years younger than Diego, twelve years younger than Angeline Beloff, and a talented artist. Marevna and Diego became lovers. If Angeline Beloff was his wife, Marevna was now his mistress. In addition, Beloff became pregnant. The baby, Diego Jr., or "Dieguito," was born in August 1916.

"Diego appeared very happy and told me that he wanted more children," Beloff remembered later. "While I was still in the hospital, a young woman who said she was my friend, and who I had received in my house at the recommendation of Ehrenburg and the other Russian friends of Diego, used my absence to conquer Diego who, according to what she said, could launch her as a painter."

She was talking about Marevna, of course. Beloff was as wounded in her way as any soldier.

"That period was terrible for me," she later wrote, "because when I returned from the hospital I found that woman in great intimacy with Diego. Deciding that they were very much in love, I decided to separate from him immediately."

Diego and Marevna stayed on together in the studio; Beloff moved to a tiny

unheated apartment with the infant. María Blanchard lived downstairs and sometimes served as babysitter. Diego contributed one hundred francs a month, but it was hardly enough in wartime Paris to pay rent and put food on the table. The baby was always hungry, susceptible to colds. Beloff was miserable. But Diego wasn't happy either. Marevna made some charming pen-and-ink drawings of Diego with his friends, including Picasso and Modigliani, Voloshin and Ehrenburg, in which Rivera is a huge, bearded, imposing figure. But although Ehrenburg thought they were "well-matched—hot tempered, sensitive, and childish," their lives together were not easy. After five months of living with Marevna, Rivera began to tire of her. He came more often to see his son. Finally he announced that he wanted to live again with Beloff. Soon they were back together in the studio and Marevna found other lodging.

"I believe he continued seeing that woman," Beloff remembered (correctly), "but at least I didn't have to know about it. Since between Diego and me, in addition to love, there was friendship, and painting created common interests, we could recommence our life together."

She could not have known that life would soon get worse. The damp, frigid wartime winter of 1917–18 was brutal. There was a shortage of coal, damp firewood "produced more smoke than heat," and the stove in the studio was often as cold as the street. The baby, Dieguito, developed bronchitis, but Diego had no money for doctors or medicine. Then the great influenza epidemic swept through Europe. It killed Apollinaire. It also killed the boy. He was fourteen months old.

L'affaire Riviera

In 1915, Rivera painted what many critics believe is his Cubist masterpiece: *Zapatista Landscape (The Guerrilla)*. Later, he would describe it as "probably the most faithful expression of the Mexican mood that I have ever achieved." The elements of this outdoor still life included a serape, a sombrero, a rifle, a cartridge belt, a wooden ammunition box, and the mountains of Mexico. The central image floats in space, its planes overlapping or diminishing in surprising ways. What could be the shadow of the gun is painted white. The reds are very red, the blues are an intense luxurious blue: as they are in Mexico. The sombrero, combined with a shape that suggests an all-seeing eye, asks the viewer to look for a face; it's as elusive as a Zapatista. Clumps of trees are painted densely, viridian green spotted or scumbled over black: good cover for snipers. In the lower-right-hand corner there's an unfolded piece of blank paper, attached to the canvas by a nail, painted in a skillful trompe-l'oeil manner: it's a kind of manifesto from the millions of Mexicans who remained illiterate.

Rivera continued working as a Cubist after *Zapatista Landscape* and made some handsome canvases, but didn't ever quite surpass this vision of distant

OPPOSITE:
The Soldier. 1918.
Graphite on paper,
12⅝ x 9⅜" (31.3 x 23.8 cm).
Private collection

Mexico. In that single painting, he established a valid claim to being one of the most successful of all the Cubists, not just another follower of an artistic fashion. As a result, he was now even more heavily involved in the theoretical debates in wartime Paris, all those attempts to create a mathematical basis for art, to establish rules. His reputation grew and so did his ego. He spun elaborate lies about his life in Mexico, his experiments with cannibalism, his revolutionary heroics. He claimed to have discovered the secret of the fourth dimension. He was said to have invented a machine that helped him to dissect planes, something he called *la chose* (the thing); the device was seen by the futurist Gino Severini and several other friends, and by Marevna, but Rivera alluded to it with the furtive style of an alchemist. He began using inflated metaphysical language (although he did not, like his friend Modigliani, go around spouting the predictions of Nostradamus). He could erupt into irrational behavior, the equivalent of seizures, and on one occasion seemed about to kill Ehrenburg. He argued. He opposed. He proclaimed.

Two events were to lead him out of Montparnasse and home to Mexico. One was the break with Picasso; the other his abandonment of Cubism. His artistic relationship with the Spanish genius was that of a son to a father, accompanied by all the usual tensions, complicated by history. Many Mexicans saw the Spanish the way the Irish viewed the British, or Koreans look at the Japanese. The Spanish were the conquistadors, those who conquered not simply the vast lands of Mexico, but its language, culture, and religion. Most of the followers of Cortés were, in fact, from the same southern region of Andalusia that almost four centuries later produced Pablo Picasso. Three hundred years of Spanish colonialism had put what seemed to be permanent marks on the Mexican character; one of those marks was what Diego Rivera called "my Mexican inferiority complex."

His educated, sophisticated Mexican friends—Guzmán, Alfonso Reyes, Best Maugard, Dr. Atl—often must have discussed the disparate collection of theories and yearnings called *Mexicanidad*, literally "Mexicanness." If Mexico was now indeed a separate nation, in command of its own history, what, then, was a Mexican? How did a Mexican differ from a Spaniard—or from any other nationality on the planet? How large was the Indian component in the Mexican mixture? In Mexico, stimulated by the Revolution, this was the subject of a growing flood of essays, books, debates in schools and coffee shops and even cantinas. In Rivera's own days at San Carlos, the debate had begun in a tentative way; it was now accelerating and its endless questions surely had reached the painter at 26, rue du Départ. Like many artists, Rivera was given to personalizing the great abstractions; if he was Mexico, then Picasso was Spain. At some point, he must declare his independence.

The occasion for the break was minor. Picasso was one of the great artistic predators; everything in the arts was subject to his hungers and his genius for transformation. This often led to grave accusations. As his biographer John Richardson has written:

OPPOSITE:

Zapatista Landscape (The Guerrilla). 1915. Oil on canvas, 56¾ x 48½" (144 x 123 cm). Museo Nacional de Arte, INBA, Mexico City

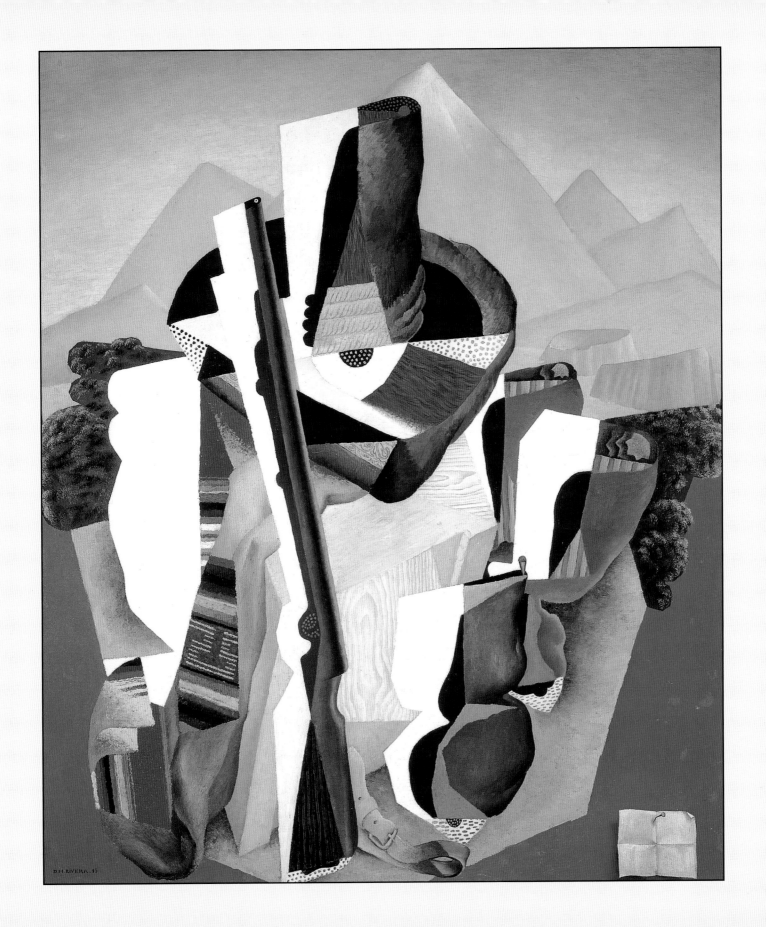

"The more plagiaristic painters would resort to charges of plagiarism; they would claim they had to hide their work from Picasso for fear that he would steal their *petites sensations*. They had little enough to steal. Occasionally, it is true, Picasso would lift something from a lesser painter, but he would always re-cycle it to greater effect."[13]

The source of Rivera's quarrel with Picasso was *Zapatista Landscape*, specifically the elements of dense foliage in that painting and the use of negative space (those white silhouettes). Picasso had seen this painting at Rivera's studio in 1915, while he was working on his own *Seated Man* that year, along with the same year's *Still Life in a Landscape*. In an early version of the *Seated Man* painting, as seen in photographs, the Spaniard had obviously lifted the shrubbery from Rivera; later, probably in response to Rivera's complaints, he would paint out those elements. But Diego also thought that Picasso had pulled off a conceptual burglary. In the Cubism of 1915, the outdoor still life was still a relatively new development; Cubist painters had been trying for some time to reconcile indoor and outdoor elements without resorting to the cliché of the window opening to the outside world. Rivera passionately believed he had solved this conceptual problem in his own painting. In *Still Life in a Landscape*, Picasso had substituted clouds for Rivera's mountains, had done his own variation on Rivera's use of negative space, and worse, again had blatantly stolen "his" technique of painting foliage, scumbling green over black.

Rivera was not quiet about this. He complained to his friends in the cafés. He shouted about it to Beloff and to Marevna. In his own memoirs, Rivera did not go into details, but did state, as diplomatically as possible: "It seems to me that, in every one of his periods, Picasso has shown more imagination than originality, that everything he has done is based upon the work of somebody else."

In her memoirs, Marevna would remember the visits of Picasso to Rivera's studio, where he would wander around, turning over canvases to scrutinize them. She wrote: "Rivera complained to me more than once, 'I'm sick of Pablo. If he pinches something from me, people will rave about Picasso, Picasso. As for me, they'll say I copy him. One of these days either I'll chuck him out or I'll shove off for Mexico.' Soon afterwards, they nearly came to blows. 'He left when I picked up my Mexican stick and threatened to break his skull,' Rivera told me. I never learned the full details of this incident, but I know that for some time there was a coolness between the two painters."[14]

Rivera might have been inventing for Marevna, his audience of one. But it is true that Picasso was becoming, if anything, more difficult. During the war, he painted much less and his mood was darker. His mistress was sick with tuberculosis and would die in January 1916. Picasso, now in his mid-thirties, drifted from woman to woman, appeared somber in the Rotonde, spent time with the wounded Apollinaire. Then, in October 1916, he abruptly moved out of Montparnasse, and out of Paris itself, to the suburban village of

Montrouge. Rivera no longer had to fear the sudden arrival of Picasso, with his greedy black eyes.

But Picasso the man, Picasso the artist, and Picasso as an idea would remain important to Rivera for the rest of his life. Years later, he would write: "I recognized and accepted Picasso's mastery in Cubism from the beginning. I readily proclaimed myself Picasso's disciple. I do not believe it possible for any painter after Picasso not to have been influenced by him in some degree." In 1949, he said: "I have never believed in God, but I believe in Picasso."

Rivera's break with Cubism took place after Picasso retreated from Montparnasse. While Apollinaire was away, his place as supreme avant-garde critic was taken by a young poet named Pierre Reverdy, a champion of early Cubism who sneered at and condemned those who followed, including Rivera. Reverdy was much like some of the critics who made themselves important in New York after World War II. He was not an artist but he wanted to tell artists how they should paint or sculpt. He did so in a style that was accusatory and nasty; if Apollinaire was a defense attorney for the arts, Reverdy was a prosecutor.

In March 1917, Reverdy published an essay setting down his rules for Cubism, and without naming names attacked Cubist portrait painters. These would include André Lhote and Rivera (a case could be made for Rivera as the finest such painter). That same month, the dealer Léonce Rosenberg organized a dinner for "his" painters, including Rivera, at the Lapérouse restaurant. Reverdy, a close friend of Rosenberg, showed up too. After dinner, Reverdy went along with the others, including Rivera, to Lhote's apartment. Ramón Favela quotes from a letter sent by Max Jacob to a friend about what happened:

"While we became livelier and livelier in the studio, Pierre (Reverdy) arrogantly raised himself up on the Cubist pedestal: he treated his friends there with such little respect that Monsieur Ribera (sic) felt insulted and slapped him without regard for his oratory talent. The young and ardent theoretician of Cubism, in whose heart runs courageous blood, leaped upon his insulter and they both forgot about the present, those present, and precedence. Reverdy yanked Rivera's hair while screaming: the crowd of people there threw themselves on the combatants. The unfortunate Madame Lhote had tears in her eyes."[15]

Some versions had Rivera roaring at Reverdy and punching him in the mouth. But when it was over, Rivera offered his hand to Reverdy and apologized. The hand seems to have been refused. And as Jacob pointed out, "the rancor of poets is enduring." The fight, with its broken china and one smashed window, became known as *l'affaire Rivera*. As Jacob predicted, the painters took sides, and after Rivera broke with his infuriated dealer, he found himself virtually ostracized. Rosenberg withdrew most of his Riveras from the market, including *Zapatista Landscape*, which wasn't seen again until the 1930s. The artists treated Diego as if he were a carrier of plague. His friend Lipchitz, now

ABOVE:

Still Life with Lemons. 1918.
Pencil on paper, 10¼ x 12″
(26 x 30.5 cm).
Private collection

OPPOSITE:

The Mathematician. c. 1918.
Oil on canvas, 45½ x 31⅝″
(115.5 x 80.5 cm).
Museo Dolores Olmedo
Patiño, Mexico City

The identity of the subject of this
ambitious portrait is not known,
but the work expresses Rivera's
interest in mathematical ideas
as they relate to art.

a Cubist sculptor, drifted away. So did Lhote and another friend, the Italian Gino Severini. Dealers needed critics more than they needed painters, and painters needed dealers. In May 1917, Reverdy published a piece in his magazine, laced with heavy-handed sarcasm and undisguised racism (he used the phrase "Indian savage" to describe his unnamed subject). Juan Gris described the piece in a letter as "a sort of fable in which, under the thinnest disguise, he insults Rivera and tries to make him ridiculous. It's silly revenge for the scene he had with him. I don't give a damn for Rivera, but I'm sorry that Reverdy does things like that. What's more, everyone is cross about it."[16]

Rivera most of all. Furious, hurt, perhaps heartbroken too, he gave up Cubism. He might have done so anyway, because after four and a half years, he, like Picasso, was looking again at other ways to paint. With the end of the war in sight, it was as if he wanted again to embrace the simple visible glories of the world and in that longing he was not alone. Beloff gives an account of one crucial moment that is also confirmed by Rivera in a slightly different version in his own memoirs:

"I remember an episode that perhaps was the one that decided him to leave [Cubism]. We were leaving a Cubist exhibition in the Rosenberg gallery; we passed one of those grand stores that there are in Paris, where they have fruits of all classes and colors, vegetables and other things, laid out on large tables on the outside. It was such a richness of forms and colors that Diego stopped to contemplate the spectacle and suddenly shouted: 'Look at them, what a marvel! And we are making such trivialities!'"

He began doing detailed drawings again, in a naturalistic style, of the human face, including his own. For the first time, he truly began exploring Cézanne, painting landscapes in the master's style. He absorbed all the news of the Bolshevik Revolution and was in Paris when the ghastly war came to its squalid end. (Marevna would give birth later to a daughter that Rivera would not acknowledge, calling her "a child of the armistice.") He and Beloff moved to a new address, away from his former friends. There was an apartment on the third floor and a studio for Diego on the sixth. He seemed to vanish from the cafés.

In his isolation, he began longing for home.

À Jean Cocteau
— Diego Rivera – 18

Italy

Rivera wanted to go home for several reasons: his artistic ostracism, his anger and weariness with the small, increasingly nasty world of Parisian art, and his realization that his long relationship with Angeline Beloff was almost worn out. Mexico would be both an opportunity and an escape.

And there was a summons. Álvaro Obregón, the greatest general of the Revolution, was about to be elected president; he wanted José Vasconcelos, who was now rector of the university, to become the head of a new cabinet-level Ministry of Education. Vasconcelos was bursting with ideas and enthusiasm, and one of his ambitions was to preside over a revival of mural painting in Mexico. Probably through Reyes, Guzmán, and Alberto J. Pani, the Mexican ambassador to France, the word of this plan reached Diego Rivera in Europe. His old rival, Roberto Montenegro, was ending his own long exile in Spain to return home for the same purpose. Diego wanted to go home.

The challenge of painting murals surely appealed to him. A new friend, the art historian Élie Faure, was encouraging the same notion in Diego. But Rivera knew nothing about fresco painting and he did not want to fail. The technique was seldom practiced anymore, and he knew of no old craftsmen, in Paris or Mexico, who might show him how it was done. He conceived of another idea. If he could sell some paintings, and the government would come up with some money, he would go to Italy and study the lost art of fresco. When he was ready, he would return immediately to Mexico and help bring into reality the visions of Vasconcelos. This ambition was forwarded by Pani to Vasconcelos, who eventually endorsed it. Pani had bought some of Rivera's paintings and commissioned a portrait, one of the best of the artist's post-

ABOVE:
Clinic of Dr. Jean Louis Faure. 1920. Pencil and graphite on brown paper, 8⅛ x 10¾″ (20.6 x 27.3 cm). Courtesy Mary-Anne Martin/Fine Art, New York

This sketch for a painting of an operation taking place in the clinic run by the brother of Rivera's friend Élie Faure is one of his earliest works to reveal an ambition to mass figures as in a mural or fresco.

OPPOSITE:
Portrait of Jean Cocteau. 1918. Pencil, 18⅛ x 11¾″ (46 x 30 cm). Carlton Lake Collection, Harry Ransom Humanities Research Center, The University of Texas at Austin

Diego and Angeline took a summer holiday in Arcueil in 1918. Rivera spent many hours with Jean Cocteau and André Lhote, who were vacationing nearby.

Cubist phase. He arranged for Rivera to obtain a small scholarship—about a thousand dollars—to study educational methods in the Italian schools.

A letter from Diego to Vasconcelos, acknowledging receipt of the grant, has survived. It is dated January 15, 1921, and was sent from Venice. It says, in part: "Thanks to this sum, I am now realizing that tour of Italy for which I so longed. . . . It would be superfluous to state of what crucial importance it is for everything that concerns my craft—but even I failed to realize in what measure and how emphatically so. . . . Here one feels, sees, touches and apprehends how the diverse materials manipulated by the different crafts unite, collaborating with, merging within, and exalting each other; until they make of the whole—building or city—a sum total that is function and expression of life itself, a thing born of the soil, organically tied to life—the living life of today, and past and future—a thing lifted above all the factors dependent on time."[17]

Before setting out, Rivera had many conversations with Élie Faure. A surgeon who had served in the horrendous field hospitals of the war, Faure

pushed Rivera to move into the future by examining the past. He urged the Mexican to look again at Cézanne and to pay greater attention to the palette and methods of Auguste Renoir. Above all, he told him to look at the art of Italy and helped design Rivera's itinerary.

Angeline did not accompany Rivera to Italy. In her memoirs, she says that he went first to paint in the French countryside in the early summer of 1920 while she stayed behind in Paris. Diego wrote to say he was working hard and that she should turn to Faure in case of need.

She later described the disintegrating relationship: "Faure, who I liked very much, wrote me a very long letter where he told me that Diego loved me, but that he would always make me suffer because in reality what he loved was love. . . . He [Faure] thought that the best thing would be for us to separate and that Diego go directly to Paris, and then to Mexico, without seeing me. I thought that Faure was right and I cried a lot. I wrote to Diego about what Faure had counseled me and that faced with the solution he had proposed to our problem, I accepted it and was resigned to being left alone. In reply, Diego wrote me a heartrending letter, where he told me I was the only person who counted for him, etc. etc., which made me cry more."

She says Diego soon returned to Paris from the countryside, but stayed away from her for almost two weeks. Then he came down with the grippe and returned home so that she could take care of him. "What could I do?" she says in the memoirs. "I still loved him." By the end of the year, he was ready to go to Italy. "I could have gone with him," she wrote, "but I was so tired of everything that I left it that he would go alone."

Rivera produced few paintings during his last year and a half in Europe, and none during his trip to Italy. Since this represents the longest such period of his life as an artist, there is a possibility that he was blocked. If so, this must have been caused by a combination of factors: the death of his son, the deterioration of his relationship with Beloff, a loss of artistic purpose after the abandonment of Cubism, the impact of the horrors of the war, even guilt over his failure to take part in the Mexican Revolution. In Italy, he did make many sketches and drawings, and notes about technique and composition. It is a measure of his long estrangement from Mexico that most are written in French.

His surviving drawings (almost three hundred of them) offer evidence of the things that drew his attention amid the dizzying array of art the first-time traveler encounters in Italy. The beautiful mosaics of Ravenna appealed to his sense of design. He must have been delighted to discover that there were two churches named Sant' Apollinare, as if dedicated to his dead friend, Guillaume Apollinaire. He made sketches of the mosaics in Sant' Apollinare Nuovo, on the Via di Roma, a complex that was originally built in the sixth century and expanded in the sixteenth century; a fluid pen drawing of a river god from the Arians' Baptistery; as well as the heads of Justinian and Theodora in the Church of San Vitale. He could not have failed to understand that

the mosaics, like all the public art he saw in Italy, were driven by a message; he might have called them propaganda for Christianity. This art dramatically conveyed simultaneous notions of heavenly paradise and earthly power.

In Florence, he made detailed sketches of Paolo Uccello's *Rout of San Romano* (1432), in the Uffizi Gallery. This tempera painting on a panel is six feet tall and twenty feet wide, and Rivera was probably drawn to it because of its scale. Later, Jean Charlot wrote about Rivera's sketches: "Stressing the fan-spreads of ruled lines, he exaggerated the artificiality of horses and armor to such a degree that they seem to become the cogs and pistons of Rivera's own machine age. Intent on muralism, he must have longed to know how the Uffizi panel, together with the companion pieces in London and Paris, blended with each other and for the lost architecture for which they were originally planned." [18]

In Padua, Rivera stood in awe before the extraordinary frescoes painted in the Arena Chapel by Giotto from 1303 to 1305. In Giotto, more than in any other painter, we see much of what Rivera's mural style would contain at its best: density that is also economical; the beautifully designed massing of figures in some scenes and in others the isolation of figures to evoke a mood of abandonment; the use of common objects such as tables or wine jars to give the viewer a sense of the familiar. There was another quality to the Giottos that must have impressed Rivera. This was acutely described by Henry James in 1873 as "the effect ever of carrying one's appreciation in and in, as it were, rather than of carrying it out and out, off and off." Such masters as Michelangelo, and Rivera's beloved El Greco, took the viewer out and out, off and off, to the very gates of Heaven. But Giotto, said James, "stamps hard . . . on the very spot of his idea—thanks to which fact he has a concentration that has never been surpassed. He was in other words, in proportion to his means, a genius supremely expressive; he makes the very shade of an intended meaning or a representative attitude so unmistakable that his figures affect us at moments as creatures all too suddenly, too alarmingly, too menacingly met." [19]

Rivera would have recognized the truth of these insights; later, his best murals would have something of that "in and in" quality while his rivals reached "out and out." And at his best, Rivera certainly stamped hard on the very spot of his idea. There are no surviving Rivera notes about the Giottos in the Arena Chapel in Padua, but he was to mention the great Florentine master with approval in other contexts. They were of immense importance in the forging of his mature style.

In Verona, he paused before Francesco Bonsignori's *Virgin and Child* and described the work of this follower of Andrea Mantegna as "magnificent." He must also have looked at Mantegna's own triptych in the Church of San Zeno in that city (he left some notes about the murals of the young Mantegna in the Eremetani in Padua), but there is little trace of Mantegna in the later Diego Rivera. In the Castelvecchio, he sketched a detailed analysis of the *Virgin and Child with St. Catherine in a Rose Garden* (c. 1430), then attributed to Stefano

da Verona but since given to Michelino da Besozzo, which used realistic details to make its essential fantasy seem plausible. His notes, scribbled in French around his analytical drawing, have a poetic quality:

"Excellent surface composition. Birds the size of angels, angels the size of live birds. St. Catherine seemingly feeds a bird while receiving from an angel the palm of martyrdom. Angels' heads are as big as are the roses, in the mystical rosebush of Stefano de Verona [sic]. The Virgin and Child. All is gold outside of paradise. Within, all idea of optical scale is destroyed and all is in the spiritual order. It is extremely truthful and gentle."[20]

In Siena, he saw in the Palazzo Publico the group of frescoes by Ambrogio Lorenzetti called the *Allegory of Good and Bad Government.* Painted in 1338–40, they were essentially secular, a reminder to the councillors of Siena—who met in this room—that good government was essential to justice and the common weal. Lorenzetti painted the commune of Siena, a hermetic hill town of tall buildings, windows, walls, and towers in obvious contrast to the forlorn emptiness of the Tuscan countryside. Elements of these frescoes would later appear in Rivera's Mexican murals: the stark black sky, the almost Cubist arrangement of buildings, the rolling countryside. More important, the notion of good and bad government would be the organizing principle for the great murals he painted in the mid-1920s for the agricultural school at Chapingo.

But it was Giotto (seen again by Rivera in Assisi), and possibly Piero della Francesca and Sandro Botticelli, who must have stirred him the most. Their work suggested to him a way out of the false choice between traditional nineteenth-century academicism and Cubism. After hundreds of years, they still looked startlingly modern. They also presented solutions to more technical problems. One was the integration of frescoes with existing architecture. Another was more complicated: the challenge of creating sufficient illusion to convince those you are trying to convince that what you are showing them is true, while *also* respecting the flatness of the wall itself. When the Italian masters were at work, there was a shared belief in the religious underpinnings of their artistic visions. But the Mexican Revolution was so new that it hadn't yet been defined for a mass audience. If Rivera was to succeed in doing that, he would have to make his visions of the Revolution as real as Heaven was to those who first saw Giotto.

There was one other possible influence on Rivera during his Italian journey. At one point in 1921, he visited Rome. While there, he must have seen the new work of Carlo Carrà, who had been part of the original Futurist group and then had grown disillusioned with them, in particular with the self-inflated rhetoric of Umberto Boccioni. The Italian Carrà and the Mexican Rivera had met in the Rotonde, and at this stage, their careers followed similar paths. In Paris, Carrà also had submitted himself to the disciplines of a rigorous Cubism, spent time with Picasso, made some excellent collages, and then, in late 1914, had begun a radical personal journey into the Italian past. Carrà was close to Gino Severini, also a Futurist who turned to Cubism, and

Severini was a friend of Rivera. Certainly these restless moves toward medieval and Renaissance art must have been discussed in the cafés, if only as an explanation for Carrà's decision to return home to Italy during the war. Back in Italy, there was another parallel with Rivera: in Carrà's groping for fresh meaning in the past, he was also looking again at Giotto.

In his autobiography, the Italian painter talked about "a need that has matured in me for something different and more measured . . . a strong desire to identify my painting with history, and particularly with Italian art history. It matters little if this aspiration was understood by few people and my new needs were interpreted as the result of tiredness. They were mistaken who saw in me a hurried reconciliation between tradition and revolution."[21]

There would be echoes of the same sentiments in some of Rivera's later explanations of his abrupt, decisive shifts. When Carrà was a younger man (he was born in 1881) he called himself an anarchist, but his abiding sense of Italian patriotism overwhelmed that creed, and when he was called up in 1917 at age thirty-six, he reported for military duty. He was found unfit for the front, sent to a hospital, spent some time in a mental hospital, apparently because a doctor thought some earlier Dada-like collages were evidence of insanity. He was passed on to another hospital, this one in Ferrara, and met for the first time Giorgio de Chirico. From that accidental friendship came Metaphysical Painting. Later, with the Italian art world growing rancid under Mussolini, Carrà and de Chirico would each lay claim to inventing the style, and bitterly accuse each other of artistic robbery.

But it is plausible that during his 1921 sojourn in Rome, no matter how brief, Diego Rivera saw Carrà's new work. Carrà was certainly a major object of discussion in artistic and intellectual circles. In 1919, the Italian had published a book on the subject of "metaphysical" painting, was exhibiting his work, and was writing for the Italian art magazines. There is little trace of de Chirico in Rivera's work. But some of the early murals are marked by the same deliberately naive quality seen in Carrà's painting in the immediate postwar period, his use of common "real world" items, from cows to tables, and a simplified, stylized evocation of landscape and vernacular architecture.

Rivera was back in Paris by May of 1921. The die was now cast. He purchased a modern textbook on fresco by Paul Baudouin. He spent some time with young David Alfaro Siqueiros, who was on a fellowship in Europe after fighting in the Revolution; in spite of their later quarrels and rivalries, Siqueiros always acknowledged Rivera's generosity in those few days in Paris. Then Diego rolled his canvases, packed his clothes, said good-bye to his friends, and went to the train at Gare Saint-Lazare. At the pier in Le Havre, he said farewell to Angeline Beloff. He told her he wished she was coming with him to Mexico, but they just didn't have the money for two fares. As soon as he was set up, he assured her, he would send the money for her fare and see her soon. They never spoke again.

At the end of June 1921, he arrived at Veracruz.

OPPOSITE:
Portrait of David Alfaro Siqueiros. 1921. Charcoal and red chalk on tan paper, 15¼ x 9½″ (38.8 x 24.4 cm). Museo Diego Rivera, INBA, Guanajuato

Chapter Five

RENAISSANCE

The man who would change Diego Rivera's life was waiting for him in Mexico City. His name was José Vasconcelos. He was a brilliant man of his generation, a messianic bundle of paradoxes and contradictions. A racist who wanted to liberate the Indians from centuries of neglect, an agent of modernity who was also a mystic and a believer in the lost Atlantis, Vasconcelos at thirty-eight was now the minister of education. He was backed by the power of the president who had chosen him, Álvaro Obregón, the greatest general of the Mexican Revolution.

"His message summarized the thinking of all competing factions: an illiterate people would always be enslaved," the Mexican essayist Carlos Monsiváis would write many years later.[1] Vasconcelos was that most formidable of intellectuals: a serious man. Obregón liked him and was amused by him. For one thing, he was honest. For another, he had grand ambitions for Mexico. Vasconcelos would teach Mexico to read. He would give it great art. He would restore its vanished cultural grandeur. He would create, in short, a Mexican renaissance.

One concrete plan was the adornment of public buildings with murals, works that would help give an illiterate peasantry a binding, idealistic idea of what it meant to be a Mexican. "As we are small," Vasconcelos said, "we must perpetuate ourselves in large works."

Vasconcelos did not exactly order a celebration when Diego Rivera arrived in his office, ready to paint murals. The minister was probably annoyed by Rivera's detour to Italy, on government money. He was also cold to most modern art. But one additional reason for his initial aloofness might have been a certain disdain for the way Rivera had lived during the years of the Mexican Revolution. Diego had chosen Paris and his career. Vasconcelos had served at the side of Madero and later Pancho Villa. He had seen the dead. He had witnessed the vast destruction. He had been jailed and threatened and exiled. Whatever his personal feelings might be, in the end,

José Vasconcelos, Pancho Villa, Eulalio Gutiérrez (provisional president of Mexico), and Emiliano Zapata at a banquet at the Palacio Nacional, Mexico City, December 6, 1914. Photograph by Sabino Osuna. Tomás Rivera Library, University of California, Riverside

Vasconcelos was on the winning side in the immense struggle, and now, with the shooting over, he was determined to make something valuable and enduring out of all the horror and sacrifice.

Perhaps, however, the initial indifference of Vasconcelos to Rivera had another, even simpler explanation: Vasconcelos was too busy. He was one of the most essential commanders in the non-shooting phase of a Revolution that had one social goal: unifying the many regions and classes of Mexico into a single nation. This meant forging together three basic ethnic strands: white Mexicans, the so-called *criollos*; those of mixed racial heritage, called *mestizos*; and the unassimilated Indians, more than a million of whom did not even speak Spanish. Diego Rivera walked into this raging debate upon his return from Europe.

In and out of the government, intellectuals endlessly debated one huge question: After centuries of an imposed Spanish culture, and the nineteenth-century importation of French culture to an independent Mexico, was there a truly *Mexican* culture, and if so, what were its components? For Mexico truly to be a nation among nations, there would also need to be a revolution in culture, an embrace and celebration of indigenous music and dance, architecture, literature, and art. At first, Vasconcelos saw murals as a way to present the artistic genius of Mexicans to the world; gradually, he understood that the content of those murals would affect the way Mexicans thought about themselves.

At the same time, Vasconcelos insisted that all Mexicans should be part of a wider culture. So he printed hundreds of thousands of cheap editions of classics: the *Iliad* and the *Odyssey, The Divine Comedy* and *Faust, Don Quixote,* and the work of his own most favored philosopher, Plotinus. During his four years at the Ministry of Education, these books were carried, sometimes on the backs of mules, to more than a thousand new schools and three thousand new libraries. They were the rifles and artillery of the war against illiteracy. With passion and fervor, Vasconcelos recruited young, educated city people to serve in his army of the word, and they traveled to places that had never before seen schoolteachers. They were often at great risk; there was resistance from landowners, from hidebound priests; some of the rural schoolteachers were murdered. But they endured. After four years, illiteracy in Mexico had been reduced by 30 percent.

"But Vasconcelos' most lasting contribution," wrote Selden Rodman, "was not to philosophy, which he loved, nor to literature, which he cherished, nor to dance (he staged operatic ballets), but to painting, for which he had (at best) an antiquarian's taste."[2]

While Diego occupied himself with easel painting, illustrations, and some no-show jobs provided by the Ministry of Education, Roberto Montenegro was at work in Mexico City on a wall in the old Church of Saint Peter and Saint Paul, built by Jesuits in the late sixteenth century. He was a natural choice,

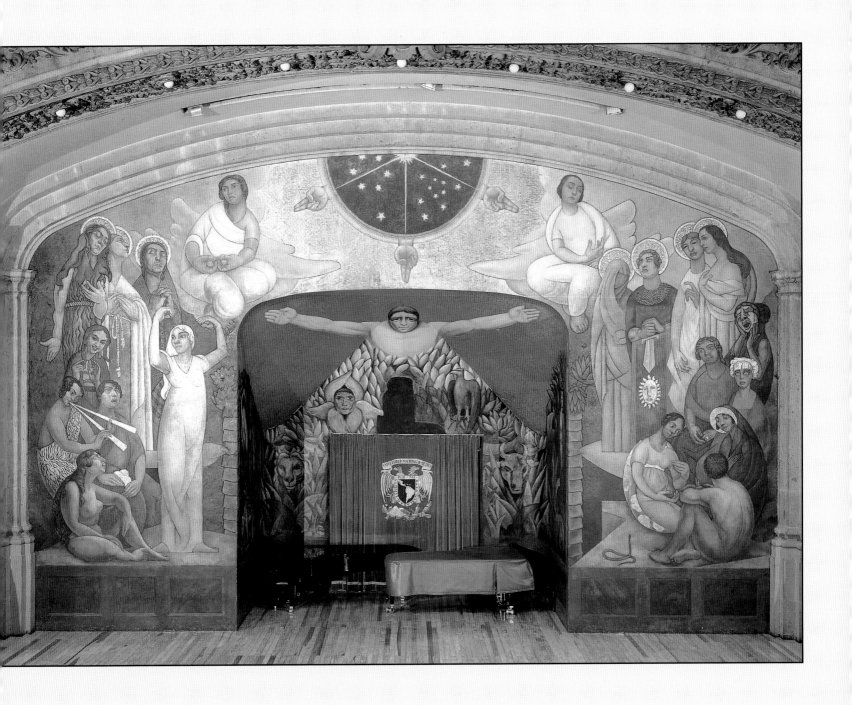

since he had already done at least one mural in Europe, for the Casino in Palma de Majorca, and because his design did not alarm Vasconcelos. In fact, the theme had been supplied by the minister himself: "Action overcomes destiny: conquer!" This was characteristically traditional, mystical, and vague; it could have been safely commissioned during the *Porfiriato*. When Montenegro showed his design, Vasconcelos loved it. When he saw the actual painting, done in tempera and nicknamed "the Dance of the Hours" for its prancing ladies in silky gowns, Vasconcelos said he was disappointed. But the fault was really his own. Meanwhile, in what might have been a small act of cruelty or a test of the newly arrived painter's ambition, Vasconcelos gave Rivera a studio on the second floor of the same building where his old rival was at work. He did not give him a wall to paint.

In the old National Preparatory School, a few blocks away, other muralists were at work. Jean Charlot, only twenty-three, a French painter and writer, veteran of World War I, was painting *The Fall of Tenochtitlán,* showing the Conquest from the Mexican point of view. This was the first true fresco of the modern era in Mexico. Fernando Leal, twenty-one, was hard at work on *The Feast of the Lord of Chalma*, which celebrated Mexican folk dancing and an enduring post-Conquest Mexican myth. These were the first painters in the Mexican Mural Renaissance. Others would follow them into the National Preparatory School, including the most important of all, José Clemente Orozco, and later, David Alfaro Siqueiros. As he saw their work, Diego was miserable.

"For the first six months . . . I painted no frescoes but supported myself with a succession of bizarre jobs," he remembered later. "One was as art advisor for a publishing house that never published a book; another was as chief of propaganda trains—a governmental scheme that came to nothing; and a third was as director of a workers school which never opened its doors."

Through this period, Vasconcelos was observing Rivera, listening to him, lecturing him. He didn't trust Rivera, because "his head was full of Picasso." In November 1921, he took Rivera with him on a journey to Yucatán. There were others in the government party, including Montenegro and the poet Carlos Pellicer, and Vasconcelos urged them to become more familiar with the true artistic heritage of Mexico. They saw the ruins of Chichén Itzá and Uxmal. They spent many hours with the charismatic socialist governor Felipe Carrillo Puerto, who was attempting a synthesis of modern economics and the traditions of the ancient Maya. Rivera filled sketchbooks. He explored the ruins, submerging his imagination in the lost past, and made drawings of the men and women of the Mayan present. He talked for hours with Vasconcelos, his visions and schemes growing grander by the hour. Vasconcelos was impressed. When they returned to Mexico City, he gave Rivera what he so desperately wanted: a wall. The thirty-five-year-old painter would execute a mural in the Anfiteatro Bolívar in the National Preparatory School.

Creation

The Anfiteatro Bolívar was an auditorium intended for concerts, poetry recitals, and lectures. It was fairly new, built near the end of the Porfirian era by the architect Samuel Chávez. In December 1921, Diego began his mural on the large wide wall at the back of the stage, his design taking account of a deep niche in center stage, holding an organ. When finished, it would cover about one thousand square feet. His assistants were all solid artists themselves: Charlot, Carlos Mérida, Amado de la Cueva, and Xavier Guerrero. But Rivera was in charge. Thematically, it was if he had learned nothing on his journey to Yucatán. The overall title of the work was *The Creation*, and it was a mishmash of abstractions about the universe, life, humanity, and the things that made men into Man: science, the arts, and philosophy. These themes were buttered together with half-digested notions that Vasconcelos had derived from Pythagoras about the universe as a form of energy. At this point, Vasconcelos hadn't learned anything in Yucatán either.

The composition is arranged around a symbol of primal energy called *Light One*, a semicircle of blue and gold from which three rays descend. Each ray ends in a human hand, and each hand is folded with index and middle finger to signify "father/mother." Within the semicircle there is a hexagram of stars on the left, representing feminine principles, and a pentagram on the right, for male principles. To left and right of this unifying device are eighteen human figures, all of them being pondered by a pair of angels with plump wings. Eight of the figures are crowned with Giottoesque halos.

On the lower right, a naked man sits with his back to the audience, while beside him an adder is poised, as if to strike. The woman to his left is *Knowledge*. She is talking, using her hands to emphasize some point. The woman to his right, in the blue tunic and gold bonnet, is *Fable*. Above her is a golden-haired woman with mascaraed eyes. She is *Erotic Poetry*, and though she reminds a North American visitor of the actress Carol Channing, the actual model was a bohemian with a gift for poetry and erotic adventures—she was then the mistress of Dr. Atl—who called herself Nahui Olin. We also see *Tradition* and *Tragedy* (weeping tears of blood), along with *Prudence, Justice, Strength* (the one with the sword and the red shield), and an appropriately vapid *Continence* (standing from right to left).

On the left side of the composition, ascending above the naked woman, are *Dance, Song, Music,* and *Comedy*. Above them is another haloed female trio: *Charity, Faith,* and *Hope*. The red-haired *Charity* discreetly offers a breast to the needy. *Hope* is heavily robed and cinctured, and gazes heavenward, presumably at God. *Faith* gazes inward, hands clenched in prayer. They don't seem happy at all.

In his easel work at this time, Rivera was responding to Mexico. In this first mural, he is responding to art history. He claimed that he was exploring "the

origins of the sciences and the arts, a kind of condensed version of human history." He might have believed this pretentious notion. But in execution, there is a clammy, dead feeling to the work that suggests a memory of the Nazarene cult embraced by some of his teachers at San Carlos. It was as if in beginning his work in a new medium, he had to erase all that he had learned in Europe and return to the essential lessons of art school. Rivera's draftsmanship is competent, the colors are chromatically balanced and designed, the faces have variety, and he makes good use of the existing architecture. But the work itself is utter rubbish; insincere, irrelevant, a pastiche created for a new audience of one: Vasconcelos. As he had during his years on scholarship in Europe, Diego Rivera was painting for the man who signed the checks.

There are two aspects of *The Creation* that are still of interest and both have to do with Rivera's own history. One is the niche. In December 1922, when most of the mural was completed, Rivera took a second trip into southern Mexico, this time to the straits of Tehuantepec. By all accounts, this journey had an even greater impact on him than the trip to Yucatán. He was swept away by the natural beauty of the tall, graceful Tehuana women. The foliage of the jungle intoxicated him with its primitive, exuberant life, its feminine shapes, and perhaps the way it confirmed the visions presented to him in Paris by Gauguin and the Douanier Rousseau. He made sketches that he would draw upon for the rest of his life. And when he returned to the Anfiteatro, he set about finishing the painting of the niche. Here for the first time, we see the work of the mature Diego Rivera.

It was apparently too late to remove the figure of the Pantocrator, with his outstretched arms in a gesture of crucifixion. But just below this godlike master-of-the-universe figure is a Tree of Life (familiar from Mexican folk art) bearing birds and animals. A lion, an ox, a caribou, and an eagle, all symbols derived from the New Testament, can be seen in the foliage. The warmth of Diego's palette here was in sharp contrast to the high-keyed colors of the rest of the mural.

The second point of continued interest is the game of identifying the models for the various abstract figures. Most are forgotten now. But Rivera's future wife Lupe Marín did pose for the nude woman in the lower left, for *Strength*, and for *Song*. In some versions of the story, *Prudence* is a beautiful young woman named María Dolores Asunsolo, who would become better known as the movie star Dolores Del Rio. Years later, when both were famous, Dolores Del Rio would pose for him again.

The mural took more than a year to complete. One reason: the medium Rivera chose was encaustic, a wax-based painting that required his assistants to use blowtorches on the walls to keep them warm enough for the paint to

anneal. Another possible reason was Rivera's own doubts about the value of what he was doing. His biographer Bertram D. Wolfe would later dismiss the Anfiteatro mural as apprentice work. And Diego was not happy with it. Years later, he said, "Though my interpretation of the Creation was essentially progressive, I was dissatisfied when the work was done. It seemed to me too metaphorical and subjective for the masses."

True Fresco

Rivera did not give up on mural painting. He continued to work on Vasconcelos, slowly persuading him that the Anfiteatro mural was only a beginning, appropriate to its setting, but no indication of what was now possible. Diego Rivera was imagining another kind of public art, another kind of mural.

The walls of the new Ministry of Education building were the great prize for any of the muralists, but it was Diego Rivera who seized his opportunity and through artistic skill, force of personality, and a ruthless will made himself *the* painter of Mexico. Here in the Ministry of Education, beginning on March 23, 1923, he created one of his undisputed masterpieces, and one of the enduring artistic triumphs of twentieth-century art. The scope of the work was epic: 128 individual panels on three floors covering a total of about 17,000 square feet. His skillful use of fresco, growing from comparative crudeness in the initial panels on the ground floor to absolute mastery of the medium in the final panels on the third floor, is a textbook demonstration of the growth of an artist.

The subject matter had extraordinary variety, culminating in the fierce struggle of Mexicans to build a utopian future. When Rivera was finished, four years and three months after beginning, he had created a new, heroic image of Mexico. Images from the Ministry of Education cycle continue to be used today as book jackets, album covers, and posters; they represent Mexico to the world, and in some ways, to Mexicans themselves.

Rivera threw himself into the work with a mixture of meticulous planning and near manic energy. After the tediousness of work in the Anfiteatro, he no longer wanted to work in encaustic. His first task was to learn the technique of fresco painting. That technique was ancient, even in Mexico, where fresco was employed in the ninth-century murals in the Mayan city of Bonampak. But it reached peaks of craft and aesthetics in Southern Europe, most specifically in Italy (but not in damp Venice) before and during the Renaissance. The first

great master of fresco was Giotto, and Rivera had studied him up close and in reproductions. In its basic technical principles, fresco painting had not changed much in more than five-hundred years; it required both speed and patience, along with clarity of design, and preparation. Diego Rivera would bring all those qualities to his use of the medium and add some of his own.

Fresco—the word means "fresh" in Italian—requires the painter to work quickly. Wet plaster is applied to a wall, and while it is still damp, water-based tempera paint is applied over it. The plaster has been pre-mixed with pure lime, which serves as the binder. As the plaster dries, the thin paint is permanently bonded to the surface through a chemical process: calcium hydroxide (the lime) converts to calcium carbonate through the absorption of carbon dioxide present in the air.

All the young muralists in Mexico studied the technique with enormous concentration, drawing heavily on a treatise written in 1400 by Cennino Cennini. All, including Diego, made their own variations. They swiftly discovered that fresco had little to do with the nineteenth-century tradition of the isolated romantic painter struggling in a garret. It was instead a collective way of working, requiring the labor of a number of people. The wall itself had to be absolutely free of dampness or the plaster would not stick. The Ministry of Education was a new building, relatively free of ancient dampness; nevertheless, since the walls were exposed to weather, it was difficult to work during the summer rainy seasons in Mexico City. The plaster itself was usually a mixture of several elements: sand or marble dust was added to the slaked lime, along with water. But the sand had to be washed clean of impurities such as clay, mica, or sea salt, and Rivera came to prefer marble dust, which he mixed in a ratio of two parts marble dust to one part lime. The water had to be pure too, which in that era in Mexico required the use of distilled water.

The wall was plastered in several coats. The first layer, applied roughly with trowels to a thickness of about one-half inch, was usually mixed with animal or vegetable fibers for strength. Once the plaster dried, it was scratched to pro-

vide a strong grip for the second layer. This, called the *arriciato* or brown coat, was stiffer in consistency. A third coat, the *intonaco* or "finish coat," covered only that area to be painted during the session of a given day. The painter has about eight hours to get his work done before the *intonaco* is too dry to absorb any more pigment.

The muralists worked from cartoons on paper that were the same size as the murals. The sheet would be perforated along the outlines of the drawing of that day's work, fixed over the brown coat, and then dusted with chalk, so that the outline was clearly marked on the surface to be painted. The outline was duplicated on the finish coat so that the section being painted each day fit into the overall design. Rivera

usually followed this process carefully in order to fit different sections into a coherent whole, as if doing a gigantic jigsaw puzzle. The problems of composition had to be solved before he started painting. He worked from the top down, in horizontal bands. The problems of matching color and tone are obvious; on given days, the same pigment might dry to a subtly different hue. As his skill increased, Rivera included such possibilities in his designs and created various design elements to derive clear boundaries between one day's painting and another. Occasionally, he would abandon the process of absolute preparation and paint directly on the wet plaster. But that was rare.

The process demanded speed of execution, and Rivera was equal to the challenge. He worked many hours on his scaffold; a fourteen-hour day was routine, and he sometimes painted all night. At least once he fell from the scaffold in a state of exhaustion. He was driven by a need for perfection, as if conscious that his work here would last as long as the building itself. Jean Charlot, who served for a while as a Rivera assistant, remembered an early moment in the work for the Ministry of Education, when Diego was making the difficult transition from encaustic to fresco:

"Late one of the first evenings that we were on the job, as I walked through the darkened court I noticed that the painter's scaffold was trembling as if at the start of an earthquake. Coming near, I saw Rivera's dim bulk at the top. Climbing up to investigate, I found him crying and viciously picking off his day's job with a small trowel as a child will kick down a sand castle in a tantrum."[3]

Much of the work was manual labor, and Rivera soon had his own highly skilled team, made up of painters and masons. They prepared the walls. They ground and selected the powdered pigments, arranging the colors for Diego's palette. These pigments all needed earlier testing against the effects of lime and light and weather. The palette was limited and relatively simple: all the ochers, Pozzuoli and Venetian reds, both raw and burnt sienna, cobalt blue, vine black. He always started painting with the lightest colors and arrived last at the darkest (a reversal of the traditional methods of the oil painter). Like a fine watercolor painter, he often allowed the white of the plaster to show through, which gave his surfaces a brilliant luminosity.[4]

His most important assistant was a pure-blooded Indian named Xavier Guerrero. Guerrero grew up in Guadalajara, where he taught himself the techniques of fresco painting as an adolescent, painting on the walls of small private houses and in *pulquerias*. Guerrero's self-education was interrupted by the Revolution. At sixteen, he went off to be a soldier. That perhaps explained his later silence about almost all details of his early life. He arrived in Mexico City in 1921, went to see Roberto Montenegro, the most famous of all Guadalajara painters, and was quickly made technical director of the project in the Church of Saint Peter and Saint Paul. He did some painting too: decorative birds and garlands that have survived to this day. He met Diego through

Montenegro, and when Diego moved from the Anfiteatro Bolívar to the Ministry of Education, Guerrero went with him. There is a handsome portrait by Rivera of Guerrero that expresses the simplicity of the man and Diego's fondness for him. Like many other young Mexicans who had passed through the experience of the Revolution, Guerrero was also a committed communist.

Politics

The masterworks of Diego Rivera were created by a man of growing political convictions. It was as if the return to Mexico had given him the confidence to express his beliefs about society—a confidence not possible in countries where he was not a citizen—and those beliefs were strongly Marxist. The emergence of Rivera as a communist was quite sudden; during the long years of expatriation, he had little to say about such theories. In Mexico, he quickly surrounded himself with passionate, strong-willed communists like Guerrero, and made friends with many others, most of them younger than he was. The maker of public art and the Marxist partisan emerged at almost the same time.

His personal life was also changing swiftly. Near the end of 1921, Rivera's father died of cancer. By all accounts, Rivera was moved by this event, and would always speak of his father with idealizing affection. Around this time he met Guadalupe Marín. She was born and raised in Guadalajara, where her middle-class family knew the family of Roberto Montenegro. Everybody who knew Lupe Marín remembered her later as an extraordinary young woman.

Diego Rivera was introduced to Lupe by a communist folk singer named Concha Michel. In Rivera's version of the tale, Michel got him together with Lupe in the spirit of self-defense. Michel was living with a "brave, stupid and fairly honest man" but, according to Rivera, she feared she would succumb to temptation and sleep with the irresistible Diego. The only solution was to divert Rivera with another woman. Lupe Marín had just arrived from Guadalajara to take part in centenary celebrations of the independence of Mexico from Spain. Concha Michel knew Lupe from Guadalajara. So she brought Lupe to meet the great Rivera in his studio in the old Church of Saint Peter and Saint Paul. Rivera was painting a still life of oranges and other fruits that he had piled in a bowl. When Michel arrived with Lupe, he stopped painting immediately, vividly remembering the moment years later:

"A strange and marvelous-looking creature, nearly six feet tall, appeared. She was black-haired, yet her hair looked more like that of a chestnut mare than a woman's. Her green eyes were so transparent she seemed to be blind. Her face was an Indian's, the mouth with its full, powerful lips open, the corners drooping like those of a tiger. The teeth showed sparkling and regular: animal teeth set in coral such as one sees in old idols. Held at her breast, her extraordinary hands had the beauty of tree roots or eagle talons. She was

round-shouldered, yet slim and strong and tapering, with long, muscular legs that made me think of the legs of a wild filly."

Such imagery would surely attract the interest of Freudian analysts and feminist scholars. But it is saved by Diego's own version of the tale. He says that Lupe turned to Concha Michel and said: "Is *this* the great Diego Rivera? To me he looks horrible."

Michel laughed, said "Nothing can stop what's going to happen now," and fled. Lupe proceeded to consume all of the fruit that Diego was so carefully painting, claiming that she hadn't eaten in two days. Then she posed for him. And kept posing for him. He loved drawing her large, expressive hands (his own hands were very small for such a huge man). In one portrait, he painted her wildness and fierce beauty. She posed for the three figures in the Anfiteatro Bolívar. When he was not working, they went everywhere together. During this period, sad and pathetic letters continued to arrive from Angeline Beloff. Rivera answered none of them.

"One night," Rivera remembered later, "during a political meeting held in the house of a friend, Lupe sauntered in. She greeted everybody and then seriously and formally asked for the floor. In the curious silence which ensued, she delivered an excellent speech, using political, social, professional, and personal arguments to prove to her listeners that if Diego Rivera were not entirely a fool, he would marry her.

"As soon as she was done, I rose to second her."

To console her middle-class parents, they married in church in Guadalajara (not legally binding in the revolutionary anticlerical Mexico of the day) and moved into an old house at 12 Mixcalco in the heart of old Mexico City. They began to make a family. Lupe gave birth to two daughters, Lupe (1924) and Ruth (1926). To support his family and his growing mania for collecting Pre-Columbian art, Rivera cannibalized his murals to make easel paintings and drawings that could be sold to Americans in the capitalist north. His drawings made as studies for the murals also began to find a market.

The house was near the great fruit and flower markets that Diego loved so much and within walking distance of the National Preparatory School and the Ministry of Education. The high-ceilinged rooms soon became a command post for the rebellious, bohemian, left-leaning young artists and intellectuals of Mexico City. Diego was older than most of them and, thanks to his years in Europe, more sophisticated. He assumed the role of mentor, ward boss, and master of revels. He was funny, smart, entertaining, worldly, and passionate about painting. Lupe was funny, smart, a great cook, and passionate about everything else.

One huge subject of debate was the role of ideology in this new era in Mexico. Many young Mexican artists and intellectuals had supported the Mexican Revolution, that cataclysm described later by Octavio Paz as "the great Goddess, the eternal Beloved, the great Whore of poets and novelists."

Some had even fought in it. But in those few years after the fighting stage had ended, they felt that the Revolution had one immense problem: it was a revolution without an ideology. Too often, it had defined itself by what or whom it was against; it had only vague notions about what it was for and what kind of Mexico it would create. Zapata's demand for agrarian reform was necessary, practical, a given, and a romantic expression of the Revolution's goals. But it was not a worked-out national ideology that could apply to all Mexicans, from all backgrounds, from all regions, and above all, from the growing cities.

The violent triumph of the Bolsheviks in October 1917 and the swift and bloody creation of the Soviet Union provided an instant model. Many young intellectuals were persuaded that a Marxist-Leninist ideology could be imported to Mexico and meshed with the existing nationalist and agrarian goals of the Mexican Revolution. They believed the lies about communist successes that were being sent to the world from Moscow. They truly believed that the new and glorious Soviet Union was a state where artists and writers flourished, and where millions of happy Russians, Slavs, and other ethnics were working selflessly toward common goals. Highways! Dams! Collective farms! Why couldn't it work in Mexico? After all, wasn't the Soviet Union primarily a rural and agricultural nation? And hadn't the great V. I. Lenin proved that Marx was mistaken in his belief that full-fledged industrial capitalism must precede communism? It was an oddly innocent time. Nobody had yet heard the word *gulag*.

Because of his long stay in Paris, and his even longer relationship with the now-discarded Angeline Beloff, Diego was conversant with the vocabulary of Marxism. As noted, there is no evidence in his work or his letters that he had embraced the creed while in Europe. But in that first year home, while immersed in the hothouse debates in his own living room, he was swept into the faith. As it had done to many intellectuals and artists of the era, that embrace would shape his life and his art.

At the end of 1922, Diego Rivera formally joined the Mexican Communist Party. This was hardly a Mexican party; its founders had included an Indian nationalist from India, an American on the lam from the wartime draft, and several Japanese.[5] The party took money from the Comintern and worked at infiltrating trade unions. Later it would accept subsidies from the Mexican government. Diego Rivera was member number 992. His biographer Bertram D. Wolfe, who was also a communist at the time, says that it would be naive to believe that there were 991 other active members of the Mexican party in 1922. It probably had fifteen hundred members through the early 1920s, but most arrived, signed up, grew bored or disillusioned, and drifted away. In mid-1924, the party's treasury held $2.50. This was essentially a tiny group, convinced of its importance as a Leninist vanguard. Diego, because of his age, his growing prestige, and his gift for oratory, quickly became a leader

OVERLEAF, LEFT:
Dance in Tehuantepec. 1928. Oil on canvas, 6'6¾" x 5'3¾" (200 x 162 cm). Private collection, New York

OVERLEAF, RIGHT:
The Flowered Canoe. 1931. Oil on canvas, 6'6¾" x 5'3" (200 x 160 cm). Museo Dolores Olmedo Patiño, Mexico City

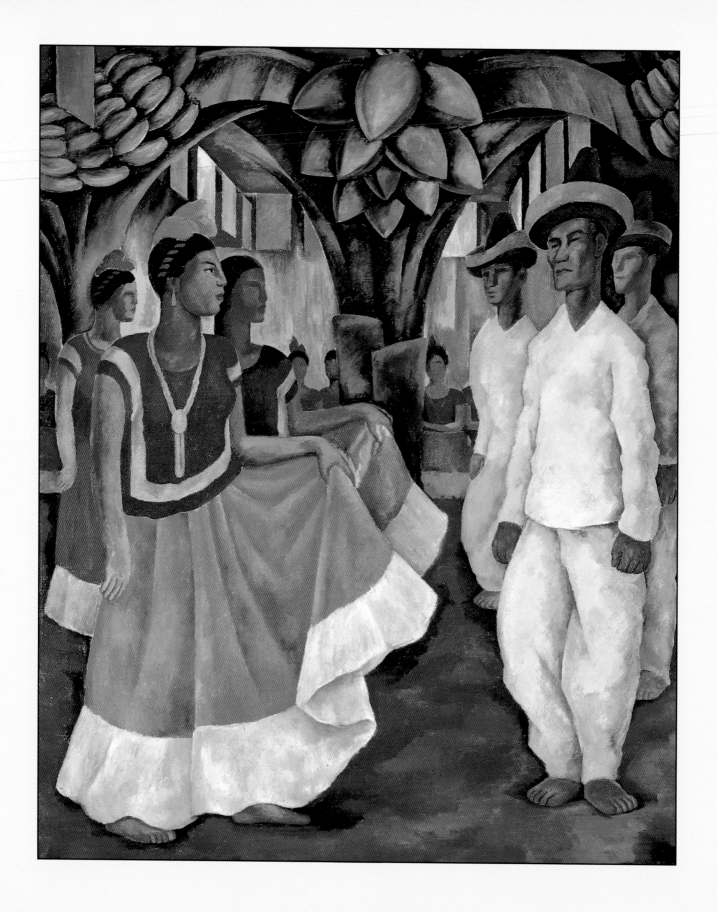

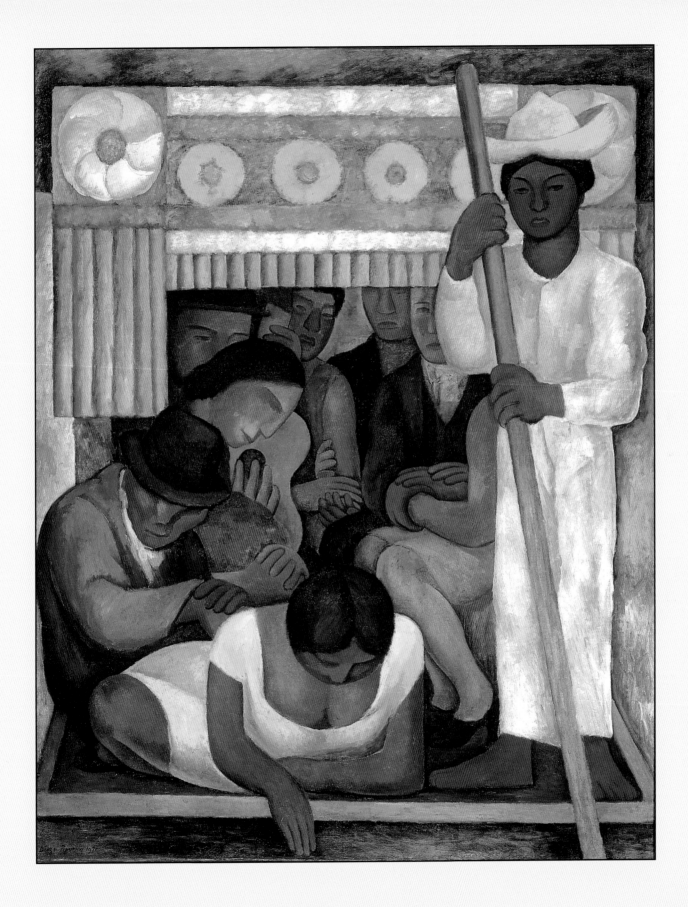

and was elected to the Executive Committee in 1923. Of the seven members of this committee, three were artists: Rivera, David Alfaro Siqueiros, and Xavier Guerrero (José Clemente Orozco never joined the party).

At the same time, after conversations in the Rivera apartment, most of the mural painters formed a union: the Sindicato Revolucionario de Obreros Técnicos y Plásticos.[6] The nature of mural painting convinced them that they were workers in the building trades, not just bourgeois artists or members of the chattering classes. They wanted to feel this way for another reason: they were communists, engaged in a class struggle. Therefore, they had to be the workers, not the hated and decadent bourgeoisie. They certainly were poorly paid; for painting murals, Rivera was clearing about two dollars a day, after paying his assistants and the costs of lime, plaster, and paint.

The twenty-four-year-old Siqueiros, who had returned from Europe earlier in 1922, was the true dynamo of the union. Like Guerrero, he was a genuine veteran of the Revolution, a combat soldier who had risen to the rank of captain, and that experience gave him authority that Rivera lacked. Siqueiros was bursting with schemes, plans, projects, and utopian visions. He possessed immense talent but in some ways, his natural medium was the manifesto, not the mural, and he was beginning his lifelong pattern of talking much and painting little.

Diego was elected president of the union but had almost no time for union

affairs. He was showing his tendency to make a grand gesture, to volunteer himself for the daring public role without ever having to do the tedious work that the role demanded.[7] The harder work of union organizing and rabble-rousing fell to Siqueiros, who served as secretary and thoroughly enjoyed his tasks. Rivera did join Siqueiros and Guerrero as coeditors on the masthead of the union newspaper, a handsome oversized broadsheet called *El Machete*. But the newspaper, which was given its name by Siqueiros's then wife, absorbed almost none of Rivera's time. It was filled with manifestos, explanations of communism, agitprop, and woodcuts in the manner of Posada, most of them cut by Siqueiros and Guerrero. Seventeen issues were produced, reaching a circulation in late 1924 of about six thousand, when the union itself collapsed and the newspaper then became the official organ of the Mexican Communist Party.

Rivera was one of the causes of the collapse of the union. As he began the work in the Ministry of Education, he was attracting much publicity, both in Mexico and abroad, and was what reporters label "a quote machine." He had become, in short, what we would now call a celebrity. This inspired a certain amount of jealousy among his fellow painters. And in many small ways, Rivera was letting his comrades know that all painters were not created equal. After finishing the Anfiteatro, he had accepted an appointment as director of the ministry's Department of Plastic Arts. This was a meaningless job, probably a way to pay him a bit more money, but Rivera used the title to exert power. He commandeered wall space for himself. He diverted meager resources to his own paintings at the expense of others.

He even used his authority to destroy an already completed mural by Jean Charlot on the walls of the Ministry of Education to make room for one of his own.

"I knew of his intention," Charlot wrote, "and hoped to carefully chop off a choice bit of my panel to keep as both souvenir and justification. But early one morning, entering the court with Pablo O'Higgins, I found that the masons had hammered it all down without previous notice. A search of the debris for a crumb large enough to include a bit of design proved fruitless."

He recalled that a year before, after he and Amado de la Cueva had physically defended their murals against right-wing students, they were described by Rivera as "two young painters (who) were our army's casualties under fire." Charlot continued, "He does not add that we were shot in the back."[8]

As for the union, Rivera must have known that the painters lacked the only true weapon of a union: the ability to strike. When a small group led by Siqueiros did try to negotiate with Vasconcelos about some issue or other, the minister called their bluff and told them to leave their scaffolds immediately; he would spend their wages, as meager as they were, on schoolteachers. Significantly, Diego was not part of the group. The others ended up pleading

for their jobs. In the parlor debates in the house on Mixcalco, or while ser-monizing on the scaffolds at the Ministry of Education, Diego spoke with great passion and militancy about the need for solidarity; but in the crunch, he always put his art and his career ahead of all other considerations.

He was also a very good politician, in the sense that he understood that all power was provisional. Other painters might worry about the future develop-ment of their work; Diego had learned to worry about the future of the peo-ple who signed the checks. When he sensed that a serious split was develop-ing between President Obregón and Vasconcelos, he began to back away from Vasconcelos. He knew that nobody in Mexico had ever won a battle with Álvaro Obregón. When Vasconcelos resigned his post in 1924, Diego worked his charms on his successor as minister of education, J. M. Puig Casauranc, convincing the new minister to keep him at work on the great mural cycle in the Ministry of Education and to go forward with another great project in the Agricultural College in Chapingo. Among other things, he pointed out that he had done scores of panels while the younger painters had done only a few; he did not mention that he had enlisted some of them to help on his own murals. The result: Diego was given full power over the min-istry murals and allowed to split his week between the ministry and Chapingo. In trade union terms, he had joined up with management.

Meanwhile, political power in Mexico remained shaky. Obregón had to put down bloody revolts led by former revolutionary generals who wanted their share of the spoils. Pancho Villa was assassinated in 1923. Violence became commonplace. The generals loyal to Obregón swaggered around Mexico City with guns glistening on their hips. The budgets for education (and therefore of mural painting) were shrunk to feed the military budget. Eventually, after Obregón completed his term at the end of 1924, the mural painters in the cap-ital were dismissed. Some went on to paint murals in more remote parts of Mexico, while a few, like Orozco, went into voluntary (and temporary) exile in the United States. Some never painted murals again. Diego Rivera perse-vered. He was working on a masterpiece in the Ministry of Education and was determined to finish.

The Great Corrido

The murals in the Ministry of Education make up a visual ballad of Mexico, resembling the traditional *corrido*, a narrative in song. The panels on the first floor express the pain of being an ordinary Mexican, exploited by those who own haciendas or mines, and the joy of being Mexican, celebrating with color and music and dance a kind of triumph over adversity. Those twin expressions of joy and grief are held in tension throughout the 128 panels, culminating on the third floor, with Rivera's visions of a future in which urban

workers and rural *campesinos* would march together to paradise under the red flags of communism. Past, present, and future are combined on those walls in a synthesis that came from Diego Rivera. Through the force of his art, he combined dreams, battles, heroes, villains into a new vision of Mexico.

The building itself was as new as the Revolution, constructed in thirteen furious months at the command of Vasconcelos himself. This would be the headquarters for the war on ignorance. The architect, Federico Mendez Rivas, chose the traditional style of the Díaz era, which was, in fact, fitting; the building blends in well with its neighbors in this oldest section of Mexico City. Resembling a cloister or convent, it is three stories high, with offices whose doors face an immense interior courtyard that is open to the sky and to weather. The courtyard is divided by a grand staircase so that one patio is longer than the other, in proportions that were probably derived from the Golden Section. The bureaucrats of the Ministry of Education went to their offices beneath arched galleries, under the benevolent sculptured scrutiny of four of Vasconcelos's heroes: Buddha, Plato, the great Franciscan priest Bartolomé de las Casas, the mythic Aztec man-god Quetzalcoatl. It was on the walls between (and above) all those office doors that Diego and his assistants created their great work.

Rivera's intended sequence begins on the north wall of the smaller patio, the Court of Labor, beside the dividing staircase. There are eighteen frescoes on the ground floor of this smaller patio, six on each wall, beginning with the *Weavers* and ending with *The Foundry: Pouring the Crucible.*

In the *Weavers*, and the panels showing women from Tehuantepec, Rivera is restrained, formal, using a limited palette. Some of these panels were permanently flawed because Rivera accepted a suggestion by his assistant Xavier Guerrero and used the juice of the nopal cactus as a binder, believing that it was the secret medium used by pre-Columbian fresco painters. This turned out to be a triumph of nationalist sentimentality over chemistry; the nopal did not adhere, and the surface blistered as it dried. Still, the early work made Vasconcelos happy; he was originally from Tehuantepec, thought of it as the "real" Mexico, and grew more confident in his choice of Rivera. As he had done in his early years in Europe, Diego was once more pleasing a patron.

The artist who had accepted sudden baptism into the communist creed began to emerge on the east wall. *Entering the Mine,* at the beginning of the east wall, has a somber, ancient feeling to it, as the workers enter what appears to be the mouth of hell. Two huge cement arches rise over the entrance to the mine, like the eyebrows of some immense beast. Clearly, with his use of muted, limited colors, the aged, dirty texture of the concrete, the descending patterns of his thousands of brushstrokes, Rivera wants us to feel that the mines were still devouring the miners as they had been doing for hundreds of years. As they did in the Guanajuato of his childhood. The miners themselves are almost all faceless, as anonymous as any candidates for human sacrifice.

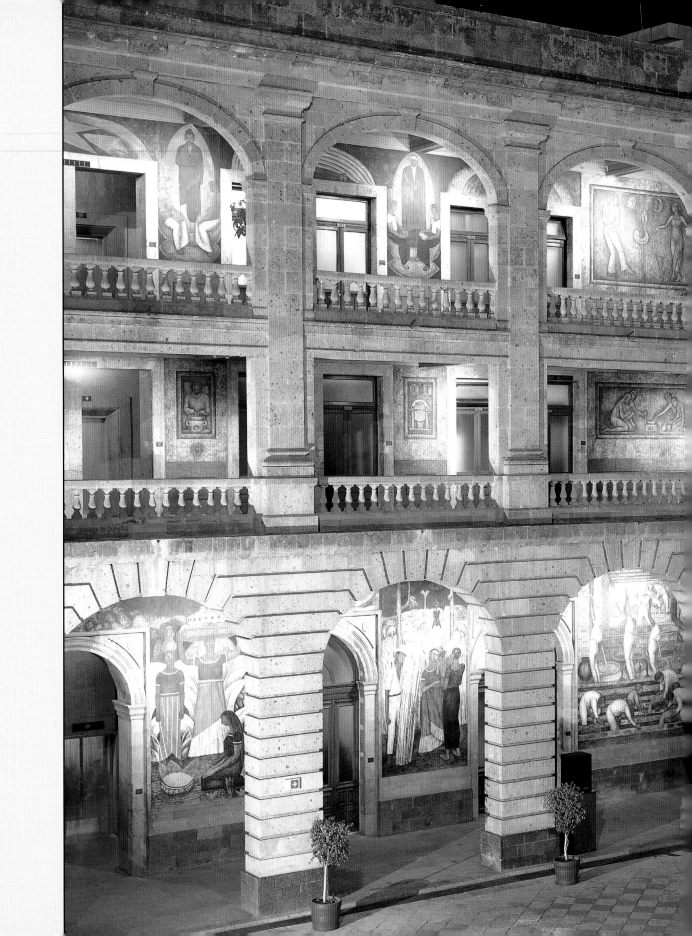

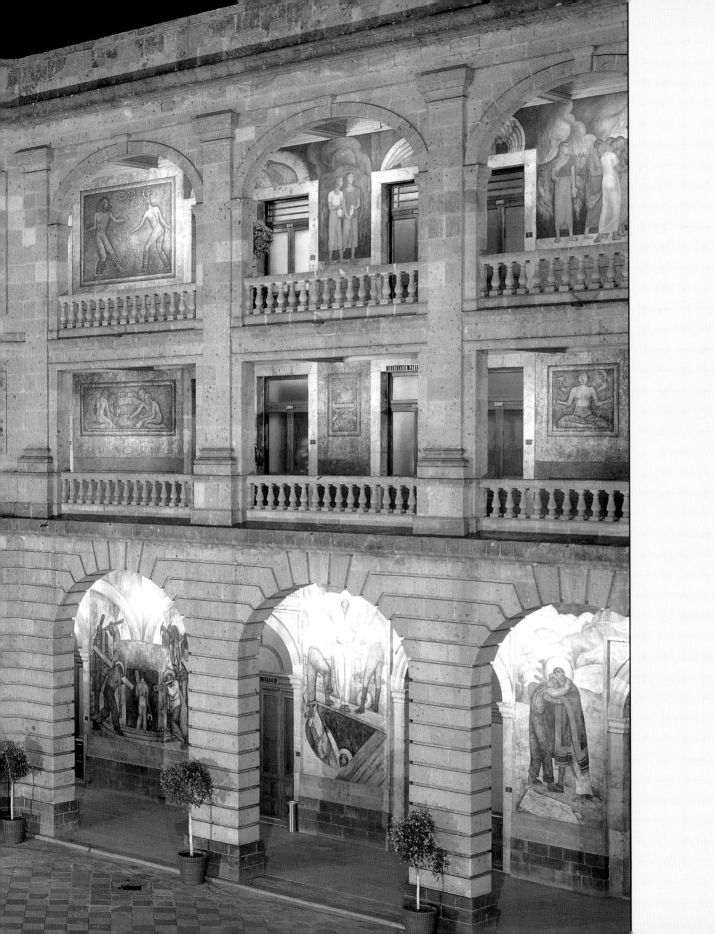

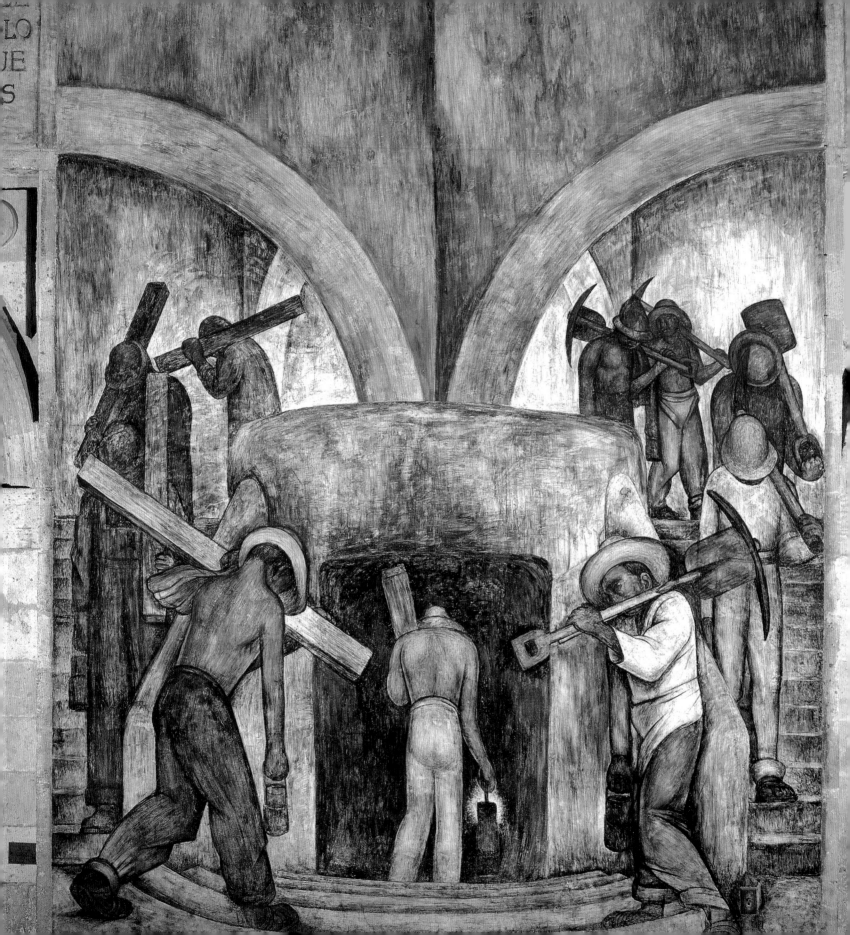

Some carry timbers that could easily be assembled into crosses, others shoulder picks and shovels that could be used for digging their own graves. Rivera here expresses a larger point: Mexicans who once roamed freely in a sun-drowned land are descending into the darkness of the Underworld.

In the adjacent panel, *Leaving the Mine*, a humiliated miner is being searched, probably for stolen silver, his arms spread wide in the pose of a crucifixion, grasping for the sky. The man doing the searching wears the cartridge belt and leather boots of a company guard. The miner wears sandals, as does another miner, waiting his turn. A third miner is in the open pit, holding to a stave of a rope-and-timber ladder. In the background, there is a stone landscape and a black sky. We feel here the presence of Italy; above all, of Giotto.

With this panel, Rivera came into his first serious dispute with Vasconcelos. Originally, over the exit from the mine, he had incorporated a poem by the leftist writer Carlos Gutiérrez Cruz. The words clearly urged violence:

> Comrade miner,
> Bent under the weight of the earth,
> Your hand errs
> When it extracts metal for money.
> Make daggers
> With all the metals,
> And thus,
> You will see
> That the metals
> After all
> Are for you.

Vasconcelos erupted. He was already engaged in an ongoing war at the National Preparatory School, a few blocks away, where right-wing students were physically mutilating murals, and painters were showing up for work armed with pistols. The national press was attacking the whole mural project, irritating President Obregón, who thought the controversy was a needless distraction from more important affairs, such as the bloody, ongoing attempts to overthrow his government. Vasconcelos pleaded with Rivera to remove the poem. It would only feed the fury of the right. Rivera met with the members of the union, and after discussion, they agreed that the larger cause of the mural program was more important than the inclusion of the poem. Rivera chiseled out the section. But he also copied the poem on a small scroll, which he inserted in a vial and imbedded in the fresh new plaster. It is still there, under the surface, like a sad agent of subversion for a cause now forgotten.

Still, at this point Giotto was more important to Rivera's work than Marx or Engels. This can be seen in the following panel: *Embrace*. An urban worker in overalls and boots embraces a sandaled peasant in a traditional serape. The peasant's large, rural sombrero forms a kind of halo that encompasses both

OPPOSITE:
Entering the Mine. 1923.
Fresco, 15′6″ x 11′6″
(4.74 x 3.50 m).
Court of Labor, Ministry
of Education, Mexico City

in a kind of holy solidarity. In 1924, that sentiment—the forging of a union between *campesinos* and the urban proletariat—was the prevailing goal of the Mexican left. But formally, the panel is a clear lift (today called an "homage") from *The Meeting at the Golden Gate* in the Arena Chapel in Padua. This was one of forty frescoes that tell the story of man's spiritual redemption and are considered Giotto's greatest achievement. The Italian shows Joachim embracing Anna, after having spent forty days fasting in the wilderness, praying that God will give them a child. God does respond, and gives them Mary, who was to be the mother of Jesus. Rivera appropriated this fourteenth-century image and boldly reinvented it for the twentieth, in a part of the world whose existence was unknown to Giotto or any of his European contemporaries. He alters some gestures; he does not show a man kissing a man; he adds local clothing. But there is an echo of Giotto in the message too: they have returned from the wilderness of separation from each other and together will give birth to a revolutionary future.

Behind Rivera's embracing proletarians, the golden landscape of his own Mexico rises above an office door to a marvelously painted townscape, obviously one of the old colonial silver cities that included Diego's Guanajuato. The town looks like a silvery Cézanne, punctuated by the tower of a church and the twin chimneys of a factory. Rivera thus formally links the austerities and geometries of the early Renaissance to the beginnings of Cubism.

Without breaking its diagonal movements, the painting then descends to a grouping of *campesinos*. Most of them are women, with serene, indomitable faces. They are shaped like the pre-Columbian sculptures that Rivera had begun to collect. The figures reside in the natural presence of cactus, most Mexican of plants. This is the Mexican countryside, not a wilderness. Their clothing is simple and bright with color, as befits people who for centuries have made so many things of beauty. Rivera is saying to his citified audience: look at, and truly *see,* the indigenous people of this country, this Mexico; they go all the way back to the Olmecs, and they have endured. Cherish them. Embrace them. Make them a true part of Mexico. The sequence—from embrace, to townscape, to Indians—simultaneously suggests the past of Mexico, its difficult present, its future possibilities (based on solidarity), along with the lasting presence of art, both European and Mexican.

The final panel on the east wall, *Pottery Workers*, shows men and women working together making pottery by hand. No machines intrude; unlike the ominous arches in the mine, the arch here has a solid, embracing, sheltering function. A man in the lower right mixes colors. Above the pale ocher arch— it suggests gold—there is a smaller panel, done in grisaille, illustrating the biblical tale of God's creation of Man from the clay of the earth. The grisaille functions as a kind of visual caption, or key, to the larger painting below. The clay used by potters is the same clay once used by God as the essential ingredient for making man. Rivera, the self-proclaimed atheist, is saying that the potter, like every artist, is doing the same work as God. The smaller painting

is tight and humorous, with hints of Rouault in the rugged brushwork. The combination is quietly brilliant.

On the south wall, a Promethean theme binds together the panels. Rivera begins with foundry workers preparing to feed ore to a smelter (*Foundry—Opening the Smelter*). At this stage of the collective work, some workers merely observe while others—one of them swinging a hammer in a vigorously balletic pose—start the process of making ore into steel. This is clearly Rivera's way of expressing what must be done with the Revolution: transforming the raw materials of Mexican society into the steel of a socialist utopia. The adjoining panel (*Surface Miners*) shows workers attacking the face of the earth with picks, sorting the pieces of ore, and shoveling them into carts for transport to the smelter. In the gestures and attitudes of the figures, Rivera expresses the satisfactions of men working at a common task. They have been freed from exploitation and humiliation and they can work with a certain amount of happiness because the mines and the smelters are theirs. This is a vision of the future, of course, not a fact in the Mexico of the early 1920s, but Rivera paints his vision with the conviction of a man driven by faith. If you were Giotto, after all, you could paint Heaven without ever seeing it.

In the next three panels, Rivera shows what was actually being done because of the Revolution. In *Liberation of the Peon,* a naked and exhausted *campesino* has been rescued from his oppressors and is being given succor by armed revolutionaries. In the distance, smoke rises from a hacienda, which stands for a hated system of exploitation that has been consumed by revolutionary fires. In the mountains painted above the next door, the sun is about to rise: a revolutionary dawn.

Then, in *The Rural Schoolteacher,* Rivera for the first time addresses the function of the Ministry of Education itself. He shows a young female teacher with a group of *campesinos*—one of whom has white hair and has waited all of his life to learn to read. An armed revolutionist stands guard. The young schoolteacher reads from an open book. Young and old are engrossed in the lesson. Rivera knew that more than two hundred schoolteachers had been murdered by the forces of imposed ignorance; he makes the vocation of the teacher seem simple, even humble, perhaps holy, and indirectly asks in paint: how can you kill people like this? Again, the peasants are shaped like pre-Columbian sculpture. In the background, men and horses are working the land. But it's the man with the rifle who must guarantee the joint existence of learning and farming. The man of the Revolution.

In the final panel, *Foundry—Pouring the Crucible,* he returns to the narrative of steel making. His fascination with machinery—which would dominate many of his later works—is seen for the first time. Mexicans have made steel. And all are connected through honorable labor. He says through his art: With the protection of the gun, with respect for the land, with the words taught by schoolteachers, Mexico truly can make the Revolution into steel. It all begins with the land, with the earth. The earth can make food. It can make

art. It can make steel. We are living, Rivera says to his contemporary audience, in the crucible.

The Court of Labor is a remarkable achievement in itself, but it was in the adjacent Court of the Fiestas, dating from 1923–24, that Rivera's talent, experience, and vision reach the critical mass of genius. Panel after panel, beginning with the *Deer Dance* and ending with *La Zandunga*, could stand alone as an enduring work. Here, in twenty of the twenty-four panels,[9] Rivera is working at the top of his immense talent. His designs, drawing, choice of color, and subject matter work individually and as parts of a complex whole. The color is more luminous, and he has left behind the flatness of much of the earlier work, adding a powerful sense of volume. Yes, there is more than a hint of Gauguin. But the end result is not imitation Gauguin; it is completely, absolutely Diego Rivera. The paintings feel that they could be nowhere else except upon these walls in this building in Mexico: "Before beginning to paint," he wrote later, "I studied the quality and intensity of the sunlight which hit a particular wall, and the architectural details—the arches and columns—and how they broke the sunlight and framed the space. Like the building itself, my colors were heavier, solider, and darker at the base than they were as the structure rose toward the luminescent sky."

Rivera had begun the project with only vague intentions. But as the months passed, and his technique matured, he began to envision the work as a whole. He was driven by his deepening commitment to the communist faith, along with his need to give a focus to the Mexican Revolution for an audience that was both local and international. But he was also placing himself in the history of art. Nothing like this project in the Ministry of Education had been seen before in the modern era, and nothing like it has been seen again. Among those to recognize what he was accomplishing was Rivera himself.

He worked like a driven man. His wife visited him on the scaffolds. He ate on the scaffolds. He dozed on the scaffolds. He dreamed on those scaffolds. A dream of a new Mexico.

And in his rousing celebration of the Mexican people he created his own visual language. Here in the Court of the Fiestas we see the pigtailed young Indian woman, her back to painter and viewer, a figure that Rivera would continue to paint for the rest of his life. We see the dense sleek female clusters of calla lilies—called *alacatraces*—that were to become a Rivera trademark. We see children: sentimentalized, chubby visions of future Mexican children rather than the actual children of Mexico in the 1920s, who died of hunger and disease in appalling numbers. The children in his paintings are what Diego Rivera wanted Mexican children to be. Here too is corn: food, god, symbol of Mexico. Here are the rituals of death, solemn but stoic, death embraced in the presence of candles burning, flowers braided into funeral arches, death gravely marked without self-pity, death as an integral part of life.

In the Court of the Fiestas, three panels of the south wall deal with the Day

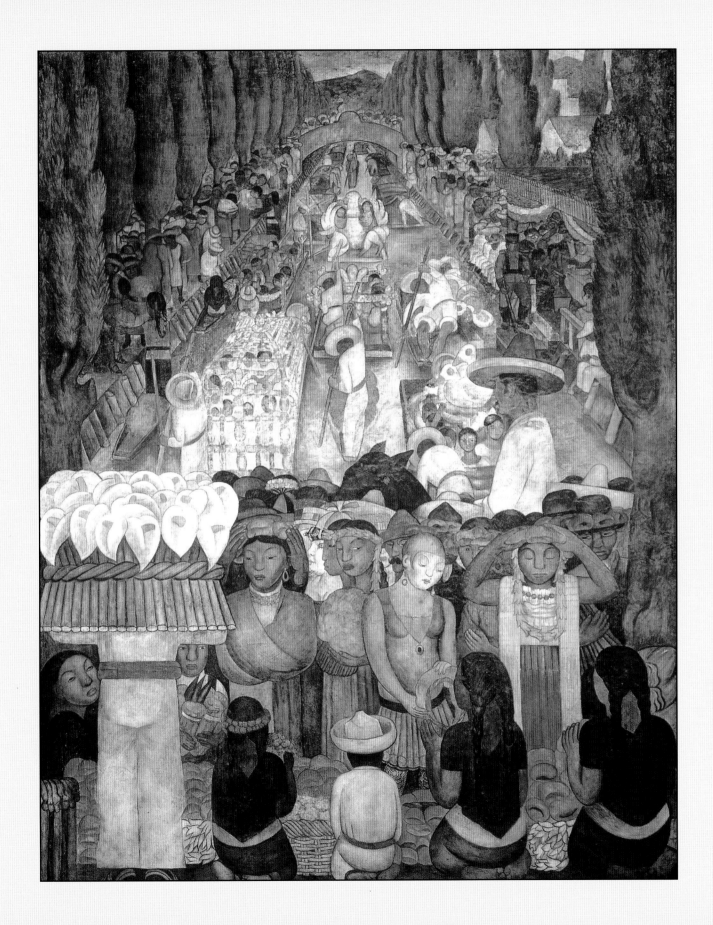

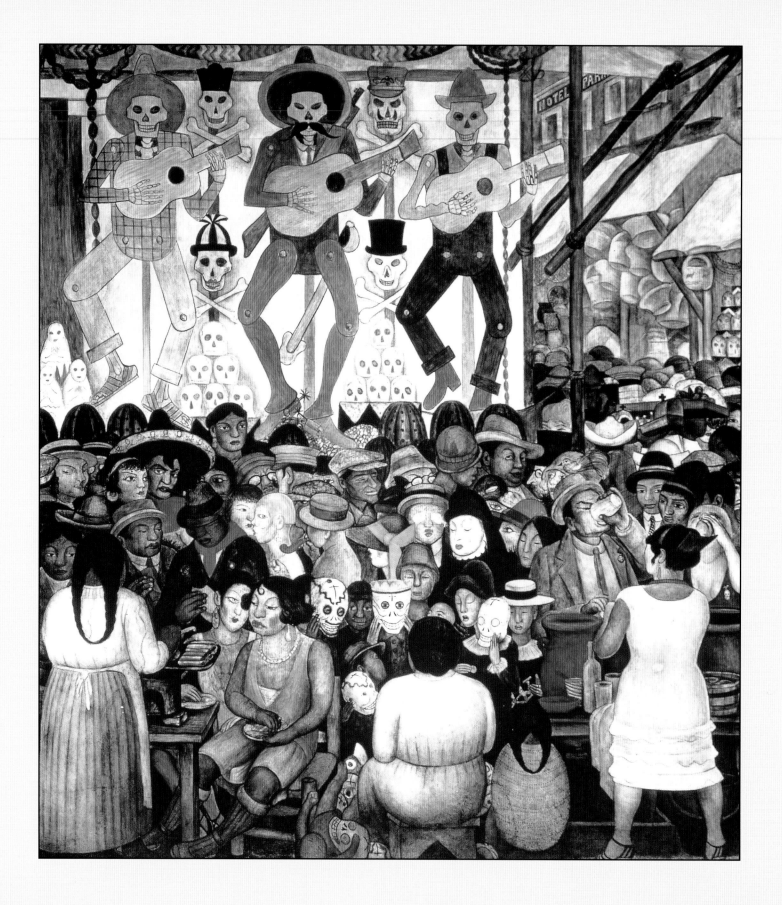

of the Dead, which Mexicans celebrate on November 2, usually bringing food and flowers and other offerings to cemeteries all over the republic. One panel, called *The Offering*, shows simple people engaged in what is clearly an age-old ritual: praying for the dead among candles, wreaths, and arches made of woven flowers. The scene is set outdoors, but is made intimate by the candlelight and Rivera's use of tight, closed, shallow space. Another, *The Dinner*, shows a family around a simply laid table, with bread, water, biscuits, and fruit, while the light of thirteen candles adds a solemnity to the contemplation of death, and the table itself echoes the Last Supper. Rivera might have been an atheist and was often anticlerical in other works, but he never attacked the religious beliefs and rituals of ordinary Mexicans.

The last of the three related panels on the south wall is an urban version of the ritual, called *Day of the Dead—City Fiesta*. We see three giant skeletal puppets called *calaveras* playing guitars: a worker, a *campesino*, a revolutionist. Rivera clearly had been studying the work of the engraver of *calaveras*, José Guadalupe Posada. Behind them, painted on a canvas backdrop, are individual skulls with crossbones, wearing the identifying hats of a priest, a soldier, a banker, and a student. They preside over piles of anonymous skulls. The dancing skeletons rise high above a packed street fiesta in an area that resembles the sprawling Mexico City market called La Merced, a few blocks from where Rivera lived as a boy. He skillfully organizes this mass of humanity, using sombreros and spot color to keep the eye moving, and giving a virtuoso display of his skills as a caricaturist.

In the foreground is an Indian woman with the pigtails, preparing tacos on a grill; she is a short, compact woman in a modest ankle-length dress. Beside her are urbanized Mexican women in bobbed hair, wearing short flapper skirts, pearls, and high heels. They look exhausted, perhaps bleary with drink. One of the women with her back to the viewer, clearly an urbanized Indian, serves liquor from a huge jar while wearing a fringed yellow dress and high heels. In this panel (and many others) high heels are symbols of the decadent, falsely modern Mexico that Rivera feared was coming. Dozens and dozens of faces push against each other in the packed street. Among them are Diego Rivera himself, wearing a rakish sombrero, and his wife, Lupe Marín, in a stylishly abrupt hat that covers most of her face. Also in the crowd are the poet Salvador Novo, the actress Celia Montalvan, the bullfighter Juan Silveti, and Diego's assistant Máximo Pacheco. All are part of the Mexican fiesta, and the painting itself is a feast for the eyes. Hats, skulls, faces, food, dolls, jars, scaffolding are woven together in intricate patterns that keep the eye moving from left to right and finally down a receding street in the background. The eye can follow the hats. Or it can follow the color vermilion. Nothing moves, but nothing is static.

In this painting you can feel Rivera's exuberant confidence; he can do anything he wants now with fresco. He shows this again in *The Burning of the*

OPPOSITE:
Day of the Dead—City Fiesta. 1923–24.
Fresco, 13'8" x 12'4" (4.17 x 3.75 m).
Court of the Fiestas, Ministry of
Education, Mexico City

Judases on the west wall. This is a traditional feast on the day before Easter Sunday, when papier-mâché effigies of Judas are ritually burned. In villages across Mexico, even today, the Judases often have a contemporary point to make: politicians, bandits, gringos, priests, all can be made into the giant lightweight totems and suitably destroyed. In Diego's version, Judases representing a capitalist, a general, and a priest are suspended from a rope while being blown up in great clouds of smoke.

Times had changed in the year since Rivera started the project: there had been brief revolts by old generals, and the image of a benevolent revolutionary soldier in the early panels now gave way to a treacherous militarist. The crowd of men below is made of ordinary citizens, backing away from the explosions, while others raise hands in triumph or protest. But something else is going on: the group below is also prying paving stones from the street. One figure, in peasant's hat and white pajamas, has a stone in hand and is about to hurl it at unseen enemies. A street battle is under way, probably between communists and right-wing goons, or competing factions in the labor movement. The composition resembles drawings by George Grosz (another graphic poet of street fighting), fleshed out with masterly control of volume and color. The figures are stylized, the space shallow, the color subtly provoking an ominous emotional response. Many citizens on the street are protecting their heads. A traditional Mexican fiesta is being wrecked by the bitter turbulence of the times.

Among all the ribbon dances and celebrations of *Mexicanidad*, there is a huge work, spreading over four connected panels on the west wall, that is to mark a turn in Rivera's art. It is called *May Day Meeting,* and is a masterfully painted entry into the art of pure propaganda. The largest single piece in the ministry project, it shows a May Day celebration in a place where the city and its factories meld into the countryside, joining workers and *campesinos* under the scarlet banners of communism. Those red banners dominate the composition, creating vertical rhythms that contrast with the red waistbands of the peasants, making the work a feast for the eye, if not the mind. Literally hundreds of figures crowd the walls, some cleverly painted sitting on the lintels of the ministry's intervening doorways. The four panels are bracketed by the *Burning Judases* and the joyful *Friday of Sorrows on the Canal of Santa Anita,* but May Day in the Mexican 1920s didn't vaguely resemble this triumphant scene. Although labor unions sometimes marched on May Day, it was not a traditional Mexican fiesta, rooted in the past, expressing the uniqueness of the Mexican experience. This was an imaginary May Day, an exercise in prophecy, a Mexican festival in Diego's vision of the glorious utopian future. The vision is serene, almost religious in its solemnity. But it remains propaganda.

Here we see the didactic Rivera at his most literal. His poetic sense, with its ambiguities and empathies, is overwhelmed by the certainties of his faith. He doesn't trust the painting to express his meaning, or his audience to understand it; he spells out his message in one unfurled red banner held by

OPPOSITE:
The Burning of the Judases. 1923–24. Fresco, 14'6" x 7' (4.43 x 2.14 m). Court of the Fiestas, Ministry of Education, Mexico City

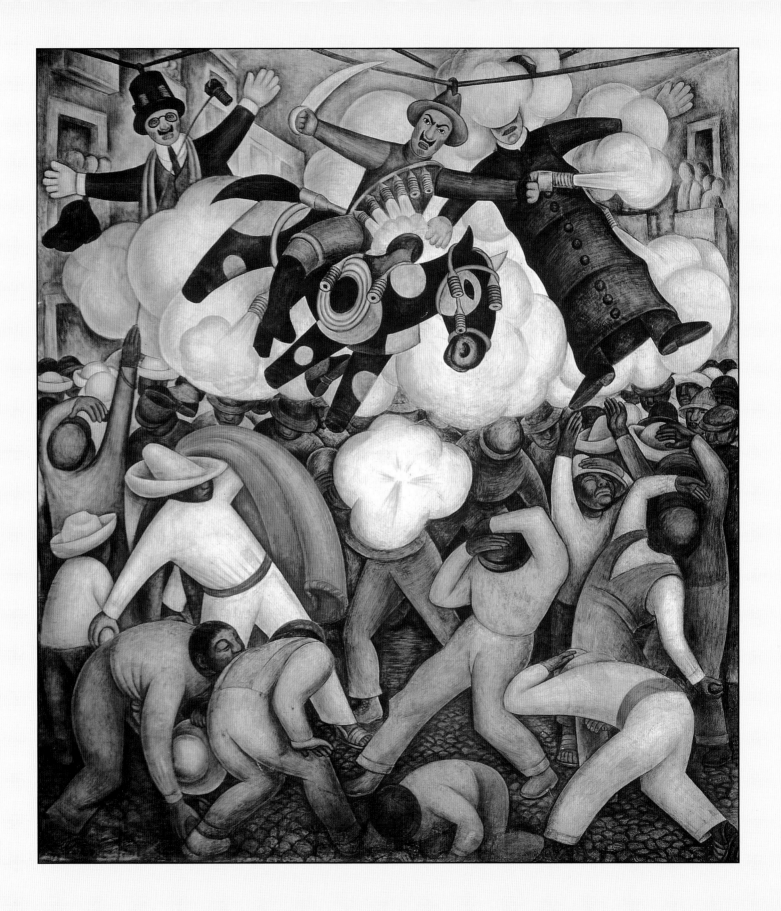

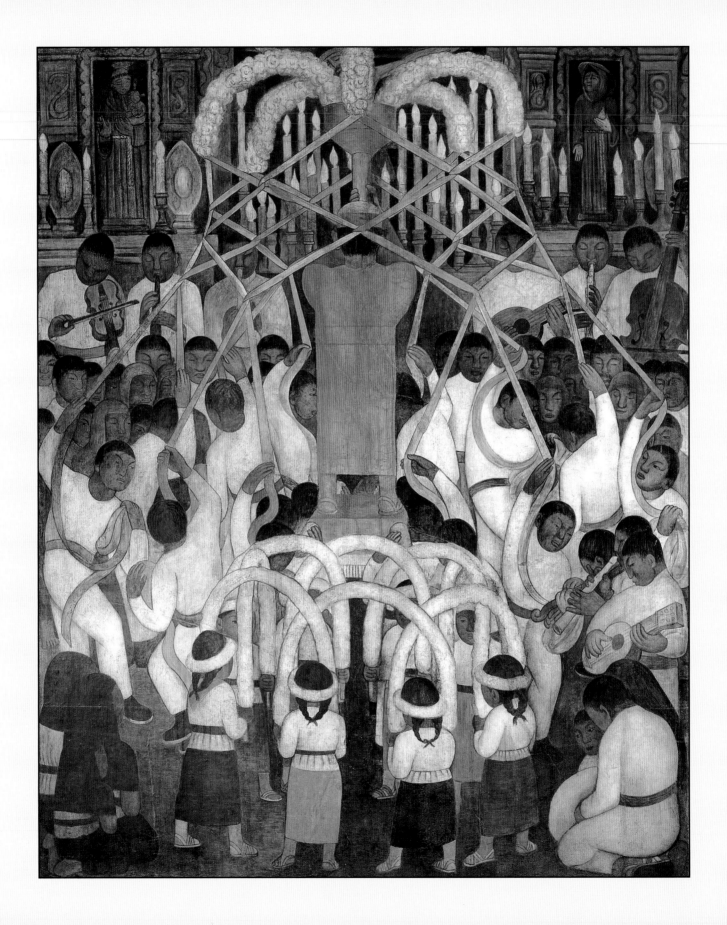

a young worker and a young peasant: "The truest civilization will be the harmony of men with the earth and of men among themselves." Another banner expresses the platitude that by the mid-1920s was already hoary: "Workers and Campesinos of the World, Unite!" Among those portrayed in the vast open-air meeting are the Irish-American painter Pablo O'Higgins, Lupe Marín, and Diego himself. On the far right, almost inconspicuous in the vast gathering, stand Emiliano Zapata and Felipe Carrillo Puerto, the socialist governor of Yucatán, whom Rivera had met on the crucial journey organized by Vasconcelos, and who was assassinated in 1924. They are counseling a young boy. The composition has its formal delights, but its message, long ago made irrelevant by assorted villainies, corruptions, and gulags, can now arouse only melancholy. This work of Diego Rivera, along with certain others, provokes a nostalgia for a world that never happened. Its intentions are decent, its vision honorable. But its message has been obliterated by the horrors of history.

When Diego finished in the ground floor of the Court of the Fiestas, he proceeded to the mezzanine, and in the east wing painted a series of symbolic evocations of medicine, chemistry, astronomy, often adorned with hammers and sickles, in a black-and-white grisaille style that imitates bas-relief (another technique borrowed from the Italian Renaissance). In the stairwell, on walls rising in zigzag fashion up three floors, he showed his first weakness for the epic. This mural attempts to trace the ascent of Mexican history from its beginnings in the sea to the tropics and the high plateaus; from its ancient civilizations, to the decline into peonage after the Conquest, to the rise through Revolution, culminating with the highest form of Mexican life: Diego Rivera and his associates. Rivera's self-portrait was painted from a photograph by Edward Weston, who was one of the many foreigners in Mexico at the time, too many of whom came as acolytes.

The murals in the stairwell, which were completed in January 1925, signal the beginning of the Post Office School of Mural Painting. The walls are jammed with scantily clad maidens playing in the sea with dolphins, noble peasants holding corn, rural schoolteachers, Arcadian jungles. The composition is crowded and Diego has returned to the stock company of allegorical figures he had seemed to leave behind in the Anfiteatro. He mixes them with figures who could have stepped out of a government promotional brochure. We see a deep-sea diver getting his suit removed while a wind goddess blows three clouds through the sky. Oil derricks signifying Progress rise from cane fields and palm trees. A woman lolls in a tropical Mexican Eden, not far from an overliteral portrait of Ochipilli, the Aztec god of flowers. We see a hacienda, with its inevitable Cruel Foreman, and an Indian ominously sharpening a machete. On the third level, a peasant is being buried while semi-naked maidens float through the sky in mourning, and a triple flash of red lightning strikes down militarist, capitalist, and cleric. Its parts are better than the whole, like a bad movie that contains good scenes.

OPPOSITE:
Ribbon Dance. 1923–24.
Fresco, 15'4" x 11'11"
(4.68 x 3.63 m).
Court of the Fiestas,
Ministry of Education,
Mexico City

In 1926, Rivera went on to the third floor to work on the culmination of the great project. These forty-seven panels were given the collective title of "The Apotheosis of the Mexican Revolution." They are divided into two sections: "The Corrido of the Agrarian Revolution" and "The Corrido of the Proletarian Revolution." The first section represents a struggle between Rivera the visual poet and Rivera the propagandist. The second series, done after Rivera returned from an eight-month sojourn in the Soviet Union (1927–28), represents the defeat of the poet.

The sequence begins in the left-hand corner of the west wall. Concha Michel is singing a *corrido* in the company of *campesinos*, including a guitar player who resembles Emiliano Zapata. The words rise above her, elegantly lettered on an orange strip that binds together all the subsequent panels. That banner rises and falls, undulates and curves, looking like painted music. It is less a caption to the picture than a kind of soundtrack. In a series of panels, we see a revolutionary soldier hanging up his cartridge belts to take part in manual labor; Mexicans of several classes (including a city woman in high heels) sharing the fruits of the Revolution, in a panel that also includes a portrait of Rivera's daughter, Guadalupe; still another schoolteacher, sharing books with the poor, the young, and the newly literate; soldiers helping with the harvesting of wheat; the pigtailed young woman preparing food for soldiers dressed in capes made of palm during a storm that lashes mountains that resemble Pre-Columbian pyramids. These are, on the whole, affecting pictures, with subtle hues, earth colors, and small human touches. They are pictures that trust the viewer.

As he moves to the north wall, Rivera becomes more directly a caricaturist. *Campesinos* learn to use a tractor, a benefit of the Revolution. This is an early example of Rivera's belief in the triumph of the machine; the tractor had not yet become central to the dreadful official art produced by the Soviet Union, but the sentiment was the same. In an adjacent panel, a decadent, clenched capitalist family, including one woman with dyed orange hair, is consuming a dinner that consists of gold pieces on plates. Behind them, a worker and a peasant, their arms full of fruits, corn, and the Mexican rolls called *bolillos*, look on in pity. Another dinner table features eight capitalists, two of whom appear to be upper-class Mexicans; the others are gringos. There's a small Statue of Liberty at the near end of their table and a stock ticker in front of an ominous bank vault at the far end. There is champagne at the table, but no food. The only source of nourishment is a snaking strip of ticker tape. Among those at the table are Henry Ford, J. P. Morgan, and John D. Rockefeller Sr.

Between the two capitalist dinner tables, there's a panel called *The Learned.* Here Rivera makes savage fun of certain intellectuals of the day: José Juan Tablada, a poet who introduced Japanese haiku to Mexico, and who had written in support of the muralists; an Argentine actress named

Berthe Singerman; Eziquiel A. Chávez, an educator and philosopher who had survived the fall of the Porfiriato, seated on a pile of books by Comte, Spencer, John Stuart Mill, and others; Rabindranath Tagore, a Hindu poet then in vogue. Worst of all, he savages the man who made this part of his career into a reality: José Vasconcelos.

The former minister of education is portrayed from the rear. He is seated on a white Hindu elephant and has a feather in his right hand. A cuspidor is on the floor beside him, as if he has been using it for an inkwell. On one level, this is simple journalism, a cartoon made for a satirical magazine, perhaps, but not for the ages. Morally, it is a truly vile painting. Rivera had every right to disagree with the evolving politics of Vasconcelos (by the end of the 1930s they would be pro-Fascist). But it was obscene to place this caricature in the building that Vasconcelos brought into existence. In this panel, Rivera was not creating a utopian vision of a revolutionary Mexico; he was lacerating an old ally, a mentor, a patron. He wasn't painting for a large audience either; this was intended to hurt Vasconcelos among a very small elite, one to which Rivera belonged. Vasconcelos was furious, of course. He had learned what Angeline Beloff had learned, and Jean Charlot, and Xavier Guerrero: there was a dark and nasty side to Diego Rivera.

The panels on the south wall, done after Rivera's return from the Soviet Union, are more of the same in content, but something awful has happened to the painting. It is colder, more linear, and too literal. We begin to see for the first time that there were at least two Riveras at work in the same man: Warm Diego and Cold Diego. Most of his easel painting was produced by Warm Diego. The colors are earth colors. The vision is celebratory. The mood is humane. These qualities are present in most of the Ministry of Education panels done before the trip to the Soviet Union. But in the work of Cold Diego, the colors are chillier, there is no compassion or pity, he functions as a prosecutor instead of a defense attorney.

It is still not clear what brought about the change. The scholar David Craven suggests that Rivera might have been influenced by the "*Neue Sachlichkeit*," or "New Objectivity," a style that was briefly in vogue in Germany when Rivera passed through in late 1927 on his way to Russia.[10] That style featured an exacting naturalism, with almost photographic renderings of surface details. The most famous artists identified with this trend were Otto Dix, from Dresden, and George Grosz, who had a one-man show in Berlin in 1927. Both were men of the left.

Rivera never mentioned the reasons for the change in the mural painting (it might not even have been conscious), but it can be seen clearly on the third floor of the Ministry of Education. In the paintings made after the return from Russia, Rivera, as in so much of his future work, is illustrating his ideas instead of expressing them. In one much-reproduced panel, we see Frida Kahlo and Tina Modotti passing out arms to the proles, while David Alfaro

Siqueiros looks on in approval. As in other panels in this sequence, the urban workers are all in blue (adding to the chilliness of the painting); hammers and sickles abound; posturing workers and aroused *campesinos* join together in glorious solidarity. There are battle scenes and handshakes. But there are no fresh ideas, no creative surprises. Pity and compassion have fled. These murals are the equivalent of street-corner speeches made by a coldly dogmatic orator.

Again, ad hominem cruelty makes an appearance. The figures in two panels would end up in one of the most sensational scandals of the era. In one, a maid wearing a red dress, gun belt, and boots hands a broom to a socialite. The maid is clearly Indian; her mistress is delicate, pale, one of the hated *gachupines*, the pure-blooded descendants of Spaniards. The message is simple-minded class hatred: now we will do to you what you have done to us. But like his version of Vasconcelos, this was caricature reveling in its own sneering brutality.

The society woman was Antonieta Rivas Mercado, the daughter of Antonio Rivas Mercado. He was the architect who directed the San Carlos Academy when Diego was there as a student; it was he who humiliated Rivera's hero, José Maria Velasco. Rigid and haughty, Rivas Mercado was widely despised by the young bohemians and idealists. He was also a proud supporter of Porfirio Díaz and grew very rich with private and government commissions.

After the end of the Revolution, his daughter Antonieta dabbled in the arts, helped support starving writers and poets, married an American engineer, gave birth to a son, had a nervous breakdown when the marriage went bad, and then founded the Teatro de Ulises, one of the first modern theater groups in Mexico City. This group produced plays by Shaw, Cocteau, and O'Neill, and Antonieta acted in some of them. She also wrote short stories, and a series of heartbreaking love letters (later published) to a second-rate painter named Manuel Rodríguez Lozano, who was homosexual. Their love affair was impossible, and therefore romantic in a doomed, grieving, mystical way. Shortly after she was painted on this wall by Rivera, she met Vasconcelos at a campaign rally and started working on his 1929 presidential campaign. This was a way of escaping the public humiliation of Rivera's savagery, but the image had been established; newspapers and magazines made even more fun of her as she wrote gushy journalism about Vasconcelos. In his drive for the presidency, he helped spend much of the money she had inherited when her father died in 1927. In Mexico, and later in New York, after he had been soundly defeated, they became lovers. Their affair was marked by separations and emotional disconnections. She remained in love with Rodríguez Lozano.

In 1931, she went to meet Vasconcelos in Paris. She asked him on the first night if he needed her; Vasconcelos said no, we only need God. Rivas Mercado later slipped into his room and found his pistol. The next day, in the

OPPOSITE:

Distributing Arms. 1928. Fresco, 6'8" x 13'1" (2.03 x 3.98 m). Court of Labor, Ministry of Education, Mexico City.

Included in this mural are, from left, David Alfaro Siqueiros (wearing a hat with a star on it), Frida Kahlo (center), Julio Antonio Mella (in a white hat with a black band), Tina Modotti, and the sinister communist agent, Vittorio Vidali (in a black beret, just visible behind Modotti's head)

Cathedral of Notre Dame, she killed herself with a bullet to the heart. Rivera could not be blamed for that, of course, but his own nasty little contribution to the tragedy of Rivas Mercado remains on the walls of the Ministry of Education. It is only a few panels away from the one in which her political hero and lover sits like a fool upon on a white elephant. Both had been touched in some vicious way by Diego Rivera.

There are some other paintings by Cold Diego in this sequence that deserve examination. The strangest are a set of portraits of revolutionary martyrs: Zapata again, Carrillo Puerta again, and a schoolteacher named Otilio Montaño. The style is Byzantine, the three men standing rigidly, their eyes focused in accusation, their long shroudlike clothes more suitable for the walls of Ravenna. The choice of Montaño was odd for a painter now convinced that Zapata was a saint (although Montaño appears in some of the other Rivera murals). In 1911, he wrote the Plan de Ayala for the Zapatistas. It was the basis for all future calls for agrarian reform, one of the most romantic and enduring hopes unleashed by the Revolution. But Otilio Montaño was executed by the Zapatistas in 1917. If he could turn and speak to his fellow martyr, Zapata, the executed Montaño might ask: Why?

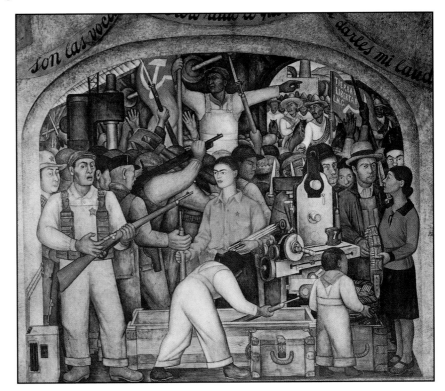

But Rivera, at this point, has little interest in mystery or irony. Propagandists never do. In these paintings after his return from Russia, Cold Diego is clearly in charge, up there on the scaffold. The fresco painter's craft is, of course, under absolute control. But the essence of Rivera's public art—its insistent human optimism—seems exhausted. It's possible that the mask he had constructed to cover his shame over ducking the Revolution might have become cemented to his face. It's also possible that the Stalinists in Russia had erased some of his humanity, insisting that decency or pity or simple human connection were just bourgeois sentimentalities. But there could have been another reason. It could have been that Diego Rivera was painted out.

For while he was executing the best of the murals in the Ministry of Education, he was simultaneously engaged in creating another epic masterpiece. Some critics believe it is the best of his public art.

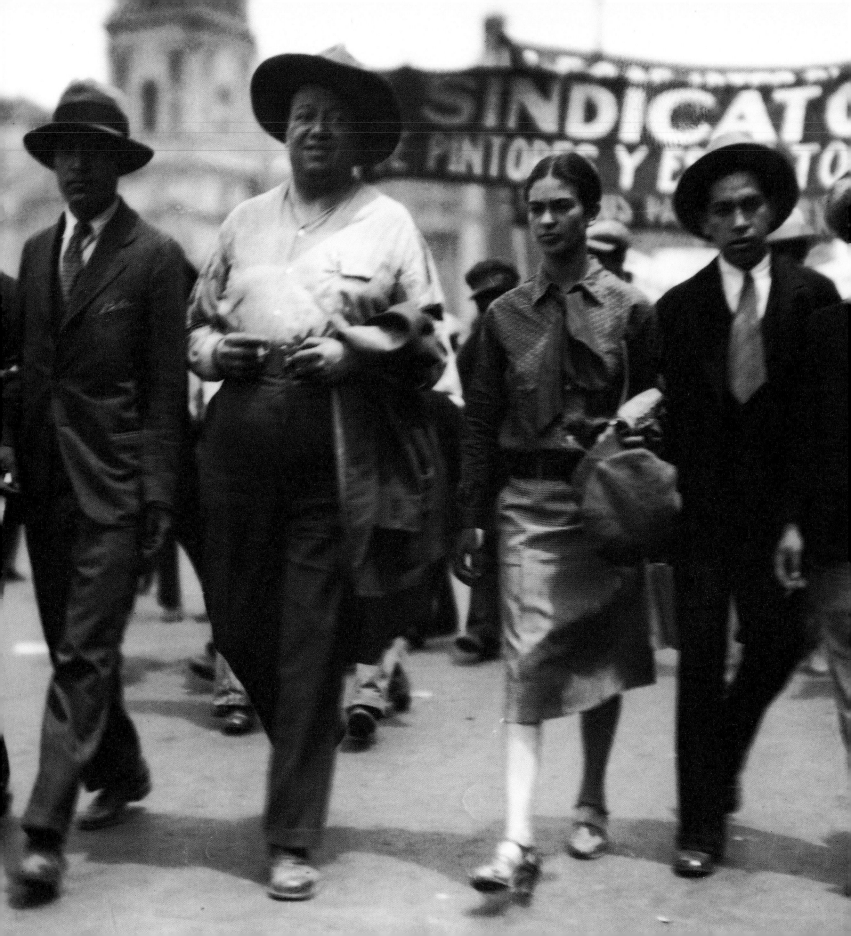

CHAPINGO, RUSSIA, AND FRIDA

I n the fall of 1924, while he was still engaged on the stairway murals in the Ministry of Education, Rivera agreed to paint a major cycle of frescoes in the new National School of Agriculture in the town of Chapingo, then about forty minutes by car from Mexico City.

The school was on the grounds of the eighteenth-century Hacienda de San Jacinto, a great sprawling complex that had specialized in cultivation of maguey cactus for transformation into the drink called pulque. It had once served as a weekend residence for one of Porfirio Díaz's puppet presidents, and in one of those coincidences that suggest that all wealthy Mexicans of the day were connected to almost all other wealthy Mexicans, the main house of the hacienda was built by Antonio Rivas Mercado, in his role as architect to the Porfirian rich. Such haciendas, often far from towns or cities, were designed to be self-sufficient and this one had its own chapel.

Diego had political reasons for agreeing to add this to his work schedule. Obregón was being succeeded as president by Plutarco Elías Calles, among whose various enthusiasms was a commitment to agrarian education. It was good personal politics for Diego to please the new president.

But it was the sight of the chapel that must have convinced him. Separated from the administration building, it was perfect for mural painting: a continuous barrel vault, with side arches resting on square columns that divided the wall spaces. A huge back wall, where the altar once stood, provoked an ambition for the monumental. There were four high windows that suggested

OPPOSITE:
Frida Kahlo and Diego Rivera with a contingent from the artists' union in the annual May Day march in Mexico City, 1929. Archivo Casasola, INAH, Pachuca, Mexico

sunbursts. In addition, these walls were indoors, protected from the vagaries of weather. The chapel suggested the possibility of public art that was also intimate. Diego agreed to paint the entrance to the main building of the school (today it houses most of the administrative offices), the stairway, and the adjoining chapel. This totaled more than fifteen hundred square feet of wall space.

Once he agreed, Rivera began to split his working week: three days at the Ministry of Education in Mexico City, three days in Chapingo. His team remained essentially the same, although Xavier Guerrero was more and more distracted by his duties to the Mexican Communist Party. Diego chose as his unifying theme *The Liberated Land*. Over the stairway in the administration building, he painted some words from Emiliano Zapata, which would serve as the motto for the agricultural school itself: "Here it is taught to exploit the land, not man."

Unlike the work at the Ministry of Education, Chapingo started with a clear plan. Rivera carefully studied the architecture, particularly in the chapel: "I was compelled to communicate the architectural style of the chapel—Spanish Renaissance—with a genuinely Mexican aesthetic, without its being picturesque or archaeological in mood—and projecting the ideas of flowering and fruitfulness, phenomena that are natural symbols in the development of the life of man, the Producer."

His designs followed the rhythms of the architecture, from fullness to emptiness, from the relaxed to the tense. The emphasis was on the stated ideas of flowering and fruitfulness.

"The Chapingo frescoes were essentially a song of the land, its profundity, beauty, richness, and sadness," Rivera later explained. "The dominant tones were violet, green, red, and orange."

After establishing the general theme and the harmonies of his palette, Rivera got more specific.

"In the entrance hall, I painted the four seasons of the year, the recurrent cycle in the life of the land," he said. "In the chapel itself, I represented the processes of natural evolution. The bottom wall was dominated by a large female nude, one of several symbolizing The Fertile Land, and shown in harmony with man, whose function in agriculture I represented by having him hold the implements of his labors. Within the earth, I showed spirits, using their powers to aid man. One, for example, was a sphinx, emerging from her flaming cave with arms outstretched to catch the flaming spirits of the metals and put them to the service of industry."

Since this work was done before the journey to the Soviet Union, Warm Diego is here in full command of his own talent. And because most of these murals were painted indoors, we can see the colors as they were in the 1920s, free from the alterations of weather. Warm Diego makes his colors vibrate. His male figures have a harder, more linear appearance, like stone. But his

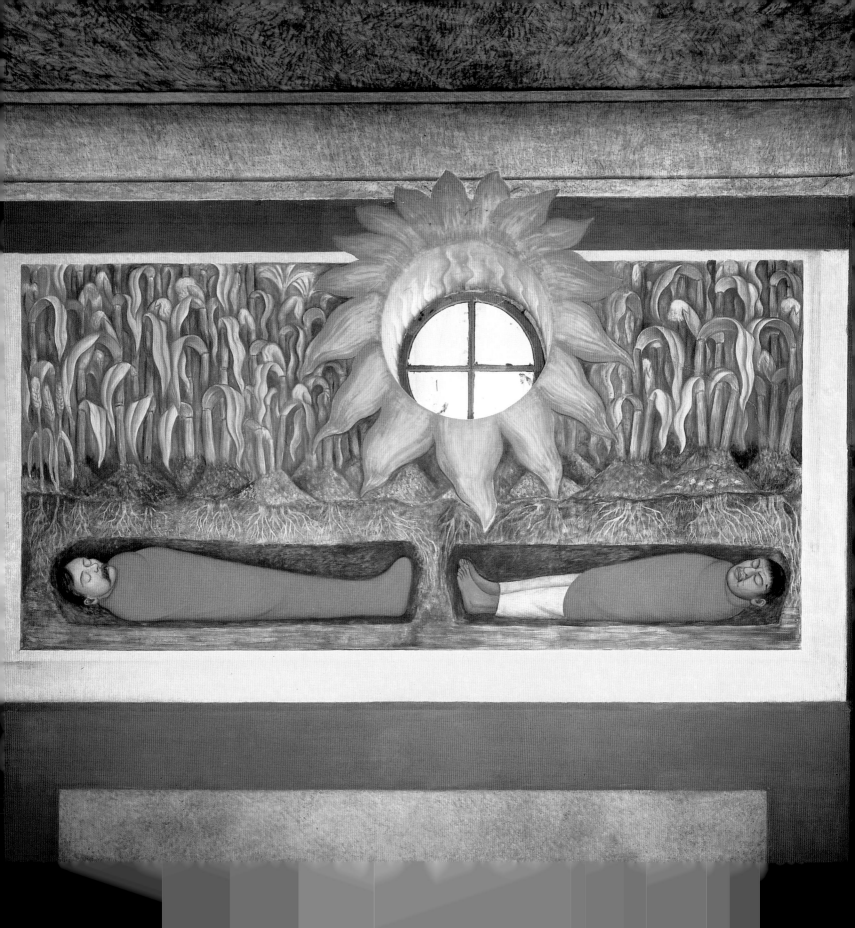

female figures are in fully developed chiaroscuro, as rich and pliable as the earth. The figures all have tangible volume.

In the entrance corridor, the stairwell, and the second-floor foyer leading to the rector's office, Diego functions as the painter of the State. He portrays the arrival of the Revolution at the Hacienda de San Jacinto, the redistribution of the land, the disgruntled former owners; these are handsomely painted in dominating earth colors, but we have been there before. More interesting are two panels that face each other and deal with the themes of good and bad government. These derive from the fourteenth-century frescoes on the same theme by Ambrogio Lorenzetti in the Palazzo Publico in Siena. Lorenzetti's well-governed city is safe and prosperous, with new buildings rising into the air, artisans at work, a busy marketplace, and even some dancing women; his badly governed vision is a barren landscape of wandering, rootless exiles. In words that could apply to certain aspects of Rivera's public work, Bernard Berenson has written of this painter:

"Ambrogio Lorenzetti could think of nothing but vast panoramas overshadowed by figures powerless to speak for themselves, and obliged to ply us with signs and scrolls. Scores and scores of episodes—some of them charming when taken alone—depict with remorseless detail what happens in town and country when they are well or ill governed. You look at one after another of these episodes, and you get much information about the way of living in Siena in the fourteenth century, and a certain sum of pleasure from the quaintness, and even the skill, with which it has all been done; but none of that life-enhancement which comes from the vivid apprehension of thoughts and feelings vaster and deeper than our own."[1]

Diego's version of good and bad government has the same limitations. Under bad government, the seacoast is ravaged, tanks ply the land, gunboats aim their cannon at the countryside. Good government results in a prosperous harbor, probably that of Tampico, secure and peaceful citizens. Lorenzetti implies that good government is derived from adherence to the catechism; so does Rivera, except that his catechism is secular, a loose melding of Marxist generalities, fervid nationalism, and the agrarian principles of the Mexican Revolution. In a final panel, Rivera again makes a point that is based on an article of faith: he shows the coming together of industrial workers and *campesinos*. Here, and in other public works, there is a religious impulse at work in Diego Rivera.

The didactic, preachy intentions of Rivera's work are also present in the chapel, but they are subverted by his own artistic triumph. The art historian Stanton L. Catlin states that Rivera's fourteen major themes and twenty-seven subsidiary themes in the chapel "constitute a scholastically reasoned curriculum, following the principles of dialectical materialism, aimed at eradicating the people's memory of past subservience and backward ways by substituting Marxist revolutionary doctrines and advanced technology as the

assured pathway to social and economic emancipation."[2]

Those intentions can be seen in the panels built around the idea of "Social Evolution" along the left side of the nave. Here again we have cruel landlords, miners being searched, oppressed *campesinos*; they are like separate drafts of the work being done at the same time in the Ministry of Education. There's a marvelous presentation of the revolutionary martyrs—Zapata, Montano—beneath the earth, their corpses fertilizing the triumph of the present. That triumph is symbolized by sunflowers with red petals and a mysterious figure of a pagan corn man. There are some splendid details, too: an Indian woman lovingly caressing ears of corn, a child dreaming of corn, apples, and wheat, the fruits of the earth. But Rivera's heavy ideological hand can't resist italicizing the lesson: the sower of dreams, for example, wears a red shirt and points at a hammer and sickle. In some ways, Rivera was also preaching to his fellow communists, urging the tiny party to work in the Mexican countryside, that is, to be *Mexican* before anything else. And to join the *campesinos* with the urban proletariat. There was also a naiveté to his preaching, a kind of innocence; there was no hard news yet from the Soviet Union about the mass slaughter of peasants. And Rivera had not yet seen the Soviet Union.

Yes: history has not been kind to such analyses and hopes, or to this attempt by Rivera to forge a visual catechism. In the arts, prophecy is always a risky enterprise. But most viewers now see Chapingo in another way: as a brilliant, passionate celebration of the fecundity of the earth. That is, as an expression, in Rivera's words, of "flowering and fruitfulness." Rivera's temporal, journalistic points have faded into insignificance beside the power of these universal themes.

"Many painters regard this as the greatest of Rivera's works because they are amazed by the virtuosity with which he solved the problems of the complicated spatial structure," Wolfe would write. "The lines of the composition are baroque, as befits the architecture. In accordance with the uses of the building, he chose themes related to agriculture; the evolution of the earth, germination, growth, florescence, and fruition of plants, and symbolic parallels in the evolution of society. The whole grows from natural and social chaos to harmony, culminating in the harmony of man with nature and man with man."[3]

But Rivera did more than solve formal problems in Chapingo. He created a personal, idiosyncratic vision of the earth itself. Starting with the huge painting at the back of the former altar, that vision was triumphantly voluptuous.

Lupe Marín and Tina Modotti

Two women served as models for Diego's vision of the earth. One was his wife, Lupe Marín. She was twice pregnant during the painting of the chapel and she appears pregnant as the huge figure looming above the altar. The title of the panel is *The Liberated Earth*. Hovering behind her on the wall are Earth, Air, Fire, Water, the four elements without which human life on this planet is impossible. Diego said later that he also used Lupe as his model for the woman being enslaved on the left wall by the forces of capitalism, clericalism, and militarism. But it is that huge representation of Lupe as the epitome of fecundity that dominates the room.

The model for most of the other female nudes was an extraordinary woman named Tina Modotti. Born in Italy in 1896, she came to the United States in 1913 as part of the great Italian migration and joined her father in San Francisco. She found work as a model, then as a stage actress in the Italian-language theater, and finally landed some small parts in silent movies.[4] But her beauty seemed to bore her and she walked away from this budding career. She married a frail young American artist who made a living as a fabric designer. Then, in Los Angeles in 1920, she met the photographer Edward Weston. He was married, too, with three children; within a year, they were lovers. Modotti's husband soon left for Mexico and, after a few happy months, died of smallpox. Tina Modotti first saw Mexico when she traveled to the capital to bury him. Staying on with friends, she met for the first time Diego and Lupe. Years later, Lupe remembered her as "slim, elegant, refined and very pretty." Modotti went back to California but would return to Mexico with Weston in 1923. Months later, when he left, she stayed on. She was now an accomplished photographer and a well-known character in the bohemian and left-wing circles of Mexico City. She was also somewhat notorious. Weston had made some spectacular nude photographs of her that had been seen by many people. And she always made clear that the rigid sexual rules of the day were made to be broken.

By the end of 1925, Tina was posing regularly for Rivera, traveling by car or narrow-gauge railroad to Chapingo, sometimes in his company, sometimes alone. She can be seen in the panels called *Subterranean Forces*, *Germination, Maturation* and *The Virgin Earth*. Rivera has meshed these images with the architectural presence of porthole-style windows, transforming the windows into sexual elements of the design. In some images, Modotti is trapped in closed womblike spaces, waiting to be born; in others she awaits an unseen lover, the one who will bring seeds to the earth. Tina and Diego began a sexual affair in late 1926; she was photographing his murals in the Ministry of Education and Lupe was pregnant for the second time. Tina's presence in Chapingo drove Lupe to heights of jealous anger.

"More than an infidelity of the man," Bertram D. Wolfe wrote, explaining Lupe's fury, "this was an infidelity of the artist."[5]

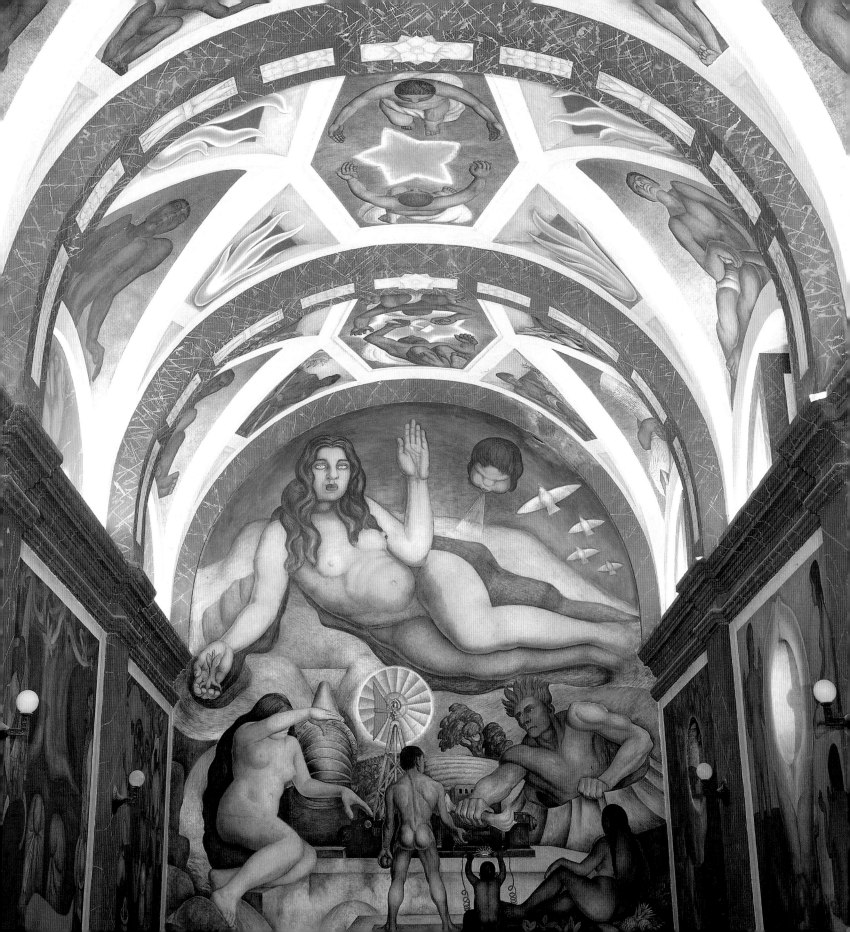

If Lupe's swollen, distended body would be seen by many thousands of people, long after all of them were dead, so would the sensuously painted body of Tina Modotti. There is Tina, arms above her head, breasts shamelessly facing the viewer, the lower part of her body painted as if she were a mermaid. There she is, holding in her hand an orange flower, like an offering, like a vulva. There is her back and buttocks. Her hair. Her too-perfect face. Faced with the competition, real or imagined, of Tina Modotti, Lupe raged at her husband, and treated him badly. At one point, the physically exhausted painter took a very bad fall from his scaffold. Wolfe describes the aftermath:

"In the middle of the day he was brought back from Chapingo, carried by three men, when Lupe was at her dinner. She was infuriated by his prolonged absences—he had not been home the night before at all—and attributed them to his new Italian model. When the men told her that Diego had fallen from the scaffold she answered, 'Throw him on the couch in the corner. I'll tend to him when I have finished my dinner.' It was not until one of the men fetched a doctor, who declared that Diego's skull was cracked, that she really paid any attention. The matter became a scandal throughout the city."

A photograph survives from the aftermath of this accident. Diego sits with a bandage on his head, while Lupe holds their daughter, a portrait of spousal and maternal affection. The effect is unintentionally comic, but Diego did miss many weeks of work. Off camera, the marriage was swiftly eroding. In the midst of one quarrel, Diego admitted to the affair with Tina: a standard scene in every soap opera. Lupe then sent a brutally direct letter to Tina, who backed away from the affair.

Modotti soon switched her affections to Xavier Guerrero. This was not surprising. Over the long run, Tina Modotti was too free a woman to submit to Rivera's extravagant style; the gravity and silences of Guerrero were more assuring and more mature and his commitment to communism more serious. And there was another factor: in subtle ways, her affair with Weston had given her an aversion to great men. For a while, she and Rivera remained friends. But the affair helped change Rivera's life, while leaving a permanent mark on his work. Before Modotti, Rivera lived according to reasonably respectable bourgeois standards. In Paris, he had a common-law wife and, for a while, a mistress. In that period in Paris, such a domestic arrangement was commonplace. Even accountants had mistresses. But there is no record of any extravagant womanizing by Rivera, in the style of such painters as Moïse Kisling, Jules Pascin, and others. And although he was a fine draftsman, he seemed curiously uninterested in the female form. In Rivera's work of the pre-Modotti period, there are virtually no nudes, either in the easel painting or in the public art.

The Modotti affair changed that; it was as if she broke open some old Catholic shell that had encased one part of Rivera's talent. The Chapingo murals remain among the few public works by Rivera that carry an erotic

charge. But in his easel work, Rivera would paint women for the rest of his life. In addition, the Modotti affair led to another evolution: in his late thirties, Rivera the Womanizer was born. In part, this too was an exercise in self-mythologizing. For whatever reasons, Rivera wanted people to believe that he was irresistible to most women, while being helpless before their carnal desires. There is some truth to this, of course; by 1927, Rivera was famous, a celebrity, and some women are always drawn to such men. But there is another possibility: Rivera the Womanizer was making public fun of the myth of machismo. In his later self-portraits, he is ruthless about his physical characteristics; the frog-eyed, fleshy, sagging Rivera of those paintings is certainly not the stereotypical Latin lover. In most of those self-portraits, there is an ironical gaze in the face of the subject. Part of the image of Rivera the Womanizer might have been presented with a wink.

Certainly, after the departure of Modotti, Rivera began to live in a different way. As his celebrity grew, as visitors came to see the great new Mexican master, ranging from a sneering D. H. Lawrence ("Bah! Gauguin!") to the equivalent of artistic groupies, Diego's marriage to Lupe became more tense and explosive: she was learning that he was now the kind of man who could never be faithful to one woman. He possessed immense appetites: for work, for food, for women. He was more committed to the communist faith than to traditional marriage, and often made grandiose gifts of money to the cause while Lupe was trying to pay for groceries. He later said, about his problems with Lupe, "I was always encountering women too desirable to resist. The quarrels over these infidelities carried over into quarrels over everything else. Frightful scenes marked our life together."

At one party she grew enraged because he was a bit too happy to show a young Cuban woman some of his drawings; Lupe tore up the drawings and attacked him with her fists. Another time, furious at the way he was spending money on pre-Columbian sculpture, she smashed a small idol, ground it up, and fed it to him in his soup. Some of this was a familiar story: the rage of the untalented against the talented. But Diego also had a genius for provocation. He might have been amused at Lupe's furies. But only for a while. "Lupe was a beautiful, spirited animal," he said later, "but her jealousy and possessiveness gave our life together a wearying, hectic intensity."

His refuge from these domestic melodramas was work. Up on those scaffolds, he was safe. He could invent a world as he wanted it to be. His growing fame was a kind of guardian now, making it difficult for powerful Mexicans to silence him. The country was trying to work out political and economic arrangements with the United States and didn't want to lose a public relations battle over a painter. He was left alone.

Alone, he began to try to synchronize his political beliefs with his art. He didn't feel it was necessary to make an iron separation. After all, weren't Giotto's murals in absolute accord with his religious beliefs? For Diego Rivera,

OVER LEAF, ABOVE:
Subterranean Forces. 1926–27.
Fresco, 11'7" x 18'3"
(3.54 x 5.55 m).
Universidad Autónoma
de Chapingo, Chapel

OVER LEAF, BELOW:
The Virgin Earth. 1926–27.
Fresco, 11'7" x 19'3"
(3.54 x 5.88m)
Universidad Autónoma
de Chapingo, Chapel

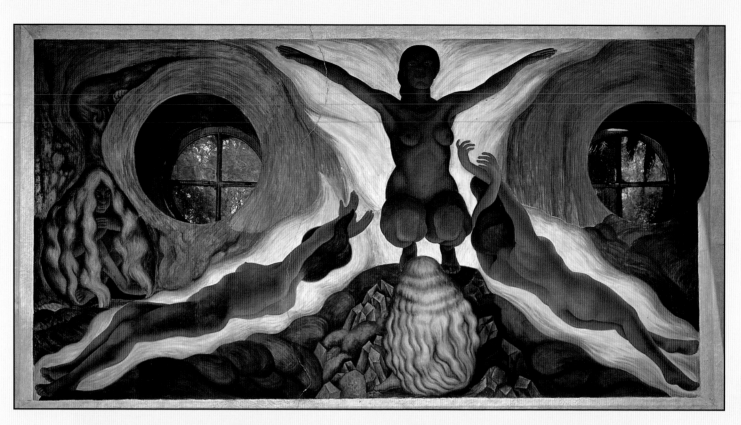

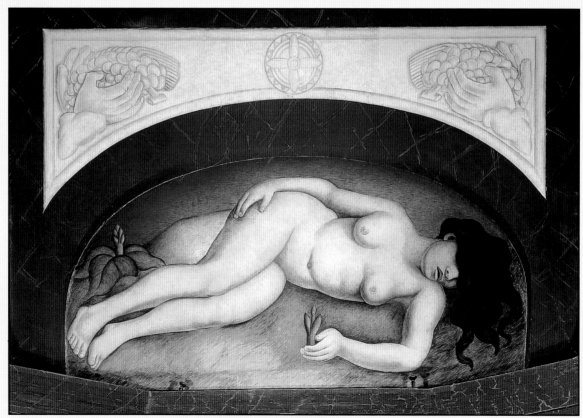

Study of Hands. 1927. Sanguine and charcoal on paper, 24¾ x 18¾" (62.9 x 47.6 cm). Private collection

This drawing appears to be modeled on Tina Modotti's head and Lupe Marín's hands.

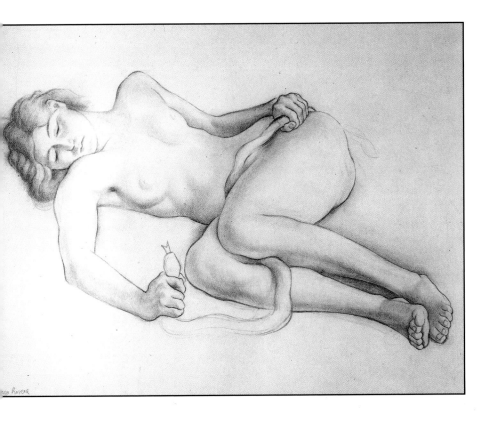

Study for Subterranean Forces. 1926. Pencil on paper, 19 x 24½" (48.3 x 62.2 cm). Private collection

Reclining Nude with Snake. c. 1929. Pencil on paper, 21½ x 24" (54.5 x 61.2 cm). Philadelphia Museum of Art: Purchased: Lola Downin Peck Fund from the Estate of Carl Zigrosser

Tina Modotti posed for these drawings.

the result was the appearance of more obvious propaganda on the walls of the Ministry of Education and, to a lesser extent, in Chapingo. Four days after the completion of the Chapingo murals, in August 1927, he left for the Soviet Union, where he was an honored guest at the celebrations of the tenth anniversary of the October Revolution. He did not bring Lupe Marín; the marriage was over. Shortly before he left, the poet Jorge Cuesta came to see him and confessed to Diego that he loved Lupe. In Diego's account, years later, he gave Cuesta his blessing, but warned him that "Lupe was dangerous to men who were not very tough."

Cuesta ignored the warning. Rivera later recounted the terrible aftermath: "Soon after I left for Russia, he married her, and she bore him a son. Cuesta became mentally ill and castrated himself and the baby boy. The following year he hanged himself."

In the Shadow of the Kremlin

Rivera spent a few days in Berlin in September 1927, visited museums and cabarets, and then left for the Soviet Union on a special train. He would remember the train ride as exuberant and gay. Communists from all over the world were converging on Moscow to celebrate the survival of a revolution that many nonbelievers thought would be murdered in its crib. At this point, Rivera was one of the most famous communists in Mexico, president of the Workers and Farmers Bloc, an active member of the Anti-Imperialist League of the Americas. He did almost no work in these roles, because of his labors in the Ministry of Education and Chapingo. But he was a celebrity, and the communists needed his presence. In the train with Rivera were the French novelist Henri Barbusse and the American Theodore Dreiser. There were also railroad workers, miners, and textile workers, a kind of rolling version of the cast he had placed on the walls of the Court of Labor. He was, at first, thrilled:

"I shall never forget my first sight in Moscow of the organized marching and movement of people. An early morning snow was falling in the streets. The marching mass was dark, compact, rhythmically united, elastic. It had the floating motion of a snake, but it was more awesome than any serpent I could imagine."

For Diego Rivera that, at first, was communism: visual images, a staged event. It's not clear how much he learned about the realities of life among the Soviets. His hosts were generally gracious; after all, through Ehrenburg's *Julio Jurenito*, he had a certain celebrity beyond his accomplishments as a muralist. He met Stalin at some function, sketched his face, attracted his attention, and accepted Stalin's autograph on the sketch. He met with young artists, preached the gospel of muralism, and even signed a contract with Anatoly Lunacharsky, the commissar of education and a Soviet counterpart of Vasconcelos, to paint murals in the Red Army Club.

The mural never happened. He had trouble finding assistants. He faced the enmity of the academic painters, who despised Rivera's anarchic streak and his insistence that he, the artist, would decide about the content of his mural, not some committee. He socialized with artists from the Octobre group, who opposed both the elitist abstractions of modernism—which had already been wiped out of Soviet life—and the rigidities of the emerging school of Socialist Realism. He got sick with a sinus infection that was so severe he landed in a hospital. He renewed his acquaintance with the poet Vladimir Mayakovsky, who had visited Mexico in 1925 and had written about Rivera and promoted the mural movement (Mayakovsky would kill himself two years later). He did some magazine illustrations. He filled four notebooks with sketches. He acquired a mistress. He hailed Russian folk art, regardless of its old religious intentions.

Did he completely miss what was happening all around him in the Soviet Union? Was he blind? A fool? Lenin had been dead for almost four years. Stalin was consolidating his power. Terror was now a weapon of the tiny cult that ruled the nation (although it wouldn't approach its zenith until the Great Terror of 1936–38). The secret police were everywhere. Good men and swine suddenly disappeared, never to be seen again. Trotsky had been expelled from the Communist Party and then in January 1928 was escorted into exile in a place called Alma-Ata in Central Asia, four thousand miles from Moscow. A bitter truth was slowly being revealed: communism, as envisioned by the theologians who composed its dogmas, was simply not working. The peasantry—the vast majority of the citizens—did not want it. Neither did the urban workers. But Stalin and his fellow mediocrities in the "vanguard" would solve that problem with murder. Robert Hughes has aptly named this "the narcissism of power."

How could Diego Rivera, whose public art argued passionately against oppression, have failed to see oppression in the Soviet Union? If he saw it, how could he accept it? Some Westerners arrived in the Soviet Union for a few weeks, submitted to the slippery manipulations of guided tours, and went home to preach the giddy gospel of the new society. But Rivera was there for *eight months*. Every day, in one way or another, he came up against the cement face of the State. He spoke some Russian, after his years with Angeline Beloff, and didn't need to place all trust in official translators. He could hear what was being said and he could ask questions. But in his various autobiographical musings, Rivera never addresses his Soviet experience in any profound way. Of course, in the larger picture, given the mass slaughters that were to come, the position of one lone painter in the Soviet Union of 1928 doesn't really matte. But Diego Rivera was a great artist, and that journey to the Soviet Union altered his art.

One explanation is obvious: his brain had grown locked into the cold rigidities of Marxist-Leninist theory. The Golden Section, analytical cubism, agrarian reform, the Plan de Ayala: all such theories had given way to this uni-

versal, all-encompassing creed that demanded utter belief and utter intellectual surrender. Communism supplied One Big Answer. It was an act of faith disguised as a process of reason, and the One Big Answer would be so big it would even rescue the Mexican Revolution from its corruptions and betrayals. Bertram D. Wolfe says that Rivera never read Marx and Engels in a sustained way; his communism—like Picasso's—was a thing of the heart. But he knew the catchphrases, the jargon, the tabloid version. It is certain that Rivera had come to believe, at least for a while, in the tenets of that seductive catechism. It talked in absolute terms about the inevitable logic of history, the certainty of proletarian triumph, the necessity of the dictatorship of the proletariat, and the millenarian withering away of the State. That was the long view; the short view would sometimes be unpleasant. You can't make an omelet without breaking eggs, and all that. Somehow, this gifted, intelligent artist, who in other parts of his life was equipped with a sense of humor and a fine talent for irony, bought this moral absurdity. In that embrace, he was not alone.

But to accept such a creed, Diego Rivera had to harden his heart. He had to accept Stalinist deceit, treachery, and murder as necessary evils, unfortunate means that would lead to a glorious end. He had to blind himself to obvious truths. He had to narrow his scrutiny to acceptable enemies. He had to mutilate certain crucial aspects of himself, starting with his fundamental decency and his genius for celebration. When he returned to Mexico, he would too often employ his gifts in the hurting of enemies. And, with a few crucial exceptions, that acceptance of obligatory malice would soon reduce much of his art to agitprop and make it irrelevant.

He stayed on in Moscow through the giant May Day celebrations of 1928. Once again, he was impressed by the theater of mass demonstrations, and would paint a brilliant series of watercolors from his notes of the event. These paintings—later purchased by Mrs. Abby Rockefeller for the Museum of Modern Art in New York—show an artist whose talent seems to have been released from jail. They are everything the Soviet Union was not: free, loose, optimistic, even joyous. There is nothing like them in his earlier career, and there would be nothing like them in the years that followed.

But after May Day, Lunacharsky came to see him. The commissar of education was by then a sad and disappointed man. His hands were now dirty with the crimes of Stalin. He told Diego that the mural in the Red Army Club would not happen. Nothing would happen. For his own good, Lunacharsky said, Diego should go home. There was a hint that Diego might even be in danger. His friendships with dissident artists could be hazardous to his health.

A few days later, without saying good-bye to his friends or his mistress, Diego Rivera went home.

Return to Mexico

After his return to Mexico in June 1928, Rivera finished the murals on the top floor of the Ministry of Education, employing his curiously altered style. Tina Modotti noticed the change, writing: "Diego comments too much, lately he paints details with an irritating precision, he leaves nothing for one's imagination."[6] Cold Diego shrugged off such criticism. He gave a report on his trip to the Mexican Communist Party. He signed protests against United States policy in Nicaragua. And then everything started coming apart.

On July 17, a religious fanatic killed President-elect Obregón in the La Bombilla restaurant and Plutarco Calles assumed all backstage power, ruling through a puppet. As a result of the assassination, Calles formed a new umbrella political party, representing all sectors of Mexican politics: farmers, trade unions, intellectuals. Under several names, that party was to remain in power for the rest of the century.

During this period, with Lupe gone off into a new marriage, Rivera kept company with many women. He roamed the night shift of the city, *la vida nocturnal*, and indulged a taste for public beauties, singers, and actresses. But he had met a very young woman who was clearly different. She was sassy, independent, tomboyish, with a unique, striking beauty: glistening intelligent eyes, brows that touched above her nose, sensual lips. Her body had been maimed by polio at age six and a horrifying streetcar accident when she was seventeen. Her name, of course, was Frida Kahlo.

Their tale has been told too often in recent years to be examined again in much detail. And, alas, much of it is obscured by myths. In one version, they met when he was working on the Anfiteatro Bolívar in 1922 and she was part of the first class of young women to be allowed to enter the National Preparatory School. This was a glancing encounter, a schoolgirl teasing a painter in the first rush of his fame. In another version, she corners him at the Ministry of Education and insists that he come down from the scaffold to look at her paintings. In the version that most Kahlo biographers feel is correct, they met in 1928, after Diego's return from the Soviet Union, at a party in the apartment of Tina Modotti. In one version, Kahlo remembers Diego removing a pistol from his belt and then shooting a phonograph. This moment of music criticism impressed her. Certainly she impressed Diego.

Kahlo had recovered from the accident and was now an unconventionally exotic young beauty. Under the influence of Tina Modotti, she had recently joined the Mexican Communist Party, was brimming with political passion, and wanted to hear from Diego about the Soviet Union. More important, during her many months of convalescence she had begun painting in a serious way. She asked Diego to look at her paintings. He did. Frida was not yet the fine painter she would become, but she was very talented.

"The canvases revealed an unusual energy of expression, precise delin-

eation of character, and true severity," he remembered later. "They showed none of the tricks in the name of originality that usually mark the work of ambitious beginners. They had a fundamental plastic honesty, and an artistic personality of their own. They communicated a vital sensuality, complemented by a merciless yet sensitive power of observation. It was obvious to me that this girl was an authentic artist."

Rivera began traveling every week to the Kahlo house in Coyoacán, then a suburb of Mexico City. This was the famous Blue House that plays such a major part in the Kahlo story. He met her parents, the German-born father (whose grandparents were Hungarian Jews), her Mexican mother, her sisters. The father, Guillermo Kahlo, was a photographer of some renown and spoke Spanish with a German accent. The mother, Matilde Calderón, was a grave, silent woman, despised by her daughter Frida. ("My mother did not know how to read or write," she said years later. "She only knew how to count money.") Rivera talked to Frida for hours about her work and his own, about politics, about Mexico. He placed her in a prominent position in the *Distributing Arms* panel in the Ministry of Education and even found room in the composition for her younger sister Cristina. The love affair started. That year, Diego Rivera was forty-two and Frida Kahlo was twenty-one. He weighed three hundred pounds and she weighed a hundred. He was more than six feet tall and she was five foot three. Obviously, they were made for each other. They were married on August 29, 1929.

They would remain together—in spite of sorrows, abortions, a miscarriage, mutual infidelities, treacheries, a divorce followed by remarriage—until Frida's death in 1954. Kahlo's biographer Hayden Herrera has written:

"There is no question that even when she hated him, Frida adored Diego, and that the pivot of her existence was her desire to be a good wife for him. This did not mean eclipsing herself: Rivera admired strong and independent women; he expected Frida to have her own ideas, her own friends, her own activities. He encouraged her painting and the development of her unique style. When he built a house for them, it was in fact two separate houses, linked only by a bridge. That she tried to earn her living so as not to depend on him for support and that she kept her maiden name pleased him. And if he did not open car doors for her, he opened worlds: he was the great maestro; she chose to be his admiring *compañera*." [7]

Diego was a grand mythomaniac; Frida was one of the century's most gifted narcissists. They fed each other, and fed *off* each other, in a union that had its own rules, its own hidden dynamics. The poet and essayist Octavio Paz, who admired the best art of both Diego and Frida but despised their politics, saw their personal relationship in another way: "Her relationship with Diego—an obese, spongy figure—was that of a young boy to his immense, Oceanic mother. A mother who was all bulging belly and huge breasts." [8]

The Center Does Not Hold

The marriage to Frida Kahlo in 1929 was only one of a number of extraordinary events that took place in that extraordinary year in the life of Diego Rivera. One involved Tina Modotti. After the Chapingo project ended, Modotti committed herself romantically and politically to Xavier Guerrero, Diego's assistant. He brought her into the Mexican Communist Party. He encouraged her to use her photography in the class struggle, making pictures for the party newspaper *El Machete.* Then the party abruptly ordered Guerrero to Moscow, for three years of training in the arts of revolution. He walked away from art, but extracted a commitment from Modotti.

Alas, affairs of the heart do not always conform to the disciplines of revolutionary politics. In the offices of *El Machete,* Modotti met a handsome young man named Julio Antonio Mella. He was born in Cuba of an Irish mother and Dominican father and by the time he entered the university in Havana had become a fiery orator, a dedicated communist, and a leader of the opposition to the dictatorship of Gerardo Machado. He was forced into exile in 1926 by the Machado regime, went to Mexico, enrolled in law school, and continued to work for the dictator's overthrow. Modotti met him when she was thirty-one and he was twenty-four, worked with him on assignments for the newspaper, then fell in love with him. This caused her much anguish. She wrote a long letter to Guerrero in Moscow, explaining her feelings, her love for Mella, her continuing loyalty to the communist cause. He replied with a brutally short telegram: "Received your letter. Goodbye. Guerrero."

It didn't matter that Mella had a wife and child in Cuba. Their love affair flourished. And then on the night of January 10, 1929, Modotti and Mella left a small communist meeting and started walking home. A Machado assassin came out of the shadows and fired two shots from a .38-caliber pistol. Mella fell, mortally wounded. He was rushed to a hospital, accompanied by Modotti. Within hours, Mella was dead and Modotti was under suspicion. The police suggested that this was just another crime of passion.

Rivera arrived on the scene in those early hours, and in the following days, as press hysteria mounted, he became Modotti's most visible defender. To some extent, this was a small war to be fought out in the newspapers, and Rivera was a great publicist. The police smeared her, releasing copies of nude photographs of Modotti made by Edward Weston, and photographs of Mella made by Modotti. They released pages from her diaries. They interrogated her over and over again. But Rivera, functioning like a detective, made the most persuasive case for her innocence.

"My evidence," he said later, "presented in court, ripped apart the net of speculations in which the prosecution had hoped to entrap Tina."

The case against Modotti was dropped. Rivera insisted modestly that his intervention was ordered by the Mexican Communist Party and it should get the credit. But his own reputation within the party was simultaneously with-

OPPOSITE:

Frida Kahlo. *Frida and Diego Rivera.* 1931. Oil on canvas, 39⅜ x 31" (100.1 x 78.75 cm). San Francisco Museum of Modern Art. Albert M. Bender Collection. Gift of Albert M. Bender

Kahlo painted this double portrait of herself and Diego in San Francisco (the banner contains an inscription to her friend, Albert M. Bender); it was clearly intended to commemorate their wedding, which had taken place two years earlier.

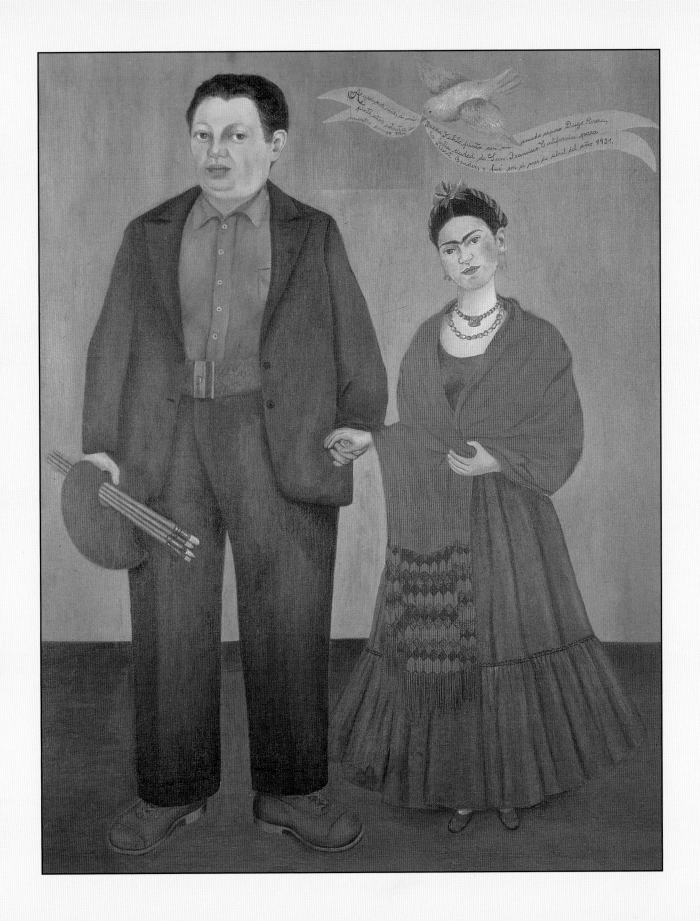

ering away. That winter, Mexico was in a state of violent tumult. Vasconcelos was waging his doomed campaign for president. Opposition leaders were being casually murdered. The Cristero uprising—the long armed struggle of Catholics against the anticlerical repression of the Calles-controlled government—raged more furiously than ever after the murder of Obregón. The communist cadres saw this disorder as an opportunity: they were making plans for an armed overthrow of the government. Toward that end, they were storing arms, agitating in various parts of the country, and dreaming romantic revolutionary dreams. They were happy to use Mella as a martyr to the cause and plastered billboards with his iconic photograph (taken by Modotti). But in abject submission to orders from the triumphant Stalinists in Moscow, they also insisted on rigid party discipline. That included artists.

The target of much wrath from party hacks was Diego Rivera. Yes, he had included Mella in the final panels at the Ministry of Education, while Mella was still alive; and yes, he had been brilliant in his investigation of the fraudulent charges against Modotti. But he always went his own way. He was an artist first, a communist second. He sold his easel paintings and drawings to North American millionaires. He refused to be a gray, faceless, boring soldier of the revolution. Worse, in the cultlike atmosphere of the party, he represented a clear case of collaborating with the enemy. He had been seen in the company of Mexican government officials. He had accepted a mural commission at the Ministry of Health and went on to accept another, even grander job: the decoration of the Presidential Palace in Mexico City, the very seat of power. That is, he was endorsing the legitimacy of that government by painting its walls.

The communists were more paranoid than other Mexicans, but they did have enemies. In March 1929, several northern generals raised their armies in revolt against the government. The communists constructed a plan that would give them a shortcut to power: support Calles against the generals, then turn on Calles. This plan split the communists. Calles learned the details from defectors, and when the armed revolt was suppressed, the government turned savagely anticommunist. The tiny party was made illegal. Party members were murdered or jailed. *El Machete* was closed, its presses destroyed. Soviet agents were expelled (diplomatic relations with the Soviet Union were broken the following year) and Cuban exiles, most of them communists, were deported. Party headquarters were padlocked.

In spite of all this, Rivera accepted a government assignment to serve as director of the San Carlos Academy. He wrote some letters protesting the murders of communist labor leaders but, in July, with many communists languishing in the dungeons of the Isla Tres Marías prison and others on the run, he began work on the National Palace murals. In September, three weeks after marrying Kahlo, he was expelled from the Mexican Communist Party.

Suddenly, he was treated like a pariah by old comrades. Even Tina Modotti, for whom he had done so much earlier in the year, turned on him. In the after-

math of Mella's murder, she had begun the gray and numbing process of abandoning photography in favor of heartless communist militancy. The logic of that terrible journey would convert her into a cold Stalinist functionary during the Spanish Civil War, where she shared responsibility for the murders of liberals and Trotskyites. In 1929, the handiest enemy was Diego Rivera. She wrote to Weston:

"I think his going out of the party will do more harm to him than to the p[arty]. He will be considered, and he is, a traitor. I need not add that I shall look upon him as one too."[9]

Later, Rivera tried to be lighthearted about the experience, saying: "Had I stayed within the bounds of party discipline, I would have voted for my own expulsion." In fact, he had a nervous breakdown. Slowly, with great affection, Frida nursed him back to health.

A Masterpiece in Cuernavaca

When he had recovered from the breakdown, Rivera accepted another commission, and this seemed to confirm the worst accusations of the party. It came from Dwight Morrow, the ambassador of the United States to Mexico. He had been a partner with J. P. Morgan, who the year before was so brutally caricatured by Rivera. Morrow had been dispatched to Mexico in 1927 by Calvin Coolidge and performed brilliantly. He was everything an ambassador should be and so often isn't: intelligent, moderate, respectful of differences in culture and politics, well-mannered, outgoing, and willing to compromise to avoid stupid conflicts. He established a personal friendship with Calles, convinced the strongman to ease up on the war against the Catholic church, and persuaded American celebrities to visit Mexico in the spirit of goodwill. One was Will Rogers. Another was Charles Lindbergh, who would meet and later marry the ambassador's daughter, Anne Morrow.

In September 1929, Morrow offered to pay from his own pocket for a Rivera mural to be painted in the former Cuernavaca palace of Hernán Cortés, the conqueror of Mexico. The purpose was again simple goodwill. Diego was now released—by expulsion—from any formal obligation to follow the party line. He was also bitter toward the Stalinists, had begun to choose the side of Trotsky in the ideological struggle. This was understandable. Stalin had become the advocate of "socialism in one country," specifically the Soviet Union, which was transforming into an autocracy ruled by terror. Trotsky still believed in the concept of worldwide revolution. This was a blurry dream, made plausible only by the power of Trotsky's rhetoric, but it had the virtue of including such countries as Mexico in its utopian scheme. There was no evidence that Trotsky would have been more democratic or humane than Stalin, but for many left-wing intellectuals in the 1930s, his primary virtue was that he was not Stalin.

OVERLEAF, LEFT:
Crossing the Barranca. 1930. Fresco, 13'11" x 17'3" (4.35 x 5.24 m). Museo Quaunahuac, INAH, Cuernavaca

OVERLEAF, RIGHT:
Revolt. 1930. Fresco, approx. 13'9" x 4'5" (4.25 x 1.34 m). Museo Quaunahuac, INAH, Cuernavaca

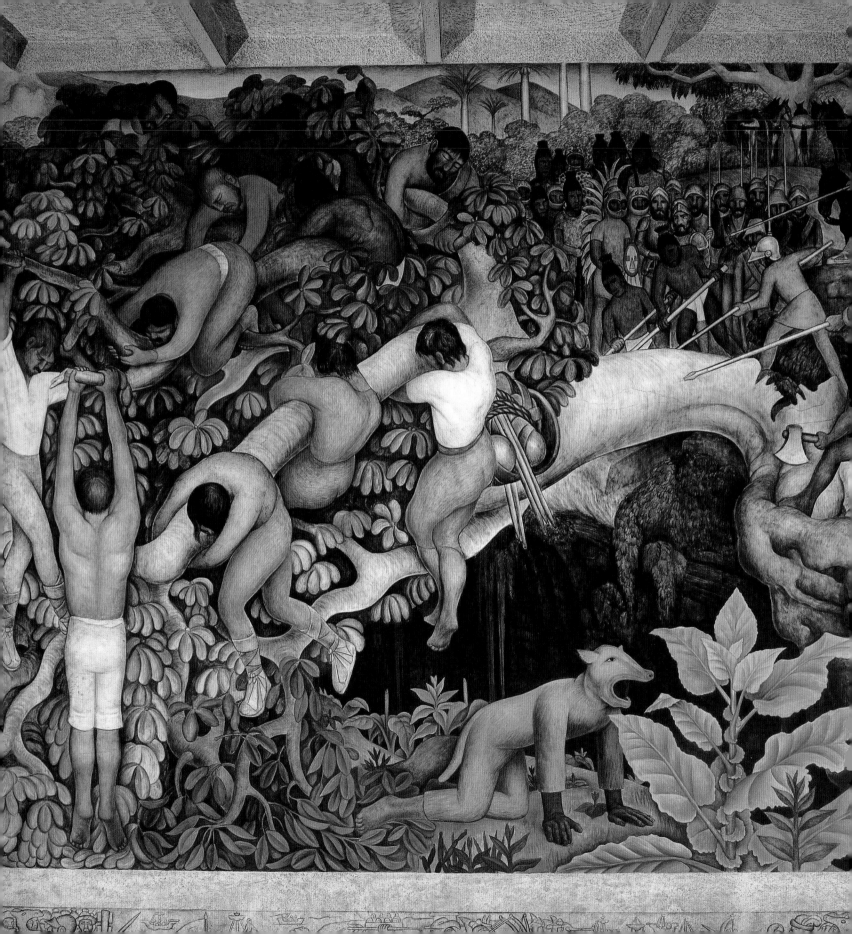

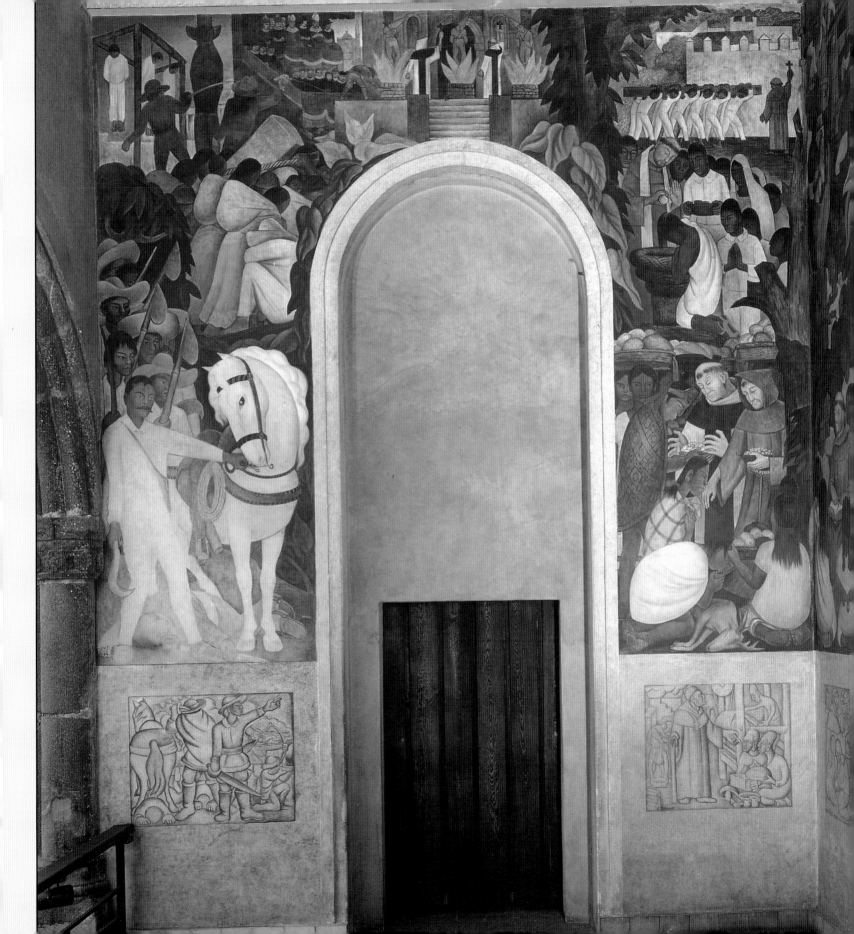

In addition to his contempt for Stalinism, which made it easier to work for the capitalists, Rivera had a more practical consideration: he needed money. After marrying Frida, he had promised to pay the balance of the mortgage on the Blue House, which his father-in-law was about to lose. Morrow's offer was for $12,000, a huge sum in those days. From that fee, Rivera would have to pay his assistants and buy materials; it was still a good deal. He agreed.

The following month, Wall Street laid its famous egg and many Marxists saw this as the beginning of the end of capitalism. Rivera was busy planning what would be one of his two remaining masterpieces of public art.

"I chose to do scenes from the history of the region in sixteen consecutive panels, beginning with the Spanish conquest," he explained later. "The episodes included the seizure of Cuernavaca by the Spaniards, the building of the palace by the conqueror, and the establishment of the sugar refineries. The concluding episode was the peasant revolt led by Zapata. In the panels depicting the horrors of the Spanish conquest, I portrayed the inhuman model of the old, dictatorial Church. I took care to authenticate every detail by exact research, because I wanted to leave no opening for anyone to try to discredit the murals as a whole by the charge that any detail was a fabrication. In some of the panels my hero was a priest, the brave and incorruptible Miguel Hidalgo, who had not hesitated to defy the Church in his loyalty to the people and to truth."

Rivera slowed his work on the murals for the National Palace (they would occupy him, in fits and starts, for another twenty years) and left for Cuernavaca, starting work in January 1930. He labored within walking distance of the extravagant weekend mansions of the corrupt generals and cronies of Calles, clustered together around the mansion of the *Jefe Máximo* on what Mexicans called "The Street of the Forty Thieves." The frescoes were painted on three walls of the outer colonnade, facing the Valley of Mexico and the great volcanoes called Popocatépetl and Iztaccíhuatl. Once again, Rivera was forced to consider the effects of light and weather. He added some painted grisaille bas-reliefs beneath the main panels, to serve as a kind of visual counterpoint. In all these panels, Rivera brought forth what was becoming his stock company of exploiters, exploited, and saviors, and once again, the Indian girl with the pigtails. But he surrendered the clenched and meticulous rendering of his painted surfaces and breathed some new life into the subject matter.

The panel called *Crossing the Barranca*, on the west wall, is handsomely composed and painted, depicting the conquistadors driving Indians and *campesinos* (in a deliberate anachronism) across a deep gully, all engulfed by timeless tropical foliage. The portrayal of a colonial sugar plantation has verve and dignity. And Rivera's portrait of Zapata, a machete in his right hand, his left holding the reins of a white horse, is the best of his many portrayals of the man from Morelos who had come during the Revolution to conquer Cuernavaca itself. That Zapata portrait remains part of the Mexican imagination to this day.

The whole Cuernavaca project had a unity of expression, standing as a reminder of what the Revolution itself was supposed to accomplish. It was a reminder to the communists who had expelled him and to Calles and his greed-driven associates. It was a statement of proud anger to Morrow and to the Americans north of the Rio Grande. Most important, it was a reminder of revolutionary intentions for all those ordinary Mexicans who were the latest in a line of the injured and insulted that stretched backward for hundreds of years. Perhaps the emotion of the work was driven by something else: an almost grieving sadness that Rivera felt about the decline of the Soviet revolution into naked terror and the Mexican Revolution into cynicism and corruption.

He had come to understand both. Only a few years earlier, the Russian Revolution had given him some hope for the salvation of the Mexican Revolution. But the sad cycle of the French Revolution seemed to be repeating itself; revolutions always seemed to consume their young. Now Rivera knew that a new kind of tyranny had been created, the tyranny of the party. In Russia, it was deadly. In Mexico, it was parody.

"For a communist," he said years later, "there is only one way to relate to the party—maintain the party's line against everything and everybody, never for a moment doubting its correctness. To hold a personal opinion at variance with the party's line means doubling one's burden. It means that, while continuing to fight the enemies of the revolution, one incurs the enmity of friends to whom the slightest difference of view appears as a betrayal."

He would hold on to the communist ideal for the rest of his life. A few years later he would sneer at "Sir Joseph Stalin" and his lackeys. He would help bring Trotsky to Mexico. He would publicly criticize Stalin's war on "social fascists," those who believed socialism was not compatible with democracy. Choosing to divide the left, he insisted, would open the way to true fascism. In this respect, he and others like him were correct. In Germany, the internecine battles on the left opened the way to the Nazis. In Mexico, he also objected to the party's decision to create separate and competing Communist unions, thus weakening the union movement as a whole. He was called a fascist, a liar, a lackey for the capitalists. But over the years he kept applying for readmission to the party.

At the end of 1929, as he finished the Cuernavaca masterpiece, Rivera began to long to get away from Mexico. His fame was greater than ever, but he was being ostracized by many of his friends and was having money troubles. And there was another thing: the stock market crash was not an aberration. The economy of the capitalist world was collapsing. There was an odor of apocalypse in the air. Now, perhaps, socialism could triumph in the kind of country where Marx had predicted it would triumph: a fully developed industrial nation whose contradictions would lead to the socialist utopia. Diego Rivera wanted to be there as a witness.

In early 1930, he and Frida began their first journey to the United States.

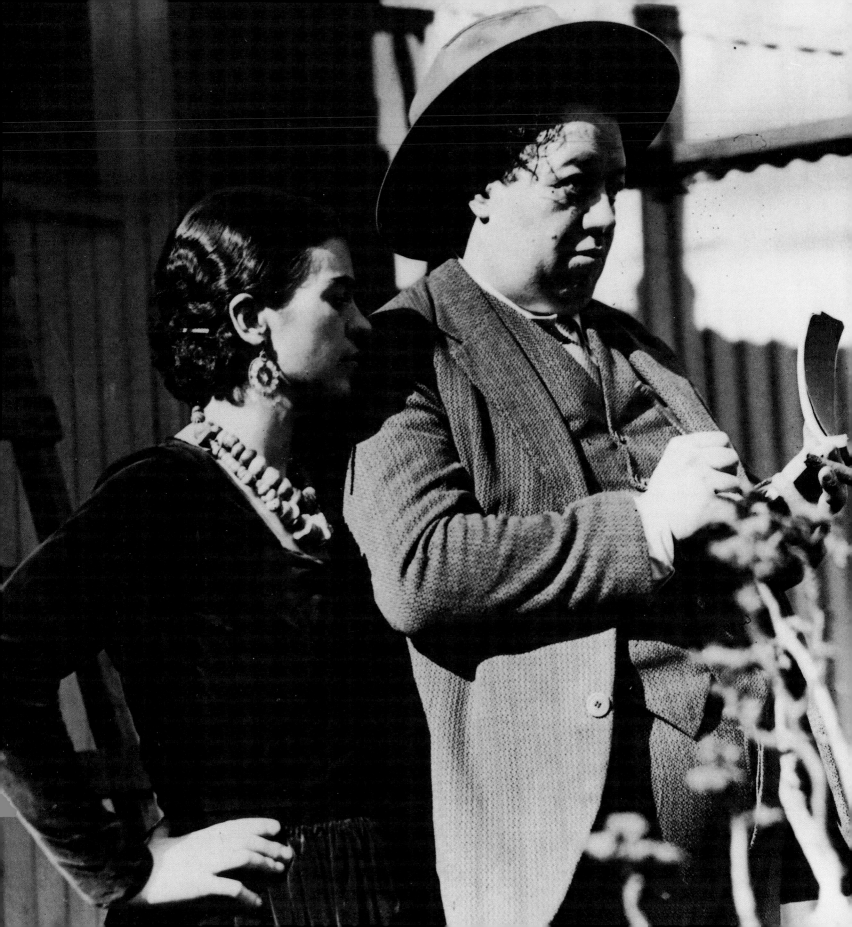

Chapter Seven

THE BELLY OF THE BEAST

Later, Auden would call it "a low dishonest decade." In many ways, he was not wrong about the 1930s. While Diego Rivera worked in Cuernavaca, the armed bureaucracy of Stalin's Russia was now using its guns to force the collectivization of agriculture; their labors would cost the lives of about two million peasants. The Nazis were maneuvering for power in Germany, and were already that nation's second-largest political power. Meanwhile, Mussolini ruled his Fascist Italy with bombast and the fist. Totalitarianism seemed like the wave of the European future. Rivera's Mexico was not immune to the virus. An openly fascist group called the Gold Shirts began appearing in the cities, battering left-wing unionists, using terror to make political points.

And in the United States, Babe Ruth signed a two-year contract to play for the New York Yankees. He would be paid $80,000 a year, which was more than President Herbert Hoover was earning. The Babe justified it by saying that in 1929 he had a better year than Hoover did. That was certain. By the fall of 1930, unemployment had reached four million, and it would get worse. Much worse. Under Hoover's orders, thousands of Mexicans were being rounded up in the cities of the western United States and deported back to Mexico. The deportees included children, born north of the border, who were United States citizens.

For Diego Rivera, the journey north meant he could leave Mexico behind for a while and indulge his sense of irony. The first irony involved the site of his next mural. He would decorate the Luncheon Club of the new San Francisco Stock Exchange. This provoked a media controversy, for which Rivera had great talents. Various jingoists raised the cry: a communist was decorating the stock exchange! Outrage! Blasphemy! But Rivera repelled the attacks with his own presence. A reporter for the *San Francisco Chronicle* described him as "a jovial, big jowled 'paisano,' beaming behind an ever-present cigar, his clothes bulkier than his big frame, a broad-brimmed hat of a distinctly rural type on his curly locks." The contrast with Frida was also noted. She was "a contradistinct living picture, the charming, thin-waisted,

OPPOSITE:
Diego Rivera and Frida Kahlo at the Golden Gate Bridge, San Francisco, 1930

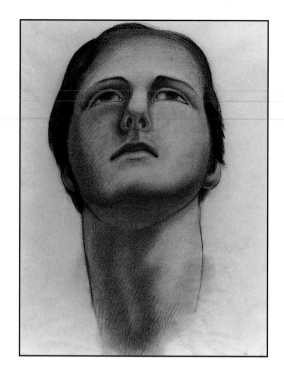

ABOVE:

Head of a Woman. 1931.
Red and black chalk, 24½ x 18⅝"
(62.3 x 48 cm). San Francisco
Museum of Modern Art,
William L. Gerstle Collection,
Gift of William L. Gerstle through
the San Francisco Art Institute

Helen Wills Moody was
the model for this drawing.

OPPOSITE:

The Making of a Fresco,
Showing the Building
of a City. 1931.
Fresco, 18'8" x 32'6"
(5.68 x 9.91 m).
San Francisco Art Institute

high-heeled, nugget-beaded *señorita*."[1] Diego made speeches (usually in French). Frida gave interviews (usually in English). At the same time, Diego presided over the first major retrospective of his art, a total of 129 works exhibited in the California Palace of the Legion of Honor. His fame spread. He was no longer an exotic import from Mexico. He was right here, in his generous flesh, in the company of his beautifully dressed young wife.

In the first month, between interviews, Rivera wandered around the Bay Area, making sketches, looking at the light, the teeming valleys, the wine country, the fishing wharves. Finally he turned his attention to the mural. He prepared the cartoons in the studio of his friend the sculptor Ralph Stackpole, who was instrumental in helping him get the commission (he had known Stackpole since their Paris days and their friendship was renewed while Rivera worked in Chapingo). The new mural was to be painted in the stairwell leading to the dining room. It was an allegory of the state's extraordinary abundance. California itself was symbolized by a broad-shouldered blue-eyed woman. Diego's model was tennis star Helen Wills Moody.

"Miss Wills has classic Grecian features," Rivera said. "Since I feel that California is a second Greece, I think that Miss Wills typifies the young womanhood of this state."

He made some elegant, stylized drawings of Wills, in sanguine and pastel, and further stylized her in the actual mural as a fair-skinned Earth Mother, a goddess of abundance. She wears a necklace of golden wheat. Her giant hands gather the fruits of the rich California earth. There are scenes showing the intelligent use of natural resources, the value of technology in exploiting harbors and petroleum, lumberjacks at rest, men panning for gold, miners using modern equipment to extract riches from beneath the surface of the earth. Luther Burbank makes an appearance, examining flora with his scientist's eye. On the ceiling, Rivera painted a soaring nude, representing the creative spirit, along with airplanes, the sun, and a second female at rest. To some extent, Rivera is here doing variations on previous work, and continues his use of over-finished details. But the general impression is one of sunniness and optimism, reflecting his embrace of the style and light of California. Rivera politely avoids mentioning the theft of California from Mexico at gunpoint, during the Mexican War. And from the evidence of this mural, the Depression was still remote from most of California.

In April 1931, he followed the stock exchange commission with a small mural in the private home of Mrs. Sigmund Stern in Atherton, south of San Francisco. He and Frida had stayed there as guests after the completion of the stock exchange mural, and this small, modest picture is beautifully done. Two Stern grandchildren are in the foreground, while a third plants seed in the

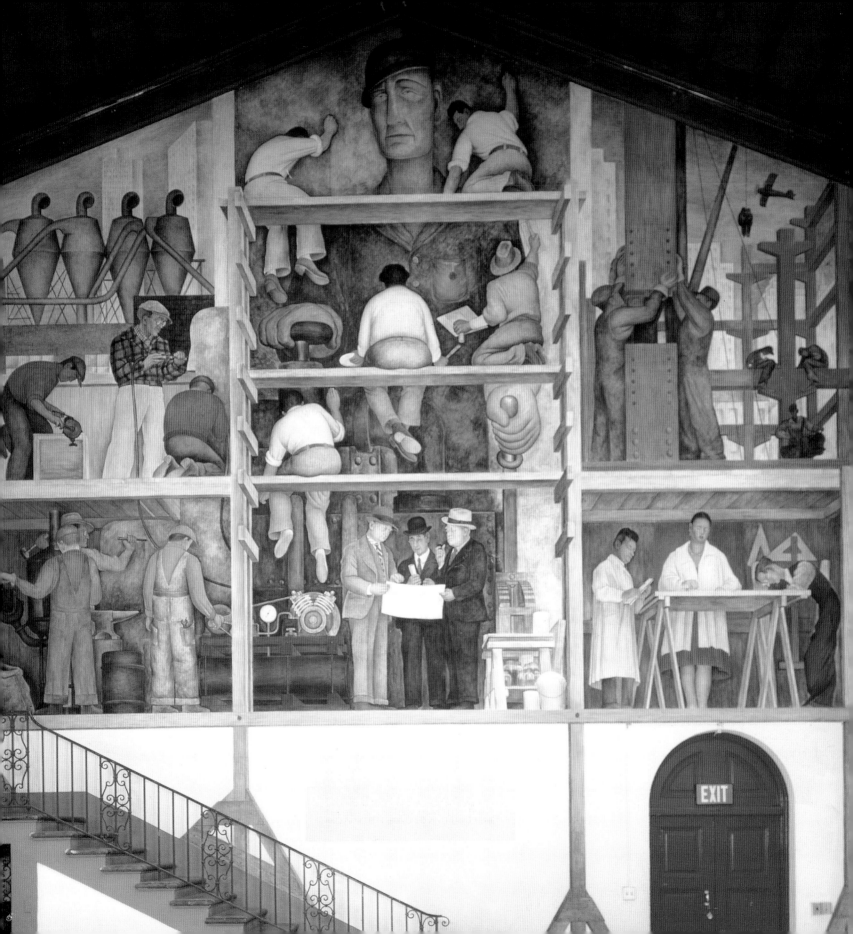

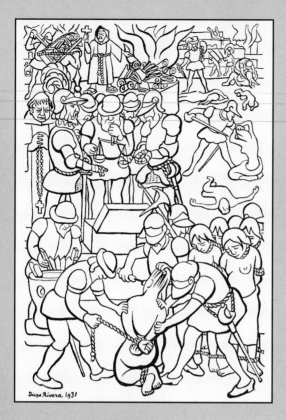

middle ground. The social commentary is oblique: a Mexican child reaches for a piece of the fruit in the foreground; a Latino rakes the ground in the immediate background; and, in the distance, glimpsed among gorgeously painted flowering almond trees, a man operates a small tractor, a symbol of Rivera's growing belief in a liberating technology. This was also the first of Rivera's portable frescoes, painted on a frame of galvanized metal lath. In 1956, after the death of Mrs. Stern, it was removed from the residence and can be seen in Stern Hall at the University of California in Berkeley. It is a wonderful small fresco, a triumph of Warm Diego.

In the meantime, as Rivera's reputation grew, so did the market for his drawings, watercolors, and easel paintings. Many drawings survive from this period, some directly used as preliminaries to the mural painting. The pencil drawings are done in an Ingres-like style. But there are also action drawings of Wills playing tennis that capture the energy and skill of the subject. Drawing clearly delighted Rivera, and he put some of his joy into many drawings and paintings of the human hand.

At the end of April, he started work on another large mural, this one in the gallery of the California School of Fine Arts. He was under pressure now to return to Mexico City and resume his labors on the murals in the National Palace. He asked his patrons to help him relieve the pressure. They succeeded, and he stayed on in California. He worked day and night through the month of May, completing the work on June 2. Rivera wanted to show how a modern industrial city should be planned and constructed; that intention was consistent with his utopian impulse. He divided his space into a classic triptych, and subdivided the triptych into eight smaller panels. Craftsmen, engineers, and steelworkers are depicted. He shows Stackpole as a sculptor, using a modern power tool on stone, while assistants sharpen chisels. In the style of many Renaissance painters, he shows in the bottom panel of the triptych's central axis his own San Francisco patrons examining plans. Skyscrapers, rooftop exhaust chimneys, and an airplane appear in the backgrounds. And the social commentary is subtle: a tiny hammer-and-sickle pin in the denim overalls of the giant figure of a worker, a small pressure gauge moving toward the red danger zone.

But the mural's great charm comes from its dominating design element: Rivera himself, seated on a painted scaffold with his back to the viewer, palette in one hand, brush in another, while four assistants labor on other aspects of the mural. The painted wall is about constructing the modern city, but it is also about constructing the modern mural. Back in Mexico City, he had painted peasants seated upon doorway lintels, watching scenes of agrarian reform; now he was both witness and participant in the making of another kind of Mexican expression, his own. The total effect is of warmth, embrace, and a satisfaction that is not smug. This is a happy piece of work.

From June to October, Rivera was back in Mexico, working on the murals in the central staircase of the National Palace. Eventually, this project would

OPPOSITE, ABOVE LEFT:
"Los abusos de los conquistadores" ("The abuses of the conquistadors"), illustration for *Mexico: A Study of Two Americas* by Stuart Chase, 1931

OPPOSITE, ABOVE RIGHT:
"Viva Mexico," illustration for *Mexico: A Study of Two Americas* by Stuart Chase, 1931

OPPOSITE, BELOW:
Mexican Highway (original drawing for *Mexico: A Study of Two Americas* by Stuart Chase). 1931. Brush and India ink, 18⅞ x 12½″ (48 x 31.6 cm). Philadelphia Museum of Art: Purchased: Lola Downin Peck Fund from the Estate of Carl Zigrosser

OVERLEAF, LEFT:
The Aztec World (detail: Quetzalcóatl instructs his votaries). 1929. Fresco. Palacio Nacional, Mexico City

OVERLEAF, RIGHT ABOVE:
From the Conquest to 1930 (detail: conquistadors attack the Aztecs). 1929–30. Fresco. Palacio Nacional, Mexico City

OVERLEAF, RIGHT BELOW:
Mexico Today and Tomorrow (detail: the repression of striking workers and *campesinos*). 1935. Fresco. Palacio Nacional, Mexico City

Frida Kahlo can be seen in the lower left-hand corner of the detail from *Mexico Today and Tomorrow*, seated behind her sister, Cristina.

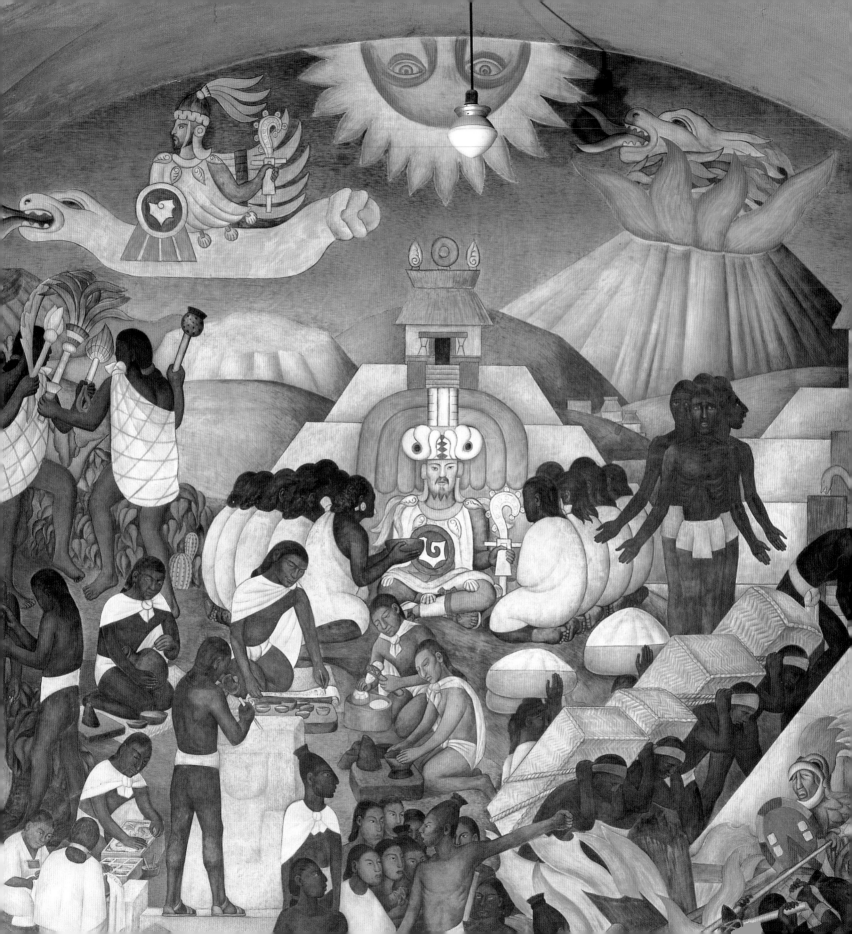

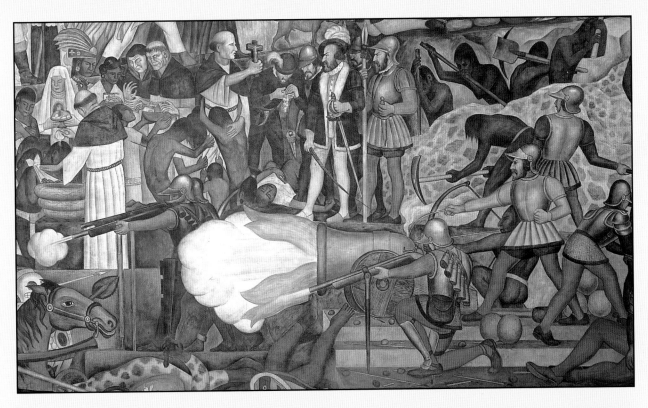

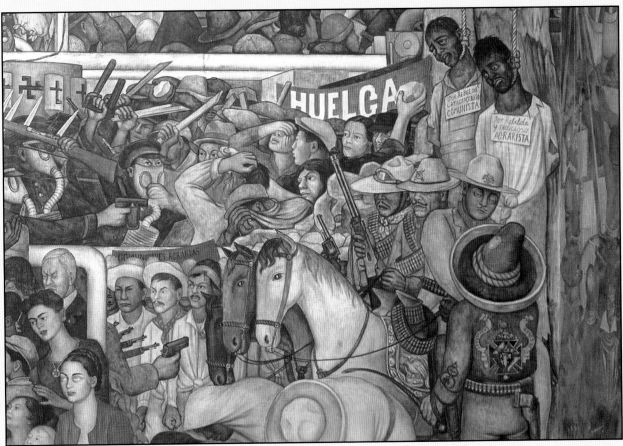

be seen by more people, including millions of tourists, than almost all other Rivera projects. It stands today as exemplary of hard work and personal industry, but is one of his least satisfying murals as art. The unpleasantly meticulous rendering is dominant; the composition is as crowded as a subway train in rush hour; the portraits are exercises in hagiography; the scenes of vanished Aztec glories are dishonest (no pre-Conquest militarism or human sacrifice here). Even Karl Marx makes a guest appearance in this Mexican panorama, as if offering a word from the sponsor, holding a banner that says: "The entire history of human society is the history of class struggle." Marx, of course, had as much to do with Mexican history as Babe Ruth did.

Rivera claimed that he was putting the epic history of all of Mexico on these walls. But with the exception of isolated sections, he functions more as a skilled, empty illustrator than as an artist. Diego's hands are painting; his heart isn't. The reconstructions of ancient Mexican cities look like foldouts from *National Geographic*. The historical figures are too often merely represented, not illuminated. There is a peculiar lack of conviction to the painting, as if he were mimicking Cecil B. DeMille with his casts of thousands while caring little about what the epic might mean. There is plenty of violence, much oppression, and almost no insight. This is painting that demands the services of a tour guide.

That summer, Rivera was also busy with other tasks. He had money now, from his California work, and from the increasing sale of drawings and easel paintings, including the portfolio of watercolors from Moscow. He commissioned Juan O'Gorman, the painter and architect, to design twinned studio/homes for him and Frida in the San Angel section of the city, each one a modernist cube. A bridge connected them. He spent time with Sergei Eisenstein, the Russian director who was preparing the film *Que Viva Mexico* (and who would end up being whipsawed by the competing tyrannies of Hollywood and the Kremlin). He worked on a series of drawings inspired by the Mayan text called the *Popol Vuh* for a book that wasn't published. He made some marvelous brush drawings of scenes in Mexico, many of which were used by Stuart Chase in his book *Mexico: A Study of Two Americas*. More important, he was preparing for a return to the United States. Before leaving, he had accepted a commission to paint murals in the Detroit Institute of Arts. At the same time he was preparing a one-man show for the new Museum of Modern Art in New York. As the world fell deeper into Depression, Diego Rivera was riding high.

A Triumph in New York

On November 13, Rivera arrived in New York City with Frida and his old assistant Alva de la Canal on board the SS *Morro Castle*. The city amazed and appalled him. If California had seemed immune from the effects of the Great

Depression, New York was not. There were breadlines and suicides. In 1931, hospitals reported ninety-five deaths from starvation. Men sold apples on corners, lived in shanties in Bryant Park, slept in doorways. As the money dried up, work stopped on the Triborough Bridge and the Hampshire House. Families lost their homes in Brooklyn and Queens. Groucho Marx said that things were so bad "the pigeons started feeding the people in Central Park."[2]

Those who were not consoled by Groucho sought refuge with Karl. More young people turned to Marxism, and membership in the Communist Party soared to the largest numbers in its history (about 80,000). This was no threat to the Republic, for the left, as usual, was riddled with schism. (In 1929, Rivera's friend and later biographer Bertram D. Wolfe had also been expelled from the Communist Party, as Stalin demanded worldwide allegiance to his vision of communism. Wolfe was now allied with Jay Lovestone in the American version of the Trotskyite heresy, and much energy went into the internecine struggle.) Left-wing New York was a mixture of turmoil and despair. More important, there seemed to have been a much wider American failure of morale.

In the midst of this apparent confirmation of his communist beliefs, Rivera set to work arranging his show at the new Museum of Modern Art, then located on the tenth floor of an office building at 730 Fifth Avenue. The show would include fifty-six easel paintings and eighty-nine watercolors, drawings, and studies for murals. To give some suggestion of the power of his mural works, Rivera procured a studio to duplicate some of those works on portable frames, each measuring six by eight feet and weighing more than a thousand pounds. These were a kind of hybrid—part mural, part easel painting. With the help of assistants de la Canal, Lucien Bloch, and Clifford Wight, he put in fifteen-hour days and got them done in less than a month.

From the Ministry of Education, he did new versions of *Uprising* and *The Liberation of the Peon*, and from Cuernavaca, he produced *The Conquest, Zapata*, and *The Sugar Cane Harvest*. He also created three new works based on his experience of New York. *Pneumatic Drillers* and *Power* were essentially genre paintings of men at work, joined in silent marriage to their tools. The third was a fine painting of the layers of New York life in the second year of the Great Depression.

"At the top loomed skyscrapers like mausoleums reaching up into the cold night," he said later. "Underneath them people were going home, miserably crushed together in the subway trains. In the center was a wharf used by homeless unemployed as their dormitory, with a muscular cop standing guard. In the lower part of the panel, I showed another side of this society: a steel-grilled safety deposit vault in which a lady was depositing her jewels while other persons waited their turn to enter the sanctum. At the bottom of the panel were networks of subway tunnels, water pipes, electric conduits, and sewage pipes."

The painting demonstrated a shrewd insight into the reality of New York: the city is never merely what can be seen. The fresco's grim, taut composition suggests a city imprisoned by the inevitability of history. The painting was labeled *Frozen Assets* by a visiting journalist and it has retained that title. Almost sixty years later, when New York was being overwhelmed by a new wave of homeless people, it seemed eerily fresh and relevant.

The show opened on December 23, 1931, and was a huge success, with more than 57,000 visitors in a month. It was an even bigger draw than the museum's first one-man show, which was dedicated to the work of Henri Matisse. The reviews were almost all positive. Young artists looked at the work and were inspired. Diego Rivera was now a major artist on the world stage.

The God of the Assembly Line

When Rivera arrived in Detroit in January 1932, with Frida Kahlo at his side, he was struggling with a need for a transcending belief. From Mexico, he was receiving news about the deepening decline of the ideals of the Mexican Revolution. The communist movement was being destroyed by Stalin (and in this year the Soviet dictator would make "socialist realism" into still another article of dogma). Capitalism was, of course, the primary enemy but it appeared to be near collapse, and, besides, you could not always define yourself by what you were against. For the moment, Rivera embraced the benevolent religion of the machine.

"Machinery does not destroy," he said, "it creates, provided always that the controlling hand is strong enough to dominate it." And machines, like Cubism, were beautiful in a new way: "The best known architects of our age are finding their aesthetic and functional inspiration in American industrial buildings, machine design, and engineering, the greatest expressions of the plastic genius of this New World."[3]

The man who at three years old drew pictures of locomotives would place his new version of the True Faith upon the walls of the central court of the Detroit Institute of Arts. The final plan called for twenty-seven panels. The money was ample: Edsel Ford, then president of the Ford Motor Company and a member of the Detroit Arts Commission, contributed more than $20,000 to make the murals possible. As always, Rivera worked hard for the money. He had been asked to reflect in his painting all the industry of Detroit, not simply the automobile industry. And he began with research. He spent a month at Ford's sprawling River Rouge plant in Dearborn, making sketches, asking questions, trying to understand, enthralled by the modernity and perfection of the technology. He also visited the Parke-Davis pharmaceutical plant, the factory of Michigan Alkali, and others.

"The more he saw," Wolfe later wrote, "the more he was stirred by

clean-lined, brilliantly planned laboratories, marvelously lined belt convey-
ors and precision instruments." Wolfe went on: "Painting, Diego had long
believed, must absorb the machine if it was to find the style for this age,
assimilate it as easily and naturally as it had still-life objects, landscapes,
dwellings, castles, faces, nude bodies, master this marvelous new material
and make it live again on walls as vividly and movingly as ever art had his-
torical scenes, old legends, and religious parables."[4]

New York was an old city of small manufacturers. Most businesses aver-
aged twenty employees. But Detroit was something else, the capital of mass
production as conceived and executed by Henry Ford. And Rivera respond-
ed to its essence with a sense of renewal and passion. In a letter to Wolfe,
after months in what later came to be called Motown, Rivera said: "For the
industrial material of this place, I feel the enthusiasm I felt ten years ago at the
time of my return to Mexico with the peasant material."

The fascination with the objects of twentieth-century technology was not
new, of course, or unique to Diego Rivera. In France, Fernand Léger (also a
committed communist) had embraced it in his own version of monumental
art. For years, the beauty of the machine had been extolled by the artists and
designers of the Bauhaus. Architect Le Corbusier called his private homes
machines à habiter (machines for living) and openly admired the clean
planes and gleaming surfaces of machinery. But Rivera reacted in his own
way, which, as before, had elements of the religious to it.

He ignored the terrors of the Depression; he was clearly innocent of envi-
ronmental concerns; and Charlie Chaplin had yet to convert the assembly
line into a symbol of dehumanization in *Modern Times.* As portrayed by
Rivera, machines were benevolent and triumphant, the redeeming engines of
the utopian future. As Wolfe put it, "He would paint the human *spirit* that is
embodied in the machine, for it is one of the most brilliant achievements of
man's intelligence and reason; the force and power which gave man domin-
ion over the inhuman forces of nature to which he had so long been in help-
less subservience; the *hope* that is in the machine that man, freed from servi-
tude to nature, need not long remain in servitude to hunger, exhausting toil,
inequality, and tyranny." Writing in the early 1960s, after the world had seen
what the Nazis and the Stalinists would do with the machine, and after the
unleashing of the atom as a weapon, Wolfe added soberly: "But it did not
occur to Diego that the machine might also be used to extend the power of a
dictator over the ruled, extend it to something approaching totality."

The whole conception has a kind of cold grandeur. Grandest of all is the
south wall, where Rivera merges the Mexican past with the machine-tooled
future, and one machine rises more powerfully than all others. This is a mam-
moth stamping press, but it also resembles images of Tlaloc the Rain God
(some analysts see it as a version of the more malevolent goddess Coatlicue).
Just as the intercession of Tlaloc provided water that was indispensable to the

fields of Mexico, technology would be the indispensable agent of the human future. It is no accident that Rivera's machines are godlike and mysterious, with enormous totemic power.

As he worked, the industrial process itself was evoked with all its fluid movement. Like a great mural, the component parts of the automobile assembly line fit perfectly into the whole. The process is smooth and perfectly integrated, a capitalist metaphor for a communist society. The machines could not work on their own (automation was not yet a consideration); they needed the presence of men. That is why, from Rivera's point of view, a faith in technology was not ideologically inconsistent with communism. He believed in the prophecies of Marx the way some people believed in those of Nostradamus; an act of faith required him to trust that eventually the men in the overalls would own these means of production, along with all others.

There are many parts of the mural worth attention. The upper reaches of the walls feature more allegorical nudes, again painted in a cold antierotic style. On the east wall, two female figures again represent the plenitude of the harvest, hugging wheat, fruits, and vegetables to their ample bodies. Beneath them, over an arch, is a long horizontal panel showing an embryo embedded in a plant. Rivera intended this "germ-child" to stand not simply for life, but for human aspirations, for art, for intelligence, for those unborn children who must live with the consequences of human choices. The panel also marks the appearance of Diego the Biologist. Here and elsewhere, he would paint blown-up portrayals of plants, bacteria, chromosomes, the elements of disease and poison gas, along with sperm, sand, granite. The effect is unpleasantly startling, like immense pages from a textbook.

The west wall shows the arrival of aviation as a fact of modern life, with passenger and mail planes contrasted with airplanes that could be weapons of war. The civilian pilots show their faces; the warriors have donned gas masks. This was six years before the word *blitzkrieg* was added to the world's vocabulary. Beneath the airplanes there's a fine *grisaille* painting of a freighter moving through seas plump with fish, bringing goods from the industrial world to workers on the shores of the tropics. Hovering above the ship is a star (possibly communist) and a human head divided between a face and a skull. War and peace. Civilization and barbarism. A dying capitalism and a vibrant socialism. The freighter is flanked by elegantly painted

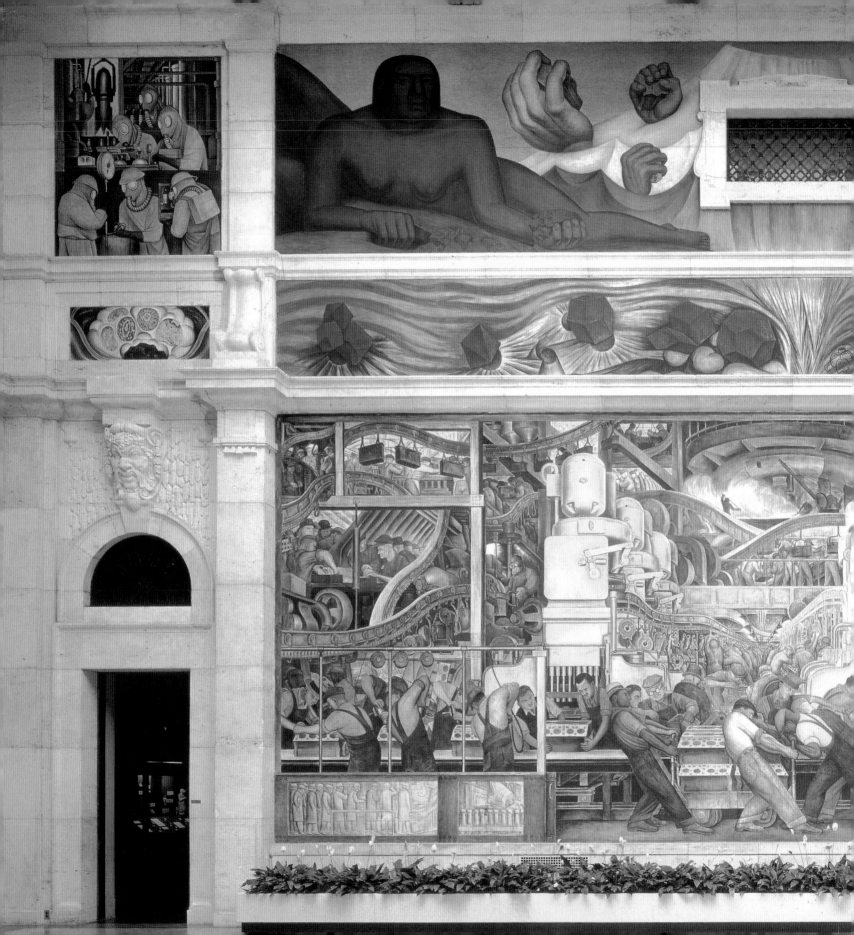

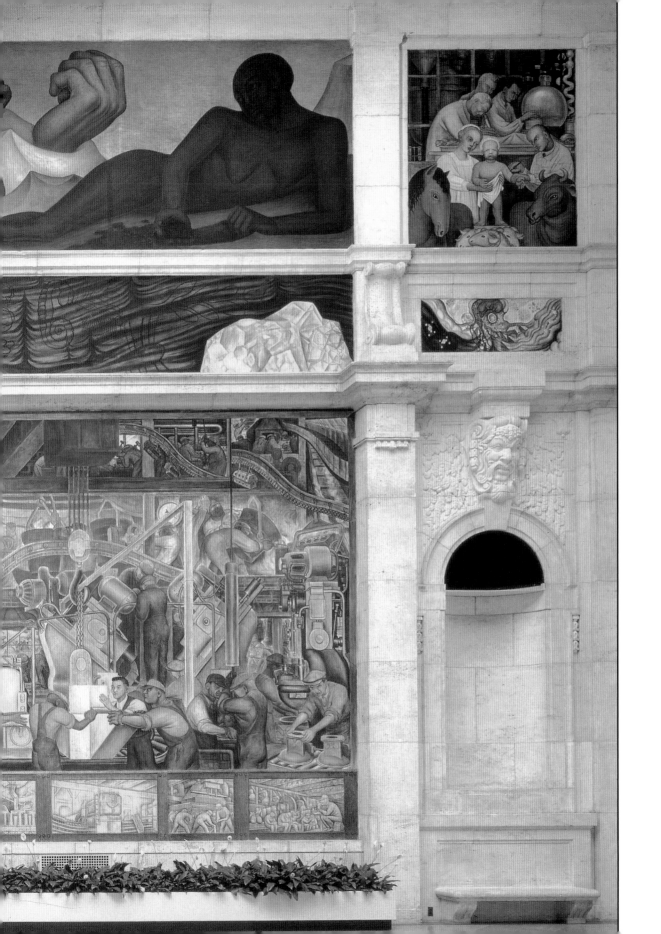

North wall, *Detroit Industry*
(main panel: *Production and
Manufacture of Engine
and Transmission*). 1932–33.
Fresco. Detroit Institute of
Arts, Founders Society
Purchased, and Edsel B. Ford.
Photograph © 1998
The Detroit Institute of Arts

The Belly of the Beast • 159

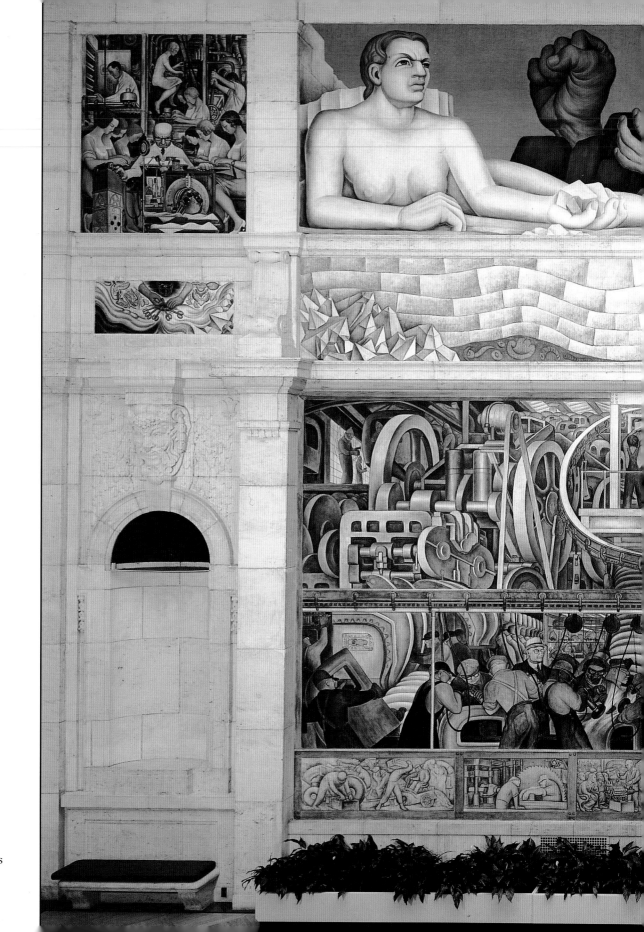

South wall, *Detroit Industry*
(main panel: *Production of
Automobile Exterior and Final
Assembly).* 1932–33. Fresco.
Detroit Institute of Arts,
Founders Society Purchased,
and Edsel B. Ford. Photograph
© 1998 The Detroit Institute of Arts

160 • Diego Rivera

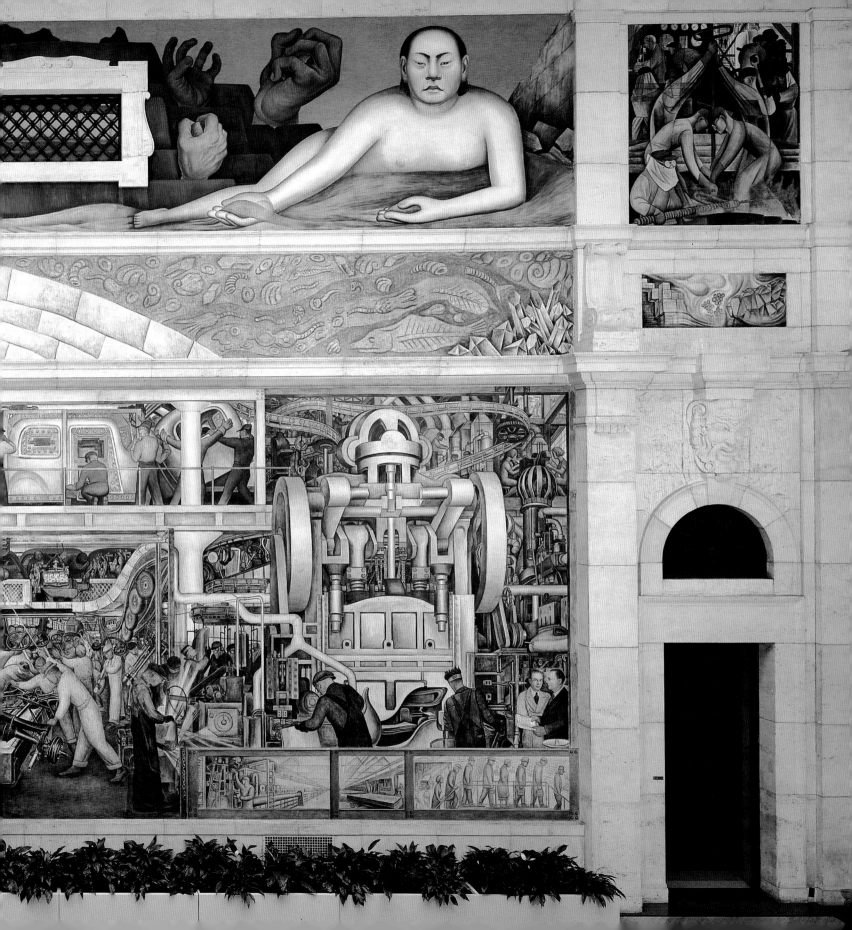

visions of birds and sunflowers. Their simplicity in this complex steel-finished hymn to technology is like the sudden appearance of the music of a flute on a factory floor.

The only true controversy over the Detroit murals was focused on a panel in the upper-right-hand corner of the north wall. This purported to show the beneficial effects of commercial chemicals. But it looked suspiciously like a parody of the traditional Christian Nativity scenes. In a shallow space as tight as a crèche, a woman who looks like the movie star Jean Harlow, wearing a halo of yellow hair, presents to the viewer a diapered child that resembles the Lindbergh baby. The idea of a manger is established by the presence of a horse, a cluster of young rams, and a cow in the foreground. The child glows with an unearthly light. A scientist—seen by some to represent Joseph—leans in to vaccinate the baby. Behind the mother and child are three scientists working in a lab. Yes: the Magi. Or so some people thought (Rivera uncharacteristically remained discreetly silent). When the murals were opened to the public in March 1933, a right-wing radio priest named Charles Coughlin went on the attack from his Shrine of the Little Flower at Royal Oak, Michigan. A Catholic from Canada, Coughlin was becoming the most powerful commentator on 1930s radio. A variety of local politicians and newspapermen served as his backup group. But the museum directors stood fast. More than 86,000 people flocked to see the murals in the first month. The crisis passed. The murals have survived, monuments to a lost era.

Rockefeller Center

Diego wasn't the only Mexican artist known in the United States. José Clemente Orozco was working on murals in Dartmouth. David Alfaro Siqueiros was painting in Los Angeles. They were becoming the Big Three of Mexican art. But Rivera was far and away the most famous, respected by the critics, his name known to many ordinary citizens.

His long American sojourn was not entirely a triumphant turn on the world stage. During this period, he was often physically ill. His eyes bothered him. He developed sores in his mouth. As he approached fifty, he went on a crash diet and lost a hundred pounds, weakening his legendary capacity for work. In September 1932, Frida's mother died and she left him alone to return to Mexico. When she returned, he had lost so much weight that she didn't recognize him.

Frida was alone so much that she began to paint more seriously, finding her way into a sustained examination of the self. She was not always happy in what she called Gringolandia. Manhattan was one thing, but Detroit began to wear her down. She was annoyed to the point of contempt by the society women who were part of the museum world. At one such affair, she met

OPPOSITE:
Frida Kahlo and Diego Rivera on a scaffold at the Detroit Institute of Arts, 1932. Photograph by J. W. Stettler, The Detroit Institute of Arts. © 1998 The Detroit Institute of Arts

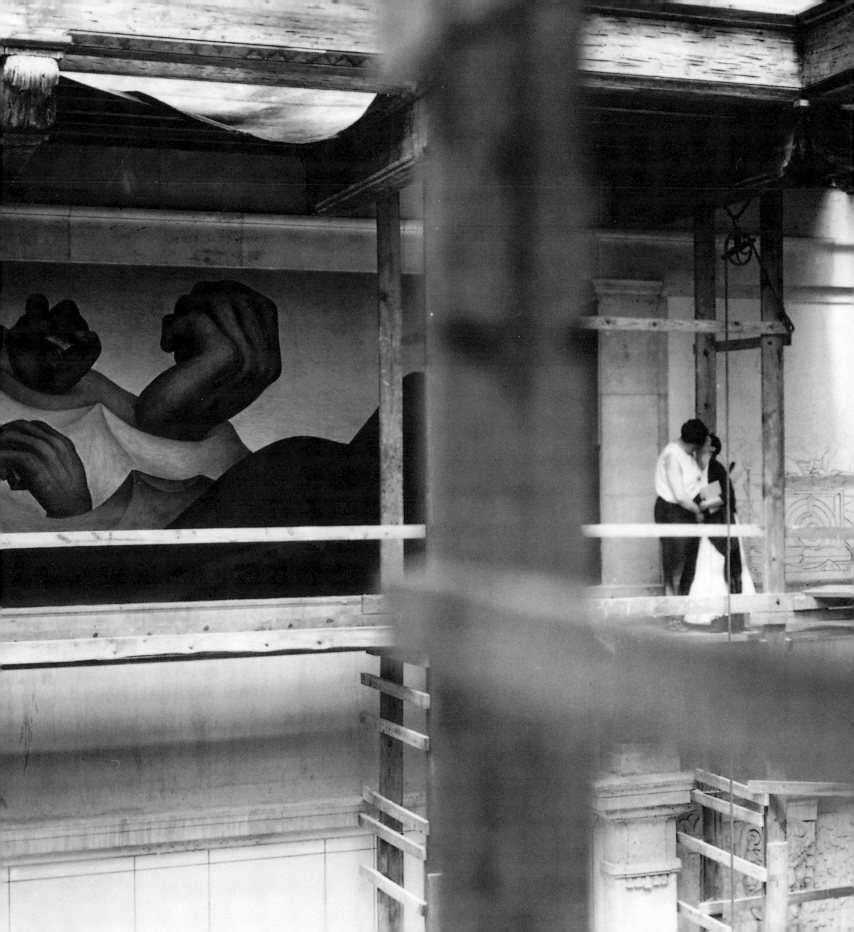

Henry Ford, who was a notorious anti-Semite, and asked him: "Are you Jewish?" She resented women who paid too much attention to her husband. A child of the eternal springtime of Mexico City, she broiled in the torrid North American summers and shivered in the frigid winters.

Then there was a turning point. On July 4, 1932, she had a miscarriage at Henry Ford Hospital in Detroit. Because of the damage to her pelvis in the streetcar accident in Mexico, there was always doubt that she could bring a child to term. But she desperately wanted a child by Diego, an ambition that she dated to her days at the National Preparatory School, when she first saw his great bulk on the scaffolds of the Anfiteatro Bolívar. Now she was distraught, immobilized. But her best paintings would begin to follow. And some analysts believe that Diego's use of a fetus in his Detroit murals was his own way of dealing with the loss of that child; if the martyred Zapata and Montaño could replenish the earth, so could a dead child, symbol of so much simple human yearning.

In March 1933, when the murals were opened to public view, they were both happy to leave Detroit for New York. Diego was convinced that he had done some of his finest work. But because of what had happened to Frida, the city of the automobile had about it the odor of death. They moved on to New York, where Diego was to paint a mural in the RCA building in the grand new complex called Rockefeller Center.

Now the world was getting even darker. It wasn't simply that the Great Depression was deepening, rather than easing. The capitalist collapse was transforming politics, pushing Europe toward drastic solutions. On January 30, while Diego was still in Detroit, Adolf Hitler took power as chancellor of Germany. On March 4, as he gave his work its final touches, Franklin D. Roosevelt was sworn in as president of the United States and told the nation "the only thing we have to fear is fear itself." This was more an expression of Roosevelt's optimism than of reality. The Nazis were rounding up the perceived enemies of the state. On March 20, the day that Diego and Frida arrived in New York, the first German concentration camp was opened in an old powder factory ten miles from Munich in a little town called Dachau. Three days later, the German parliament granted Hitler dictatorial powers. A few days after that, Rivera began work on his mural.

The RCA mural was entitled *Man at the Crossroads Looking with Hope and High Vision to the Choosing of a New and Better Future*. This windy title, chosen by the architects, was supported by an even windier description by Rivera and, what was more important, by a detailed preliminary sketch. The sketch was approved by the Rockefellers and, reluctantly, by the architect, Raymond Hood. Originally there were to be three murals. One by Rivera, one each by Picasso and Matisse. The others dropped out and Rivera was left as the man who would provide the most powerful visual signature for the new complex. The lateral walls were to be painted in monochrome by the academic

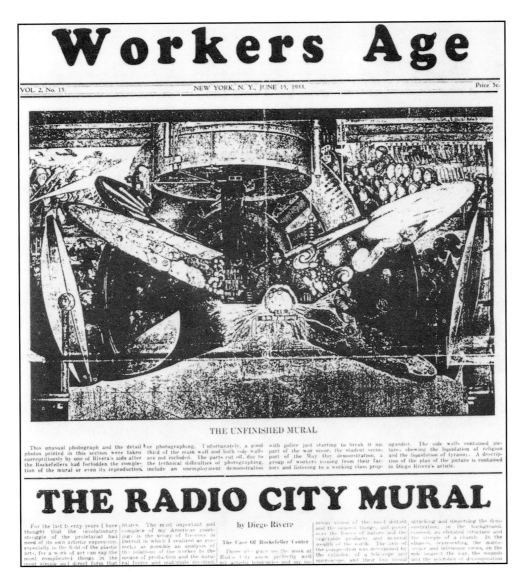

Workers Age

VOL. 2, No. 15. NEW YORK, N. Y., JUNE 15, 1933. Price 5c.

THE UNFINISHED MURAL

This unusual photograph and the detail photos printed in this section were taken surreptitiously by one of Rivera's aids after the Rockefellers had forbidden the completion of the mural or even its reproduction. For photographing. Unfortunately, a good third of the main wall and both side walls are not included. The parts cut off, due to the technical difficulties of photographing, include an unemployment demonstration with police just starting to break it up, part of the war scene, the student scene, part of the May Day demonstration, a group of workers issuing from their factory and listening to a working class prop- agandist. The side walls contained pic- tures showing the liquidation of religion and the liquidation of tyranny. A descrip- tion of the plan of the picture is contained in Diego Rivera's article.

THE RADIO CITY MURAL

by Diego Rivera

For the last twenty years I have thought that the revolutionary struggle of the proletariat had need of its own artistic expression, especially in the field of the plastic arts, for a work of art can say the most complicated things in the most simple and direct form that States. The most important and complete of my American paint- ings is the series of frescoes in Detroit in which I realized as cor- rectly as possible an analysis of the relations of the worker to the means of production and the natu- ral forces and materials involved.

The Case Of Rockefeller Center

Those who gave me the work at Radio City knew perfectly well my artistic tendencies and my so- means vision of the most distant and the nearest things, and power over the forces of nature and the vegetable products and mineral wealth of the earth. The axis of the composition was determined by the cylinder of a telescope and the cylinder of a telescope and microscope and their two visual attacking and dispersing the dem- onstration in the background, over an elevated structure and the steeple of a church. In the side nearest the war, the wounds and the microbes of decomposition

muralists Frank Brangwyn of England and José María Sert of Spain. In this international trio, Rivera was the star. He was to paint the wall facing the main entrance of the main building of the Rockefeller Center complex.

The result was a great scandal. Rivera worked steadily into mid-April (among his assistants was young Ben Shahn). Then a reporter from the *New York World Telegram* noticed that Mexico's most famous communist was plac- ing upon the Rockefellers' wall a heroic head of a benevolent Vladimir Ilyich Lenin. By the early 1930s, the idealizing of the dead Lenin by some commu- nists was providing a sentimental alternative to the brutality of the live Stalin; communism would have been beautiful and just, if only Lenin had lived beyond January 1924. This was almost certainly another delusion, but it was believed by many communists, including Diego Rivera. "When I think of the supreme type of labor leader," Rivera said, "I certainly think of Lenin."[5] He

did not apparently know that on Lenin's orders, leaders of the Russian typographers' and railroad workers' union had once been murdered. But he should have known that the newspaper stories would alert the Rockefellers to danger. Unlike his work in California or Detroit, this mural was evolving into a blatant Marxist call for class struggle.

In Rockefeller Center, Rivera's defiant exercise in communist idealism came up against one huge legal problem. The insertion of Lenin into his mural was an alteration of the original plan; Lenin does not appear anywhere in the approved sketch. In addition, there was a practical consideration that was more important than the narrow language of contracts: the Rockefellers were anxious to rent offices in a new seventy-story building in the middle of the Depression. It was unlikely that capitalist tenants would be happy arriving for work each morning if forced to gaze at the face of Lenin. To insist on the inclusion of Lenin was absurd, even adolescent. Rivera insisted it was critical to his artistic vision. On May 4, Nelson Rockefeller tried to mediate, sending Rivera a letter that said:

"While I was in the No. 1 building at Rockefeller Center yesterday viewing the progress of your thrilling mural, I noticed that in the most recent portion of the painting you had included a portrait of Lenin. The piece is beautifully painted, but it seems to me that this portrait, appearing in this mural, might very easily seriously offend a great many people. If it were in a private house it would be one thing, but this mural is in a public building and the situation is therefore quite different. As much as I dislike to do so, I am afraid we must ask you to substitute the face of some unknown man where Lenin's face now appears."[6]

Rivera refused. Rockefeller turned the problem over to the building's managers. On May 9, Rivera was paid off and fired. The mural was covered with a canvas and placed on Death Row.

Immediately, there were appeals for mercy: protests, picket lines, fiery editorials, press conferences. Diego made an impassioned speech at a rally in Town Hall. Liberals drew parallels between the brainless censorship of Stalin's "socialist realism" and that of the Rockefellers. The event was used in different ways by opposing elements of the left. The American Stalinists saw it as evidence of the old saw that if you lie down with dogs, you should expect to get fleas. The Lovestoneites—including Rivera's friend Bertram Wolfe—used it to attack Stalin. Most communists presented themselves as bulwarks against Nazism; Stalin might be bad, but Hitler was worse. Obviously, they said, capitalism as epitomized by the Rockefellers was not an option. It was a time for choosing sides; most artists chose the side of Diego Rivera. Months later, when the Rockefellers had the mural hammered off the walls on the night of February 9, 1934, the painter John Sloan spoke for many others in declaring the act "a premeditated murder of art."

But there was one problem with all of this: the unfinished mural was

almost as bad as its title. In Rockefeller Center, the worst of Rivera was back in play. The propagandist overwhelmed the artist, as he seemed more interested in currying favor with various communist critics than in making an enduring work of art. Cold Diego defeated Warm Diego. At the center of the composition, a blond-haired male worker in overalls maintains firm control of technology. He could be American, he could be Russian, but Rivera clearly makes him a Caucasian. Above him looms part of a giant telescope, which Rivera said "brings the most distant celestial bodies into man's vision and understanding." He added a microscope that would make "the infinitesimal living organisms visible and comprehensible to man, connecting atoms and cells with the astral system. Exactly in the middle, cosmic energy, received by two antennas, is carried to the machinery controlled by the Worker, where it is transformed into productive energy."

This grandiose conception was made visible in two huge intersecting ellipses, images from a telescope and a microscope, filled with more of the blown-up spores, germs, and cells of Diego the Biologist, along with distant planets and a dead moon. On the capitalist side, we see syphilis, gonorrhea, gangrene, and tetanus; on the communist side, images of human life; with some cancer cells representing Stalinism. Rivera uses mechanical devices to create structure: a magnifying glass, film projectors, and, what was then a remote reality, television.

Oddly, in this crudely Manichean vision, Rivera places all the bad guys on the left. Bridge-playing, champagne-swilling rich people make an appearance, stock characters from the third floor of the Ministry of Education. To their left, thuggish cops beat heroic workers. Above these symbols of capitalist decadence are gas-masked soldiers, some equipped with flamethrowers, symbols of war. They are all part of the bad uses of technology, which is to say, the wrong side of the class struggle.

To the right, grateful, modest workers, including a black man, absorb the wisdom of Lenin, the Great White Father. Above them, handsome young female athletes run exuberantly in a May Day sports event. And rising above them, women in babushkas march triumphantly and militantly through Red Square.

As seen in a photograph, and as examined in its smaller repainted 1934 version in the Palacio de Bellas Artes in Mexico City, this didactic work is second-rate Rivera. It is completely devoid of wit or irony. Its painted surface is obsessively detailed. Its sense of history is based on self-delusion or ignorance. It is marked by an imposed grandiosity. That doesn't mean it should have been chopped off its wall; that act alone was stupid and careless and probably unnecessary; when it was destroyed, negotiations were under way for its removal to the Museum of Modern Art.

Perhaps driven by guilt over taking the final $14,000 paycheck from the Rockefellers, Rivera agreed to paint another ambitious work in New York: a

suite of twenty-one portable frescos, each weighing about 300 pounds, for the New Workers School on 14th Street. The school was run by Bertram Wolfe and was the educational center of the anti-Stalinist Lovestoneite communists. On July 15, Rivera began the murals that would depict his own version of American history.

"I painted them for the workers of New York," he explained later, "and for the first time in my life, I worked among 'my own'; for the first time I painted on a wall which belonged to the workers, not because they own the building in which their school has its quarters, but because the frescoes are built on moveable panels which can be transported with them to any place where their school and headquarters may be called to move."[7]

Rivera worked for five months on these paintings, ranging quickly (and glibly) through American history from the colonial past to the uneasy present, and in 1934 stated his aspirations for the series:

"I hope that this portrait may be in some small degree useful to a few hundreds, or thousands, or as many as possible, of the millions of workers who, in the near future, will carry out the formidable task of transforming, by means of revolutionary struggle and proletarian dictatorship, the marvelous industry of the super-capitalist country into the basic machinery for the splendid functioning of the Union of Socialist Soviet Republics of the American Continent."

The U.S.S.R.A.C. never happened, of course; American workers preferred the New Deal and the union movement to revolutionary struggle and the dictatorship of the proletariat. The New Workers School murals were again didactic: Abe Lincoln, Tom Paine, John Brown, Henry David Thoreau share the densely crowded space with Hitler and Mussolini, Trotsky and the pope, anonymous workers, a variety of oppressed peoples and their oppressors, Karl Marx, Augusto Sandino, and, of course, Comrade Lenin. To mention only a few. In reproduction, many of the panels look like predictable cartoons for left-wing magazines (Rivera was, in fact, an admirer of the American comic strip); as art, they are methodical products of research rather than inspiration.[8] Diego told Wolfe they represented the best work of his career. He must have known better.

On December 20 1933, he and Frida boarded the *Oriente* and set sail, at last, for home.

ABOVE:

Sinarquistas. c. 1940s. Charcoal on paper, 18 x 24″ (45.7 x 61 cm). Private collection

Dedicated to fighting communism and re-invigorating the Catholic Church, the Unión Nacional Sinarquista was organized in 1937 in Guanajuato, the town where Rivera was born.

OPPOSITE:

Proletarian Unity (panel nineteen of *Portrait of America,* a series of twenty-one portable frescoes painted for the New Workers School). 1933. Fresco, 5′3¾″ x 6′7¼″ (161.9 x 201.3 cm). Nagoya City Art Museum, Japan

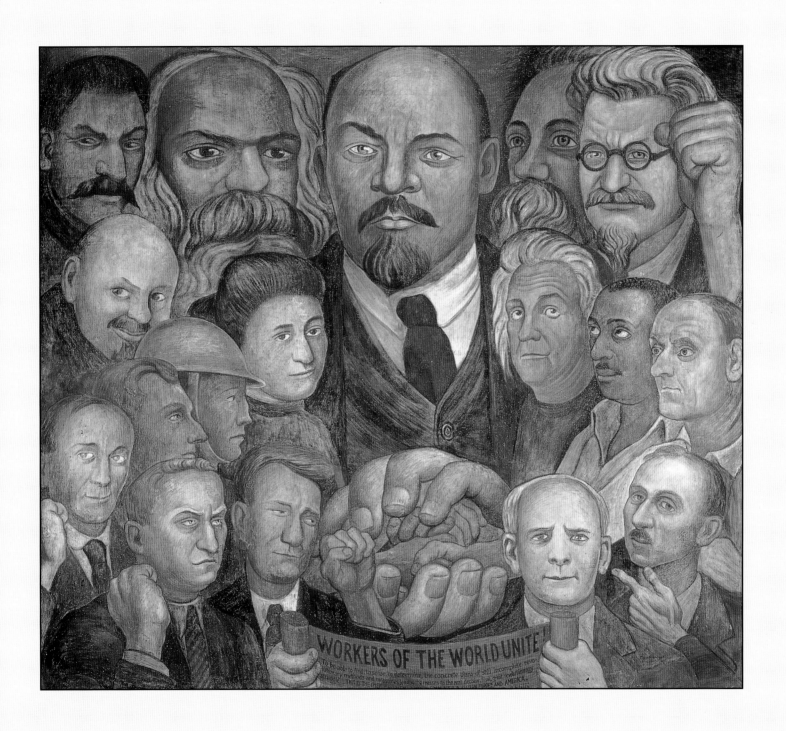

WORKERS OF THE WORLD UNITE!

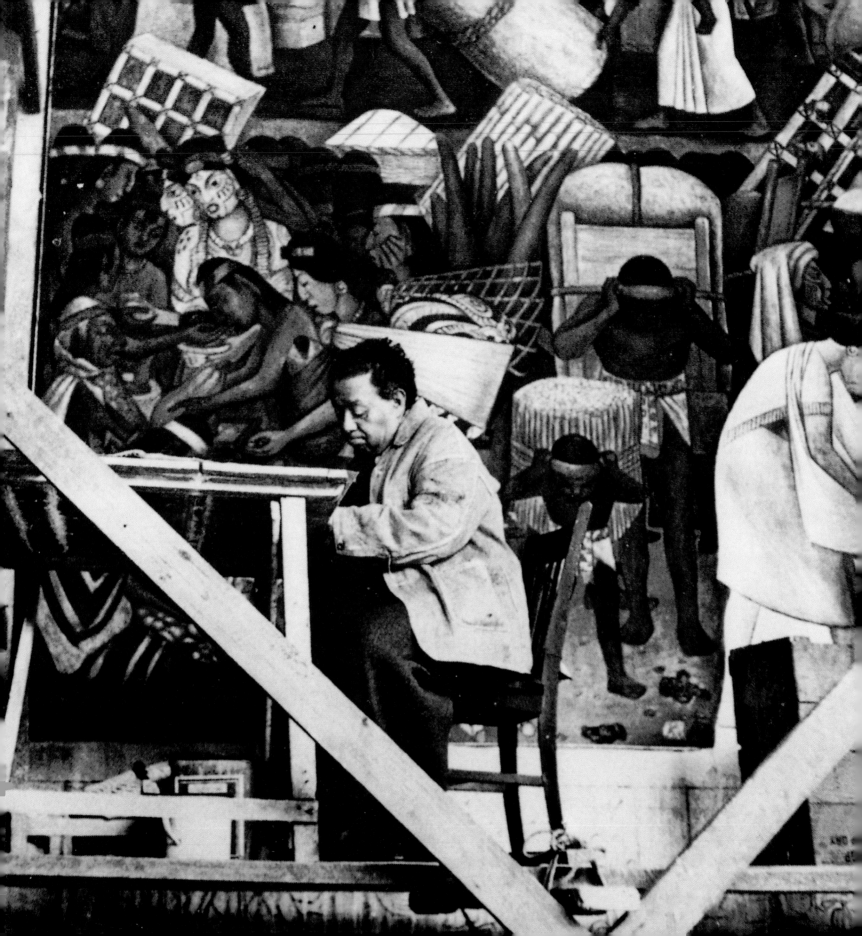

Back in Mexico, the Riveras moved into the new house in San Angel, and Frida went to work trying to make a house a home. This was not easy. Diego was exhausted and depressed. He thought none of his painting was any good. He was shunned by old comrades on the left. He had lost another big commission in the United States when General Motors canceled a contract for a Rivera mural at the Chicago World's Fair. As if driven by a sense of duty, he did some work at the National Palace, but he must have had some doubts about its ultimate worth.

Certainly, the culture of Mexico had changed during his four years in the United States. One driving motivation for painting murals was to present them as a mass medium, great panoramas that would instruct the poorest Mexicans about their country and themselves. But the movies were changing all that. The spring of 1932 saw the opening of the first Mexican movie with sound. Based on a novel by Federico Gamboa, *Santa* was a sad tale of a young provincial woman who falls into the degraded life of prostitution in Mexico City and is given a respite by the love of a blind musician. Lupita Tovar returned to Mexico from Hollywood to play the title role. The score was written by Agustin Lara, the greatest popular composer of the Mexican century. The director was Antonio Moreno, another Mexican who was working in Hollywood. It was a smash hit.

By 1934, *El compadre Mendoza*, directed by Fernando de Fuentes, was reflecting widespread cynicism about the Mexican Revolution, and it was followed by many movies set during the Revolution. The worst of them were like the worst Hollywood movies: escapist nonsense. But the best suggested the many ambiguities of Mexican history and the complexity of the Mexican character, while playing their own powerful part in shaping both. Only a decade earlier, José Vasconcelos had imagined the mural movement as a means of teaching the illiterate Mexican masses about their country and themselves. Now the greatest of all mass media had come to Mexico, with the addition of sound making the Mexican narrative available even to those who were illiterate. The movies drew greater crowds on a single Saturday in Mexico than could view murals in an entire year. Mural painting was becoming an art made for private patrons or the vanity of politicians.

OPPOSITE:
Diego Rivera working on the scaffold in front of a scene of the marketplace at Tlatelolco, a section of *The Great City of Tenochitlán,* at the Palacio Nacional, Mexico City, 1945. Photograph by Héctor García. CENIDIAP–INBA

As an artist, Rivera went back to his easel. From 1934 to 1940, he started no new murals. But slowly, as he emerged from his depression, and then with greater passion and energy, he began to paint some of his finest easel work.

Faces of the Rich and Faces of the Dispossessed

With his new house and his renewed mania for collecting Pre-Columbian art, Rivera needed money. He turned to the same market that had supported other great painters for centuries: the rich. He painted rich men. He painted the wives of rich men. The motivations of his patrons were basically simple. They wanted to have a Rivera in their new, well-defended homes in the Lomas de Chapultepec or in the town of Cuernavaca. They didn't care about Rivera's politics. Some indeed might have been amused by those politics, since the prospects for a Marxist regime in Mexico were increasingly remote. Or they enjoyed being able to purchase his talents as a kind of reproof. In the end, what mattered was the brand name. Diego Rivera was the most famous Mexican artist in the world. They wanted a Rivera.

Rivera gave them Riveras. To be sure, he did not indulge in cheap flattery. His portrait of Henri de Chatillon, called *The Milliner,* shows the subject trying on an absurd pink hat, in a room whose Frenchified furniture reveals something about the world the man inhabits. He is facing a mirror, wearing a slightly amused look along with the hat, and that hint of amusement provokes in the viewer some affection for the man. The trademark Rivera calla lilies are clustered on a table, along with miniature multicolored objects of the millinery trade that are spread like candies.

He painted men, suggesting isolation, the burdens of wealth, personal unhappiness, or an exultant, arrogant power, but the finest portraits were of women. In most of his portraits of women, Rivera allowed sensuality to live in his work, a quality that had vanished from the murals after Chapingo. Flesh is flesh in these paintings, lovingly, almost caressingly painted; the bodies have volume; the expressions on faces are suggestive of interesting erotic lives. Sometimes, to be sure, his eye was curdled with malice, and a few women are reduced to vapid fools. But more often, he was looking for some deeper psychological truth, a macho penetration of the subject. Today, those society portraits have more aesthetic life than any of the embalmed illustrations on the walls of the National Palace or those that were done for the New Workers School.

A hat dominates the portrait of Adalgisa Nery, a hat made of feathers and gauze, worn proudly by a woman with a haughty disdain for any criticism from her inferiors. Her gaze says: You might find this hat amusing, you might find my looks unconventional, but I have more money than you, and I have a private life that you cannot begin to imagine. One collar of her suit jacket

OPPOSITE, ABOVE:
The Milliner (Henri de Chatillon). 1944. Oil on canvas, 47⅝ x 60⅝" (121 x 154 cm). Collection Vicky & Marcos Micha

OPPOSITE, BELOW:
Portrait of the Knight Family. 1946. Oil on canvas, 71¼ x 79½" (180.9 x 201.9 cm). The Minneapolis Institute of Arts, Gift of Mrs. Dinah Ellingson in memory of Richard Allen Knight

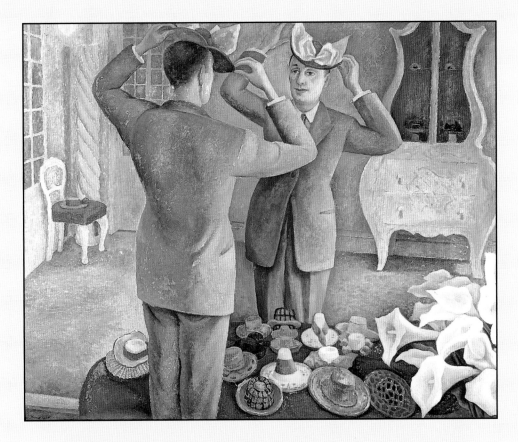

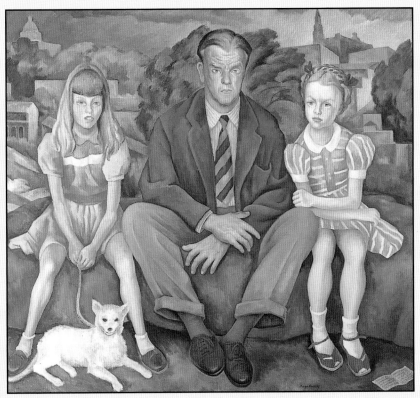

BELOW:

Portrait of Ann Harding. N.d.
Brush and black ink and pencil
on paper, 24⅜ x 18¾″
(61.9 x 47.6 cm)

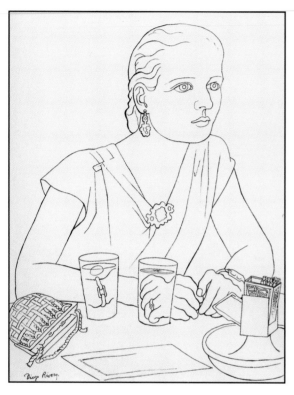

rises toward her face like an arrow, at once forcing attention upon that face while suggesting a hint of personal carelessness. She might be the plumed serpent.

His bare-shouldered portrait of the actress Dolores Del Rio runs against her own cool image. She was one of the great public beauties of the century, and as an actress she had made a successful transition from silent movies to sound. Her oval face and high cheekbones gave her an elegant beauty that lasted into her old age. But in his 1938 portrait, Diego paints her as a girl in a see-through blouse, hands lying primly on her lap. She was then thirty-four years old. Her eyes are wide and glossy and strangely lifeless. Her nipples seem like an extra set of eyes.

The two portraits of Mexican movie star María Félix have a more theatrical vitality. In the Mexican cinema of the 1940s, Félix projected the image of a man-killer, *la devorada*; this endeared her to millions of Mexican women, but made some men tremble. While painting a lifesize portrait, Diego fell in love with her and wanted to divorce Frida. "Frida suffered deeply," he said in his memoirs. But so apparently did Diego. María Félix not only refused to marry him, she wouldn't even allow her portrait to be used in a fifty-year retrospective of his work. The first portrait (1948) shows Félix with her trademark cocked right eyebrow, her eyes gazing in an amused way at the unseen painter. Her hair is full, rich, demanding to be grasped. She wears large gypsy-style earrings. The thumb of her elegant hand holds a loose garment to her full bosom, and there is a salacious quality to the way she peers at us. Much of this quality vanishes in the 1949 portrait. This is full length, with Félix in a diaphanous outfit that shows her body. But she has become an object to Rivera, not a subject, a lifeless doll instead of a living passionate woman. He had not lost his skill; that same year he made one of his greatest portraits, this time of his daughter Ruth Rivera, holding a round mirror as she looks over her shoulder at the artist. What obviously skewed the second portrait of María Félix was Rivera's vision. In falling in love with her to the point of wanting to marry her, his emotional and carnal desire for her was transformed into an obsession with acceptance. As a result, he painted the kind of painting he thought would convince her to love him back. He failed. Clearly, Diego Rivera was one of those painters who was a better artist when he didn't think too much.

Many of the society women in his portraits have been Mexicanized, dressed in regional costumes like those worn by Frida Kahlo, or in the shawls called *rebozos,* and are frequently seated upon the small wooden chairs called *equipales.* This transformation can be seen in the *Portrait of Mrs.*

Carrillo Flores (1948) and in the very late *Portrait of Dolores Olmedo.* But sometimes they were Diegoized. One of his best portraits was of Natasha Gelman, the Czech wife of the Russian-born producer of the Cantinflas movies. She is reclining on a blue sofa, her long-legged body encased in a white sheath, her left wrist bejeweled, rings on her fingers. Her blonde head is framed by Diego's calla lilies, which also spill down the foot of the couch in blossoming erotic counterpoint to the cold and virginal image of personal control. Her steady intelligent eyes are not flirtatious. In following years, Gelman would be painted by Frida Kahlo, Siqueiros, Angel Zárraga, and Rufino Tamayo; she preferred the portrait by Diego Rivera.

As in his Cubist days, he also painted those who were close to him. He painted Frida Kahlo in 1935 and did not shrink from depicting her anger and personal unhappiness. The source of some of that unhappiness was Diego's affair with her younger sister Cristina, who had always been her closest ally within the family. It is not known when the affair started. Six years earlier, Cristina was a figure in *Distributing Arms* at the Ministry of Education. A few months later, in 1928, she was persuaded by Frida to pose nude for Diego's dreadful murals in the Ministry of Health, holding a flower that, as Hayden Herrera has pointed out, "looks like a vagina."[1] After his return to Mexico at the end of 1933, the affair either began or resumed. Frida discovered the truth and was heartbroken. She took her own apartment. She fled for a while to New York.

That year, 1934, was difficult for Frida Kahlo. In the early months, Diego was depressed and sulking; he had not wanted to leave the United States and blamed Frida's pressure for their return. Her own physical problems compounded the gloom. She entered the hospital to have her appendix removed. She had an operation on her foot. Worst, she had an abortion for medical reasons in the third month of another pregnancy. Doctors told her to refrain from sexual intercourse. And there was Cristina, alone, available, a symbol of fecundity. Diego made his move. There is a 1934 drawing of Cristina, in charcoal and sanguine, that shows a woman of almost stony solidity, except for the confused eyes. At this time, Cristina had been recently divorced from her husband and was living with her two children (and her aging widowed father) in the Blue House. In November, Diego used her in a portion of the left wall at the National Palace. Hayden Herrera has written:

"Once more, Cristina posed for him, this time accompanied by her two children, and holding a document instead of a flower. Nevertheless, she looks seductively round in face and body, and her golden eyes have that blank, orgasmic expression that Rivera reserved for women with whom he was sexually infatuated."[2]

Frida is behind her sister in this section of the mural, dressed in denim and red, looking like a cartoon version of a communist militant. By now she was doing little painting; Rivera must have justified his betrayal by thinking of her

OVERLEAF, LEFT TO RIGHT:
Portrait of Adalgisa Nery. 1945. Oil on canvas, 48½ x 24½″ (123.3 x 62.4 cm). Collection Sr. Rafael Mareyna

Portrait of Ruth Rivera. 1949. Oil on canvas, 78⅜ x 39½″ (199 x 100.5 cm). Rafael Coronel Collection, Cuernavaca

Portrait of Dolores Olmedo. 1955. Oil on canvas, 78¾ x 59⅞″ (200 x 152 cm). Museo Dolores Olmedo Patiño, Mexico City

Nude with Flowers (Veiled Woman). 1943. Oil on canvas, 60 x 46″ (152.4 x 116.8 cm). Private collection, New York

Nude with Flowers was one of a series of lighthearted "Pin-up Girls" that Rivera painted for Ciro's, a night club in the Hotel Reforma in Mexico City. The women portrayed were not professional models but rather the same high-society clientele that paid to sit for Rivera's portraits.

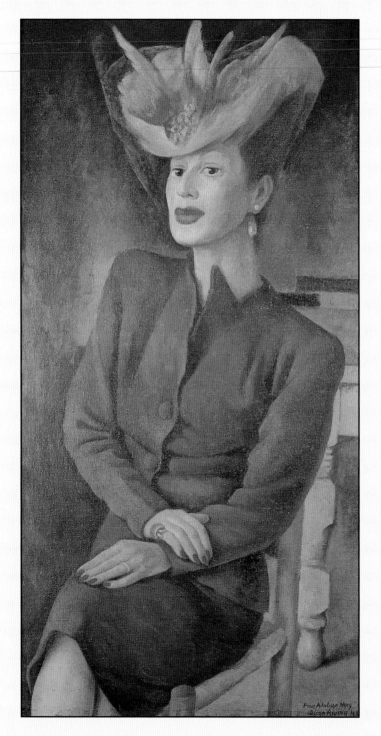

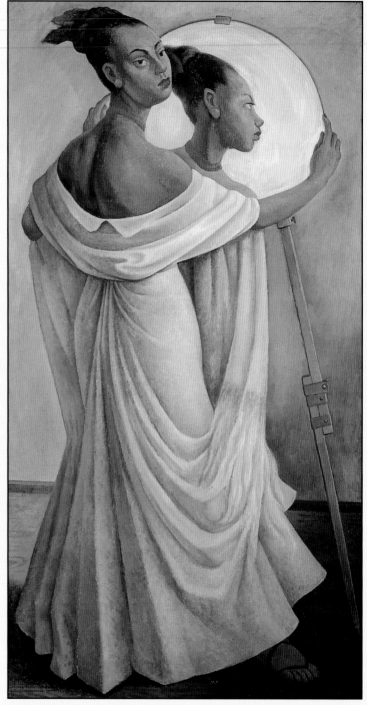

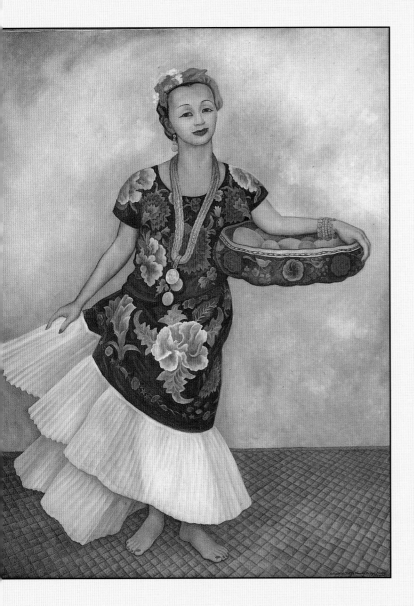

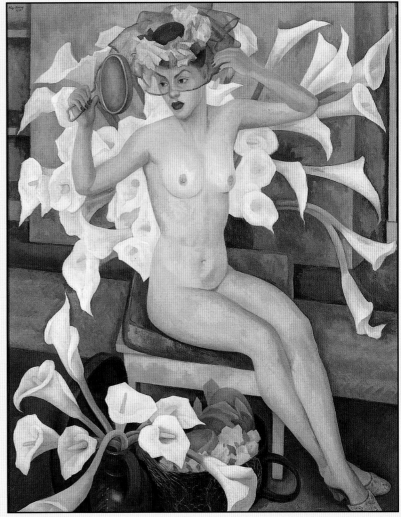

only as an ideological comrade. She was erotically attractive to men and women and would have affairs with both. But it is worth noting that in all their years together, Rivera made only one drawing of Frida nude, as if their union was artistic, intellectual, and ideological before it was sensual. Late in life, Diego expressed his sorrow over the way he treated Frida: "If I loved a woman, the more I loved her, the more I wanted to hurt her. Frida was only the most obvious victim of this disgusting trait." He certainly knew what he was doing. The 1935 portrait clearly recognizes her rage. Eventually Frida forgave her sister, as if understanding her vulnerability. She never completely forgave Diego Rivera. But she would divorce him, remarry him, and stay with him until her death in 1954.

There was one other woman who never completely detached herself from Rivera's life: Lupe Marín. Because of their children, their lives remained entangled. Lupe became friendly with Frida and helped her learn to cook. Diego loved painting her when she was young and wild, and in 1938—eleven years after their divorce—he had her sit for him again. The result was one of his most powerful easel paintings. Her brown skin glowing, Lupe sits on a straw-covered stool, her back reflected in a mirror behind her. She is dressed in a long white gown, and forms a diagonal that is emphasized by the bracing angle of the reflection in the mirror behind her. The picture plane itself is tilted, the floor pushed up, the axes of the composition adding tension and unease. Her mouth is open, her green eyes slightly glazed and looking into the middle distance. She wears two necklaces that resemble teeth; a third is jade, the color of her eyes. But it is her large hands grasping her crossed knees that dominate the picture. They push out of the surface, hands of immense bony power. Those hands are not tamed by the metal bracelets that are painted like handcuffs. As painted by the man who once loved her, they are the hands of a strangler.

There was one other series of portraits that evolved throughout Rivera's life: the portraits of himself. He first painted himself in 1906, when he was a student at San Carlos. Over the years, he made about twenty portraits and uncounted self-caricatures (usually in the form of a frog). His last known self-portrait was done in 1951. These paintings were not exercises in vanity. As noted, Rivera was ruthless with himself, particularly in the later years, when he was in full physical decay. In all the self-portraits he emphasized his eyes: bulging, doubting, sometimes quizzical, other times ironically amused. In some of the late drawings, the eyes are vacant. Looked at in sequence, they constitute a remarkable document, a record of a personal descent that was as much moral as physical, and they are as powerful in their way as the self-portraits of Rembrandt.

Starting most seriously in the 1930s, he also produced still another immense body of work that had nothing to do with murals. He became *the* painter of the Indian, the artist who burned into the world's consciousness

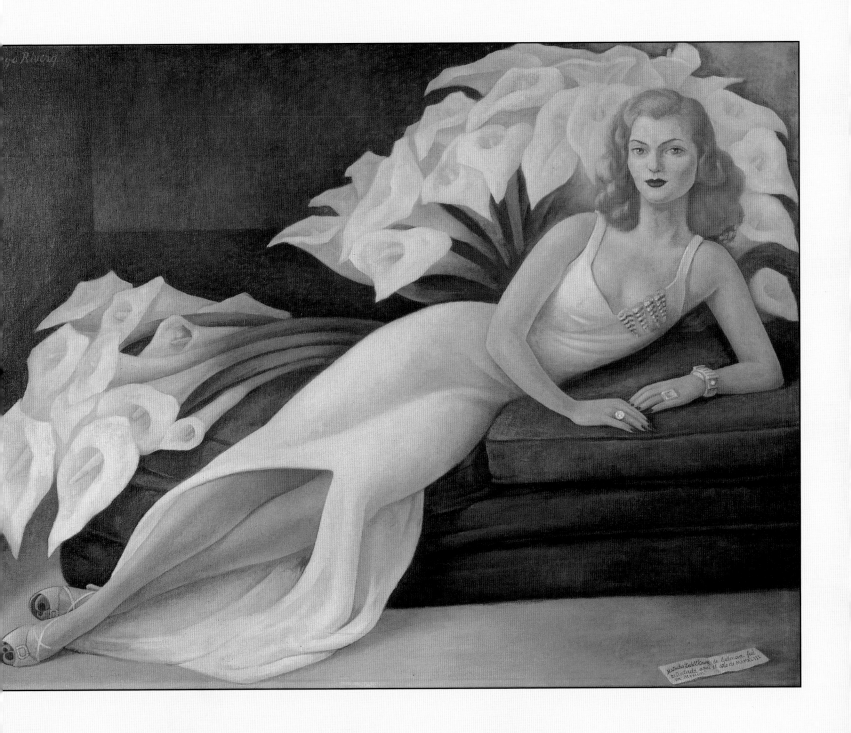

RIGHT:
Indian Woman. 1935.
Reddish, brown, yellow,
and black crayon on laid
(Japan) paper, 15¼ x 11″
(38.7 x 28.0 cm).
Brooklyn Museum of Art,
Carll H. De Silver Fund

FAR RIGHT:
Cabeza de Campesino Viejo. 1939.
Sanguine, charcoal, and
watercolor on rice paper,
15½ x 11″ (39.4 x 28 cm)

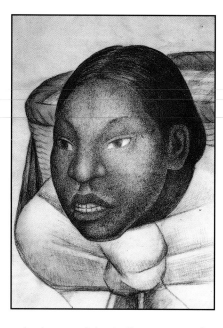 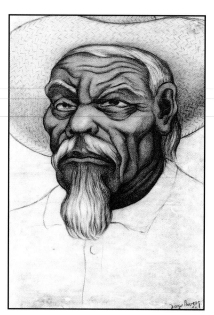

OPPOSITE:
Illustrations for *El Indio*
by Gregorio Lopez y Fuentes, 1936

OVERLEAF, LEFT:
The Flower Carrier. 1935.
Oil and tempera on Masonite,
48 x 47¾″ (122 x 121.3 cm).
San Francisco Museum of Modern Art,
Albert M. Bender Collection.
Gift of Albert M. Bender
in memory of Caroline Walter

OVERLEAF, RIGHT:
Zandunga, Tehuantepec Dance. c. 1935.
Charcoal and watercolor,
18⅞ x 23⅞″ (48.1 x 60.6 cm).
Los Angeles County Museum of Art.
Gift of Mr. and Mrs. Milton W. Lipper,
from the Milton W. Lipper Estate

the image of the indigenous people of Mexico. Both Orozco and Siqueiros were creating their own versions of the Indian, and Rufino Tamayo would provide his own quieter and more subtle evocation of the Indian spirit. But Rivera made the subject his own. In many oil paintings, hundreds of watercolors, and perhaps thousands of pencil and ink drawings he evoked the dignity, honor, and beauty of the Indians.

Rivera painted numerous enduring works with Indian subjects, many of which are still being reproduced in posters and calendars decades after he made them. *The Flower Carrier* shows a peasant on hands and knees carrying an immense basket of flowers while a woman tries to help. The painter celebrated regional folk dancing in charcoal and watercolor in *Zandunga, Tehuantepec Dance.* The work seemed to pour from him: men at hard labor, women selling flowers or tending children. A young Indian woman named Delfina Flores was his favorite model and he painted her many times in the 1930s. Two other Indian women, named Nieves and Modesta in the titles of the paintings, followed her, often in powerful nudes. There is a charming innocence to the Delfina paintings; the others, particularly those of Nieves, have a more deliberate sexual charge. Increasingly, Rivera painted children too, usually standing alone, some beautiful to the point of sentimentality. If he and Frida could have no children, he would borrow children from others and have them forever on canvas or paper.

There was, of course, much repetition. After 1935, there are at least ten full-scale oil versions of the pigtailed woman with the calla lilies. In each, something has been shifted: the details of the lilies, the position of the woman's head, the texture of the *petate* mat upon which she kneels. But the idea is always the same. Rivera is like a jazz musician returning again and again to the same tune, in the hope that, as the saxophonist Lee Konitz once said, "this

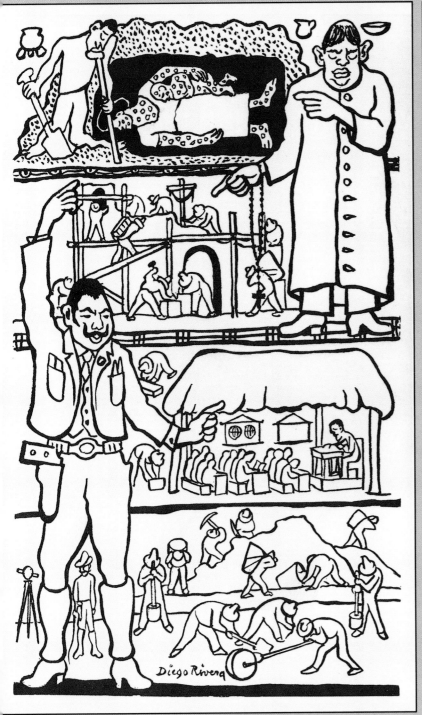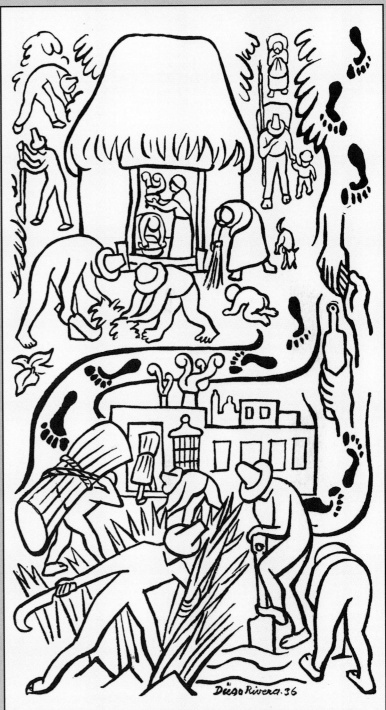

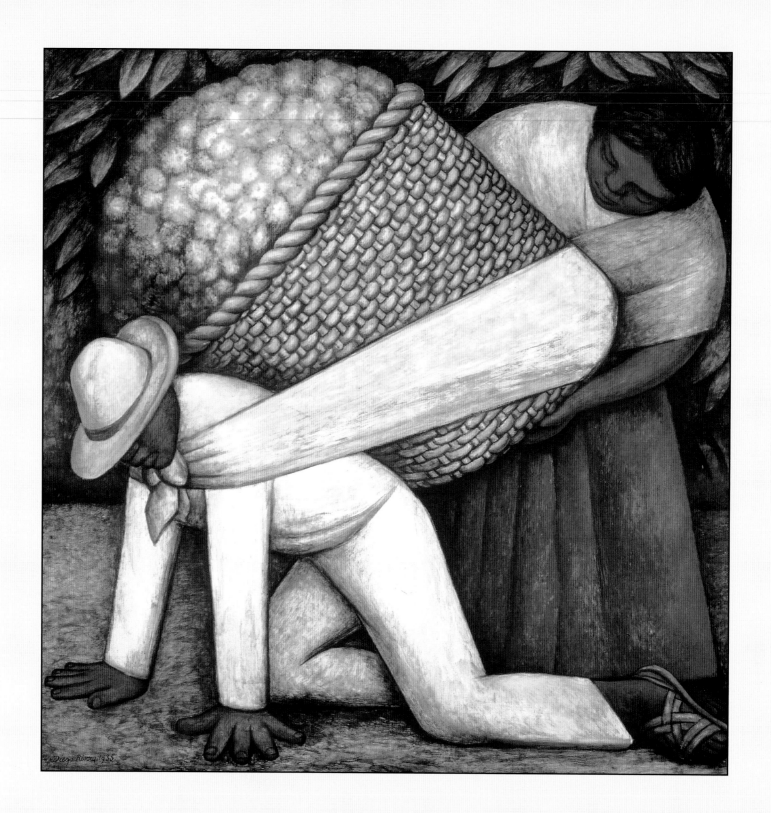

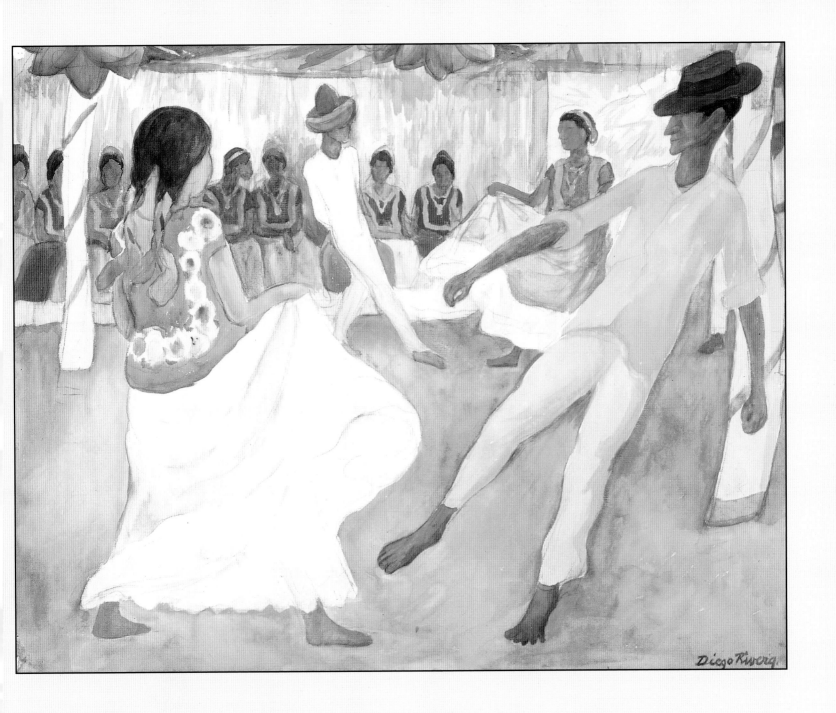

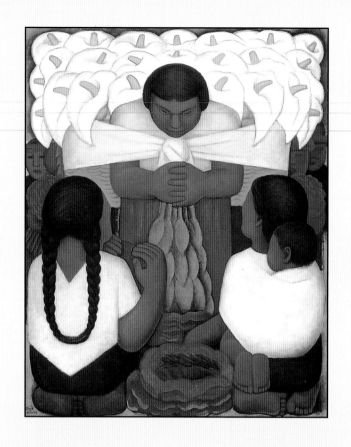

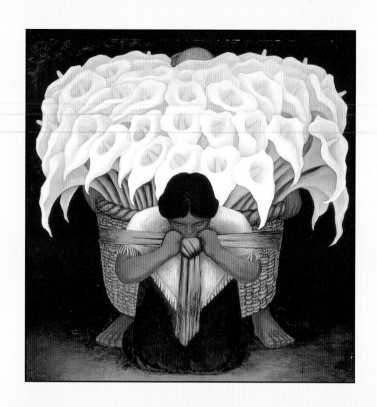

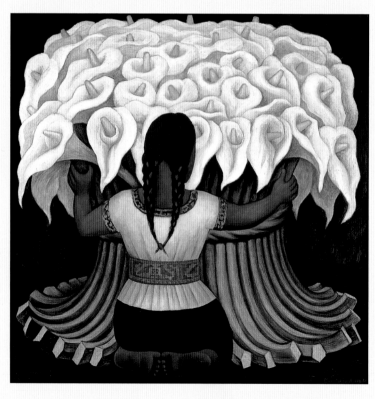

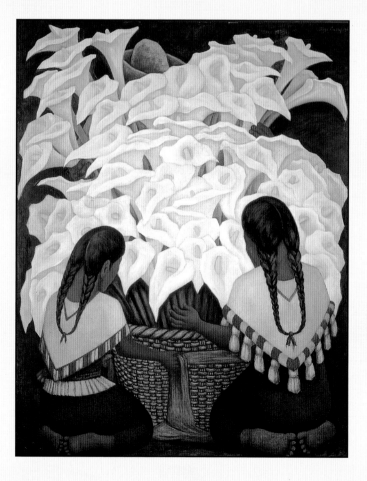

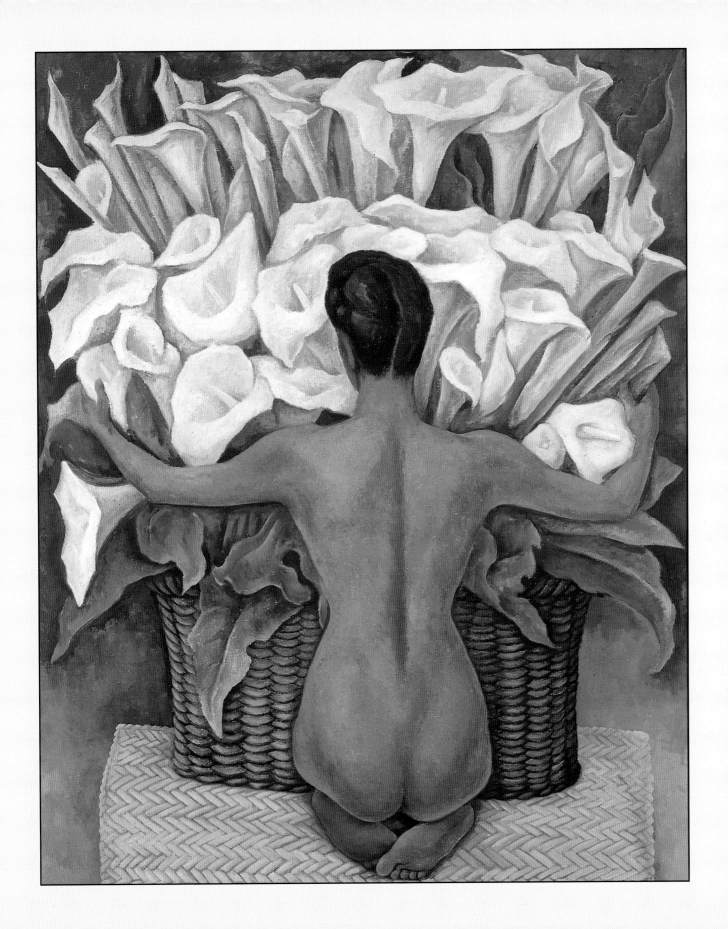

time I'll get it right." One of the finest variations on the theme is the *Nude with Calla Lilies* (1944) in which a cinnamon-skinned woman with her back to the viewer embraces an immense bunch of lilies. In this painting, the hair is piled high on the head, the body is longer, but it is saved from being an empty pin-up by the boniness of the buttocks, the slight awkwardness of the stance.

The sheer volume of work was driven in part by what capitalists called market forces. In the studio in San Angel, there were many visitors from the United States and Europe, and Rivera welcomed them. He chatted with them, sold them drawings and watercolors, sometimes accepted portrait commissions, and in general acted like one of the artist-entrepreneurs of the Renaissance. One visitor remembers seeing Rivera working on five watercolors at the same time, laying in all the yellows, then all the reds, then the black outlines of the figures. He joked that he had adapted the techniques of mass production he had studied in Detroit.

Even under these circumstances, driven by the need to earn money, often distracted by political matters, his relations with Frida in turmoil, the work had more vivacious life than all but one of the later murals.

Trotsky

The bitterness of left-wing politics began to shift after the election of Lázaro Cárdenas as president in 1934. Most Mexicans were initially skeptical, believing that young Cárdenas would be just another puppet of Calles. They were wrong. He quickly bundled Calles onto an airplane and sent him into exile in the United States. Cárdenas was on his way to becoming the best Mexican president since the Revolution. As the writer Selden Rodman has written:

"Without being patronizing about it, he was always on the side of the poor and the oppressed, functioning practically and without publicity on their behalf. He never revenged himself upon his enemies. He did not enrich himself. He acted upon principle."[3]

Cárdenas also confused the sects of the left. He was personally austere, generally humorless, and serious about his work. He began to distribute millions of acres of land to the landless, keeping the pledges made by Zapata. He traveled to all parts of the country, sometimes on horseback, and he didn't simply talk to the *campesinos*, he listened to them. He began making his plans to nationalize the Mexican oil industry. All of this infuriated the hard-line Mexican Stalinists, whose primary loyalty was to Stalin, not Mexico, and who correctly perceived that Cárdenas was taking away their franchise.

Their hatred of Cárdenas deepened in December 1936 when the Mexican president, on the urging of Diego Rivera, allowed Leon Trotsky and his wife, Natalia, to enter Mexico as refugees. On January 9, 1937, they arrived in the port of Tampico on the tanker *Ruth*. The long, perilous journey that had taken

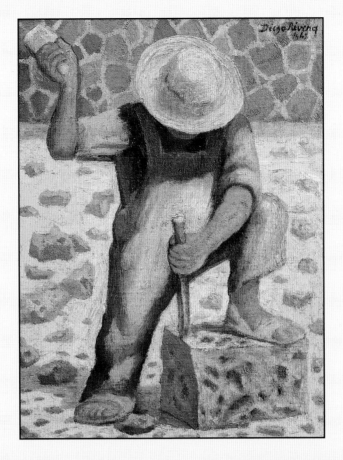

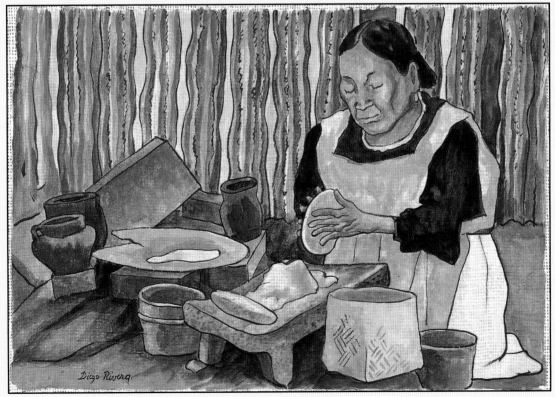

Trotsky from Siberia in 1929 to the island of Prinkipo, off the coast of Turkey, to Norway, seemed at an end. Waiting for him at the pier were various North American Trotskyites, a crowd of journalists, and Frida Kahlo. Diego could not make it, since he was in the hospital with eye and kidney problems. But if the Stalinists were fierce in their criticism of Cárdenas, they expressed loathing for Diego Rivera.

Trotsky and his wife would live as guests in the Blue House in Coyoacán. Frida's widowed father moved to the home of his daughter Adriana, leaving his photographic equipment locked in a room of the house he'd built. The Trotskys stayed for two years. Their most critical problem was security, and Diego took an active hand in converting the Blue House into a small fortress. Windows open to the streets were plugged with adobe bricks. Volunteer guards supplemented the police. To prevent Stalinist commandos from blasting through an adjoining wall, Diego bought the house next door, knocked it down, and extended the garden. Some people were amused at all this, dismissing it as paranoia; but Stalin's hit squads were very real. Even in the raging Spanish Civil War, the Stalinists reserved greater passion for the murder of Trotskyites and anarchists than for combat with the fascist legions of Francisco Franco. In the vicious polemics of the day, Rivera was often the target of Stalinist fury. Even his friend Siqueiros, who had gone off to fight in the Spanish Civil War, turned against him.

At first, the Riveras and the Trotskys spent much time together. They took one famous trip in the company of the visiting André Breton. As secular pope of the surrealists, Breton was claiming Frida as a member of that movement and trying to synthesize Surrealism with Trotsky's version of Marxism. Breton was in such fawning awe of Trotsky that the messianic Trotsky himself was made uneasy. Trotsky and Breton worked together on a manifesto about art and revolution that appeared in various magazines, including *Partisan Review*. But Trotsky was barred from open political activity in Mexico, so the manifesto was signed by Breton and Rivera. Later, it was made clear that Rivera wrote exactly two words of the document: his name.

The relationship of Rivera and Trotsky was probably doomed from the beginning. The Russian was still a pompously dogmatic man, full of abstract certainties, with a continuing commitment to Lenin's "dictatorship of the proletariat"; a gifted pamphleteer, with airy notions of world revolution and as intolerant of open debate as was Lenin. Diego was essentially an anarchist. There were irritations. As time passed, the irritations got personal. According to Hayden Herrera, Frida entered into an affair with Trotsky. She was probably driven by the need for revenge against Diego over his affair with her sister, and often secretly met Trotsky at Cristina's house. Natalia Trotsky figured this out before Diego did.

In April 1939, Rivera and Trotsky finally parted. The sexual affair between Trotsky and Frida certainly played a major part in the split; it was a grievous

case of bad manners on the part of Trotsky. But there were ideological factors too. Three months earlier, the insufferable Trotsky had announced that he no longer felt "moral solidarity" with Rivera's political ideas. They were too anarchistic, too . . . *free*. This self-important proclamation was, of course, made public. By April, the Trotskys had moved out of the Blue House to another house in Coyoacán. Rivera was probably glad to see them go, but he had other matters on his mind. His personal life was becoming intolerable. That summer he and Frida separated, and by the end of the year they were divorced. Frida had affairs with various men and women; Diego pursued a number of women, including the movie star Paulette Goddard.

In August, the communist movement was shaken to its core when Stalin signed a nonaggression treaty with Hitler. Most idealistic members abandoned the world's orthodox communist parties; only hardcore Stalinists remained, convinced that Stalin was infallible. Trotskyites—including Rivera—were not surprised. They had been drawing parallels between Hitler and Stalin for many months. But the tide of totalitarianism seemed to be winning. The Spanish Republic had been defeated by Franco in January. By March, the Nazis were in Prague. Five weeks after the Hitler-Stalin pact was signed, the German army smashed into Poland and Stalin grabbed his share of the spoils. In Mexico City, Nazi agents could be seen in the same restaurants as those of Stalin. On the left, only the militant true believers still carried water for Stalin.

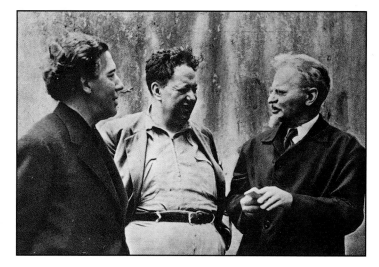

One of those true believers was David Alfaro Siqueiros. In the spring of 1940, he returned from the Spanish Civil War. As usual, he was too busy to paint. On May 24, he led a squad of armed Stalinists in an attempt to murder Trotsky. They were dressed as cops and soldiers, which gained them entry to the grounds. Thousands of rounds were fired into the house, more than two hundred into the bedroom where Trotsky and his wife had been sleeping (the bullet holes can still be seen in the walls). The Stalinists failed to kill the old revolutionist, or even wound him. But they did kidnap an American bodyguard named Robert Sheldon Harte, took him into the nearby countryside, and murdered him. It was a vile, dirty business.

Rivera was alarmed, perhaps even panicked. Mexico City was feverish with lurid rumors. One claimed that Trotsky had arranged the attack himself, to discredit Stalin. Another claimed that Diego had a hand in the attempt on Trotsky, motivated by jealousy over the great man's affair with Frida. In the fever zone of rumor and murder, Rivera also felt he was in physical danger

himself. After all, he was the man who had brought Trotsky to Mexico. He was identified as a Trotskyite, one of the most famous in the world, severely critical of Stalin. His celebrity was like a "wanted" poster, his face known to almost all Mexicans. Many knew where he lived. And in the hours after the attempt on Trotsky, Rivera received a number of death threats. He was, as Paulette Goddard said, "on the spot." While the Mexican police tracked down Siqueiros and then jailed him (he would serve only a year before being exiled to Chile), Rivera began making arrangements to protect his own hide.

He decided to quickly accept still another mural commission in the United States. He had been invited to take part in the Art in Action program of the 1940 Golden Gate International Exposition. Now he would say "yes." Like so many Mexicans before him, he would seek refuge in the north.

Diego's Dirty Little Secret

The problem was getting there. In the first hours after the attempt on Trotsky's life, Diego hid out in his lawyer's house. Getting a visa then, as now, was a complicated, time-consuming process. But unknown to his enemies, his friends, and perhaps even to his now ex-wife, Frida, Diego Rivera had friends at the American Embassy. He had very good friends there, and the reason was based on a fact that he never mentioned in his autobiographical writings: he had been an informant for many months for the U.S. State Department.

This activity was discovered in 1992 by Professor William Chase of the University of Pittsburgh, who was researching a study of Trotsky.[4] Making use of the Freedom of Information Act, Chase found that the Federal Bureau of Investigation had been keeping files on Rivera since 1927, when he crossed the border on his way to New York and then to the Soviet Union. That file, filled with notes and newspaper clippings, would remain open until Rivera's death. Rivera did not cooperate knowingly with the FBI itself and, in the 1930s, the Central Intelligence Agency did not yet exist. His contact at the American Embassy was a man named Robert McGregor. All reports on their conversations went to the State Department.

Rivera and McGregor first met at Rivera's home on January 11, 1940, the day after a committee meeting of the Mexican Communist Party. Rivera had already publicly released a list of Communists serving in the Mexican government and had met with a reporter for the Hearst newspaper chain to add new names to the original list. That reporter apparently notified the American Embassy about Rivera's willingness to talk. The appointment was arranged with McGregor. As always, the painter was amiable and expansive. Rivera gave the same names to McGregor and added a few more. He told McGregor about political assassinations connected to the ongoing Mexican presidential campaign, which would choose a successor to Cárdenas. He voiced his belief

OPPOSITE:
Frida Kahlo. *Diego and I.* 1949.
Oil on Masonite,
11⅝ x 8¹³⁄₁₆″ (29.8 x 22.4 cm).
Private collection

This sorrowful double portrait has been associated with Kahlo's pain over Rivera's intention to marry the actress Maria Felix, which came to nothing. But it also captures the quality of their entangled relationship throughout their last years together.

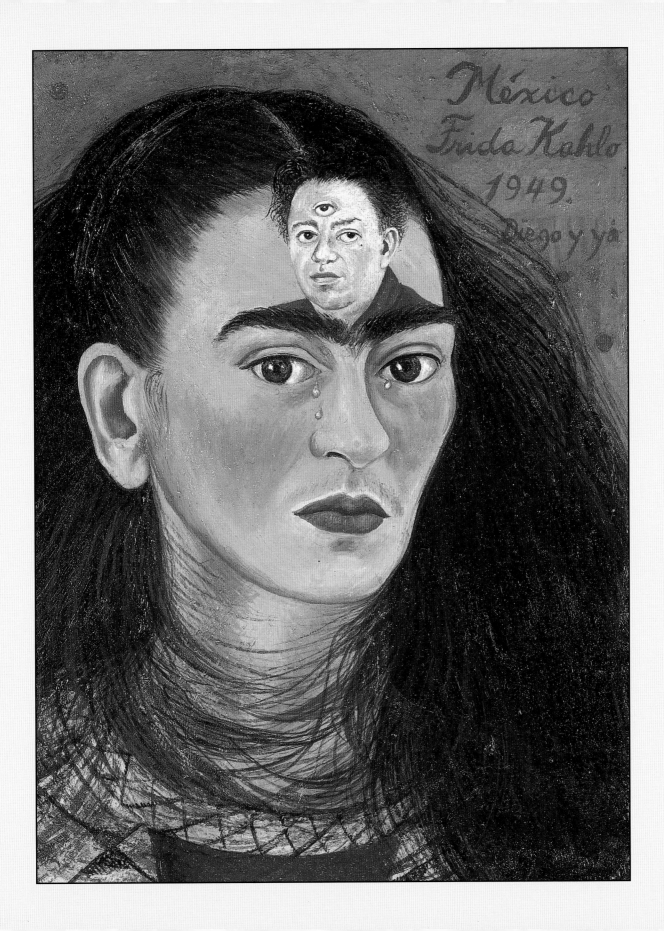

that Stalinist agents were entering Mexico with the many legitimate refugees from the Spanish Civil War. He told McGregor that the Mexican Communist Party was being financed through the Stalinist party in New York, using a bank in Mexico City. The information was taken with a certain skepticism; Rivera's reputation for telling the truth was not good. But Diego named names. They were all Stalinists and he was a Trotskyite. Not a name was a surprise to the Americans. But he named them.

Rivera met with McGregor again in February and in March. According to the notes, Rivera and Trotsky both appeared willing to testify before the Dies Committee in Washington. It is doubtful that Diego gave the Americans any information of real value, but he obviously believed the Stalinists were a clear and present danger to Mexico and the rest of the hemisphere. For all of his quarrel with American capitalism, he was fond of the United States itself; he admired its industry, its sports, its comic strips, its optimism; he had not wanted to leave after the fiasco at Rockefeller Center. He certainly did not want to see a United States that was controlled by Stalinism. And so he gave his information—erratic, personalized, and occasionally even accurate—to the American government.

Five days after the May 24 attack on Trotsky's house, Rivera called the American Consulate. He was, as the saying goes, cashing in a marker. He wanted a Border Crossing Card that would allow him to leave immediately for the United States. The specific reason was to paint his mural in San Francisco. The true reason was to escape an assassin's bullet. McGregor came to see Rivera in his hideout. They arranged an elaborate travel plan. Rivera would go to Tamaulipas in northern Mexico. There, a friendly governor would give him his Mexican documentation. At the same time, the American Consulate in that city would notify the Immigration and Naturalization Service in Brownsville, Texas, asking them to make it easy for Rivera to cross.

Rivera made this journey with Paulette Goddard. In Brownsville, according to Professor Chase, the INS convened a Board of Special Inquiry, which interviewed Rivera and granted him an immediate one-year visa. He and Goddard then flew from Brownsville to California. It helped to have friends.

For six months, Rivera worked in San Francisco. The painting of the mural was a kind of stunt. He did the work before an audience on Treasure Island. Every day, crowds would arrive to watch him, as he labored with his assistants on a portable fresco. The painting isn't very good. With its mountains, blended races, clenched portraits of people ranging from John Brown to Charlie Chaplin, it is a visual anthology of old work. In some parts it is inadvertently comic. In the center, beneath a god-machine that is part Coatlicue, part Henry Ford, three figures join to plant "a tree of love and life." One is the engineer-artist Dudley Carter. Another is Frida Kahlo. The third is Paulette Goddard. Some viewers laughed out loud.

Diego was in San Francisco on August 21, 1940, when the news came that Ramón Mercader had driven an ice pick into the brain of Leon Trotsky. Frida

called Diego with the news, saying, "They killed old Trotsky this morning. *Estupido!* It's your fault that they killed him. Why did you bring him?"[5]

Frida's anxiety was real, and there was a note of hysteria in her voice. She had met the assassin in Paris (he was a handsome young Spanish Stalinist) and he had even dined in the Blue House. She was picked up and interrogated for twelve hours. Diego's house was ransacked by the police. Diego suggested that she come to San Francisco. She did. He also added armed guards to the site of his mural painting on Treasure Island.

When Frida arrived in early September, Diego was at the airport to meet her. She was jittery and haggard (already thin, she had lost fifteen pounds in a few months). Her beauty was swiftly fading. She stayed with Diego for a few days in his apartment at 49 Calhoun Street on Telegraph Hill. Then she went into the hospital. The prescription was simple. She should get plenty of rest. She should stop drinking. She did both. Then she moved on to New York with a twenty-five-year-old lover.

But Diego had asked her to marry him again. She brushed him off at least twice. He persisted. He needed her, he said. And somehow she needed him. Near the end of November, Frida returned to San Francisco. They were married for the second time on December 8. It was Diego's fifty-fourth birthday. When they returned to Mexico, he moved into the Blue House with Frida, although he continued to work in his studio in San Angel.

One Final Masterpiece

The rest of Diego's life was a prolonged, sad, sometimes morally squalid twilight. To be sure, his easel work was often superb. But the moment of the Mexican muralists had passed. In the years after the war, the movies had made murals irrelevant to most Mexicans. To the critics, too many of the murals seemed dated now, embarrassing artifacts of the fevered 1930s. In New York, artists who had learned much from the heroic scale of the Mexicans—Jackson Pollock was the most prominent—were forging a new art, stripped of content, based on energy and gesture and rebellion. All ideologies seemed dead. Art that was driven by ideology seemed even deader.

But in 1947 in Mexico City, Diego Rivera, after recovering from a struggle with bronchial pneumonia, roused himself one final time to paint a masterpiece. He was commissioned to adorn the immense restaurant of the new Hotel del Prado, on the Avenida Juárez, facing the south side of the Alameda Park. Diagonally across the street to the left was the Hotel Regis, where movie stars and politicians, old generals and new bankers gathered in the booths of the café to exult in the materialist triumphs of the regime of President Miguel Alemán. For six long years, the war had sealed off Europe to American tourists; now modern Acapulco was rising on the shores of the Pacific and tourists were arriving in *la capital* by the planeload. The Mexican movie

OVERLEAF:
Dream of a Sunday Afternoon in Alameda Park. 1947–48.
Fresco, 15'9" x 49'3" (4.8 x 15 m).
Museo Mural Diego Rivera,
INBA, Mexico City

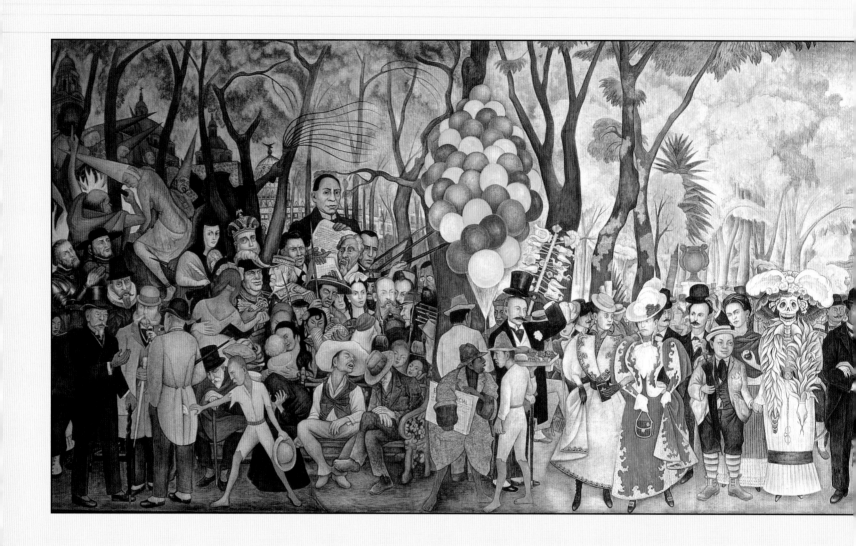

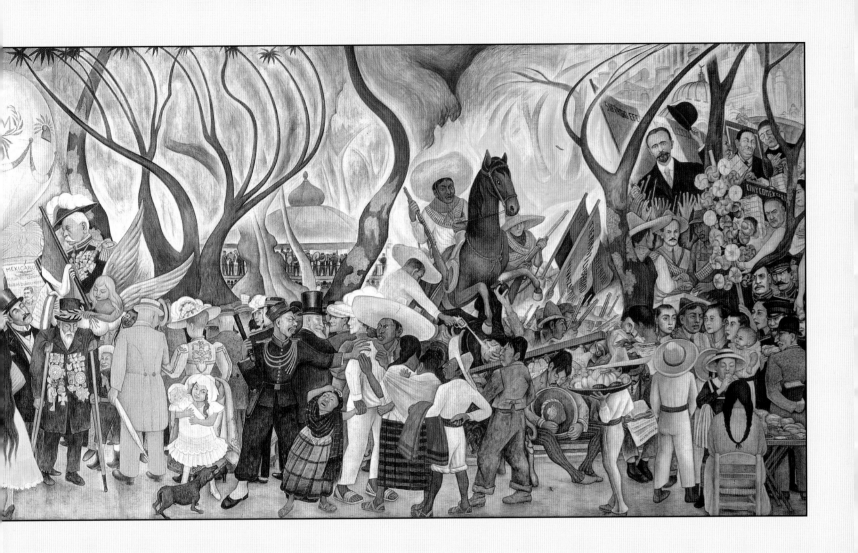

industry was in its *epoca de oro*, its Golden Age. The capital was booming. The Del Prado hotel was part of the boom.

Rivera's mural would be painted on portable frames that together measured fifty feet in length and sixteen feet high and weighed about thirty-five tons. It was called *Dream of a Sunday Afternoon in Alameda Park*. Rivera placed himself as a boy in the center of a vivid panorama of Mexican history and remembered pleasures. He is here a pudgy boy with bulging eyes, holding an umbrella with a vulture's head, wearing knickers and striped socks and the straw hat of the middle class. A signature frog is in his breast pocket, an adder with flickering tongue rises from another. A grown Frida is behind him, a protective hand on his shoulder, a sphere representing yin and yang in her left hand. Beside the boy is an image of death wearing a boa hat, a grinning skeletal version of *la calavera Catrina* as depicted by José Guadalupe Posada. Death gently holds the boy's hand; her other hand is on the arm of a bowler-hatted Posada.

Also behind young Rivera is José Martí, a martyr to Cuban independence, a man who had lived part of a long exile in Mexico before dying on the sands of Cuba in 1895. And to his right is Carmen Romero Rubio de Díaz, the second wife of the dictator, the woman who had bought Diego's paintings on that night long ago in San Carlos, the night when Francisco Madero had begun the Revolution. She is dressed in the high fashion of the 1890s, and is in the company of the dictator's daughter from his first marriage, Lucecita Díaz (sometimes identified as Rivera's aunt, a woman of the *Porfiriato* named Tanta Vicenta). Over on the right of the mural, bemedaled and beplumed, is Díaz himself, stiff and vain, his face powdered to conceal his Indian skin.

All of Mexican society, past and present, is in the painting: prostitutes and *campesinos*, newsboys and candy sellers, food peddlers and pickpockets. The park had been the burning ground of the Inquisition and there is a portrait of a humiliated Jewish woman named Mariana Violante de Carbajal, who was burned as a heretic. There is an old man who had once been a general in the war against the French; he had been reduced to a character in the park, nicknamed by everybody "General Medals." A snarling policeman pushes a sandaled *campesino* out of the park. The *campesino* holds a crying child with one hand, makes a fist with another, and is being calmed by his woman, who carries another child on her back in a sling. A dog barks at the policeman. A middle-class girl, holding a blonde doll whose lace dress is finer than the clothes of many of the humans, is amused at the dog but doesn't see the crying child or her angry father. Neither do other "decent" people. Their backs are turned to the scene.

This could have become another Rivera exercise in painted revolutionary rhetoric. It didn't. In this mural, Warm Diego comes flooding back in triumph. The picture is suffused with nostalgia, the trees bright and golden, the park itself a kind of Mexican Eden. There are multicolored balloons, tacos, pinwheels, drinks, sweets, commotion, and argument. There is nostalgia, but

not sentimentality. Diego truly feels this place; it is the park of his first years in Mexico City. He does not turn away from injustice and villainy; he gives it its place. But the warmth of his vision embraces heroes *and* villains. It is as if he had understood finally that in any narrative there can be no great heroes without great villains. He doesn't make a case for the villains. But he acknowledges that the casualties of revolution have been enormous, and he represents those casualties with old soldiers, dozing on benches, dreamy with the past.

There was, of course, a controversy. On the extreme left of the painting, Diego placed the figure of a once-famous nineteenth-century liberal named Ignacio Ramírez, nicknamed *El Nigromante*. In 1836, he made a speech at the Academy of Letrán about the separation of Church and State in which he said, in passing, that God did not exist. Diego painted the phrase "Dios no existe" into his mural. God does not exist. Catholic militants objected. Students barged into the hotel and mutilated the mural, scarring the painted face of Diego, scraping at the words of Ignacio Ramírez. Diego repainted them but refused to change them. The hotel owners finally constructed a curtain that covered the greatest Rivera mural since Chapingo, opening it occasionally for special guests. They did not chop it off the wall.

Envoi

The final years were a mess. Diego did more murals. They were all terrible. Perhaps their quality had something to do with other distractions. In spite of everything he knew, in spite of *gulags* and mass killings and thirty years of state terror, in spite of the assassination of Trotsky, he pleaded to be accepted again into the chilly womb of the Mexican Communist Party. Frida had been taken back in 1948, probably because she had never been an official Trotskyite. But Diego was simply not welcome. He debased himself, in the manner of those who had appeared in the late 1930s before the Moscow Purge Trials. In 1952, he called himself "a coward, traitor, counterrevolutionary and abject degenerate,"[6] adding that the work he had done while separated from the party was all bad art. He was still rejected. He continued going back on bended knee, craven, shameless, obsequious.

The reasons for Rivera's desperate quest for readmission to the Mexican Communist Party remain blurry. Rivera's most recent biographer, Patrick Marnham, speculates that it was driven by a combination of factors: communism was a powerful bond to Frida in their last years together; Rivera had a need for a spiritual home; his residual Catholicism included a need to confess his sins. But at this date, with many of Rivera's letters and papers unavailable to scholars, nobody truly knows.

We do know that in 1952, he painted the worst mural of his career: *The Nightmare of War and the Dream of Peace*. It showed a heroic Stalin, his hand

OVERLEAF, LEFT:
Sunset. 1956.
Oil and tempera on canvas,
11⅞ x 15¾" (30 x 40 cm).
Museo Dolores Olmedo Patiño,
Mexico City

OVERLEAF, RIGHT:
Self-Portrait. 1949.
Tempera on linen,
13¾ x 11" (34.9 x 27.9 cm)
Private Collection

Rivera painted this self-portrait
for the editor of *Vision*, a Latin
American news magazine.
In the background are
vignettes from his paintings.

Diego Rivera 1956

resting on the Stockholm Peace Petition, standing as a savior of the earth. Beside him is an equally heroic and benevolent Mao Tse-tung. Heroic North Koreans are being shot, hanged, or whipped in the background. In the foreground, a heroic Frida Kahlo sits in her wheelchair collecting peace petitions. It is a great lie of a painting, and Rivera had to know it.

The Mexican government, which had commissioned the mural as part of a touring exhibition, turned it down. Rivera sent back his fee. The Mexican Communist Party still didn't want him. Stalin died in March 1953, an event that revived hope in the aging Mexican apostate. In August, Frida Kahlo's right leg was amputated. She was fading quickly, using drugs and alcohol against the physical pain. She died on July 13, 1954. She was forty-seven. Rivera turned her funeral into another application for admission to the party. The services were to be held in the Palacio de las Bellas Artes, the most important museum of art in the country. The director general of the Institute of Fine Arts, a childhood friend of Kahlo named Andrés Iduarte, made Rivera promise that this would be a Mexican event, not a communist one. Diego broke that promise. Frida's coffin was draped with a red flag emblazoned with a gold hammer and sickle. Iduarte was blamed and ended up being fired. But Rivera got what he wanted. In December he was readmitted to the party.

Six months later, he was diagnosed with cancer. He married a woman named Emma Hurtado, who had been serving as his dealer, and then went off on a long trip to Eastern Europe and the Soviet Union. By January 1956, he was claiming that communist medicine—"the cobalt bomb"—had cured him of cancer, a triumph of faith over intelligence. While in Russia, he made some dreadful paintings of wide-eyed Russian children who resembled small zombies. On the way home, he stopped in Czechoslovakia, which had been converted by Stalin's agents into a police state; in Poland, where dissidents had been hammered in the spring; and then to the grim police state of East Germany. In October, he supported the Soviets when they used tanks to crush the rebellion in Hungary.

He was never well again. The cancer, of course, returned. Diego must have known he was running out of time. On April 13, 1956, he walked into the Hotel Del Prado, went to his great mural, and painted out the offending words, "Dios no existe." He substituted the words "Lecture at the Letrán Academy, 1836." Students could find the terrible words on their own. Two days later at a press conference he announced: "I am a Catholic." The journalists were amazed. So were his friends. He offered very little explanation, saying only: "I admire the Virgin of Guadalupe. She was the standard of Zapata, and she is the symbol of my country. It is my desire to gratify my countrymen, the Mexican Catholics, who comprise 96 percent of the population of the country."

He went then to Acapulco, to convalesce in the home of his friend Dolores Olmedo. Years earlier, he had made nude drawings of her. Now he painted